Architect's Choice

Art in Architecture in Great Britain since 1945

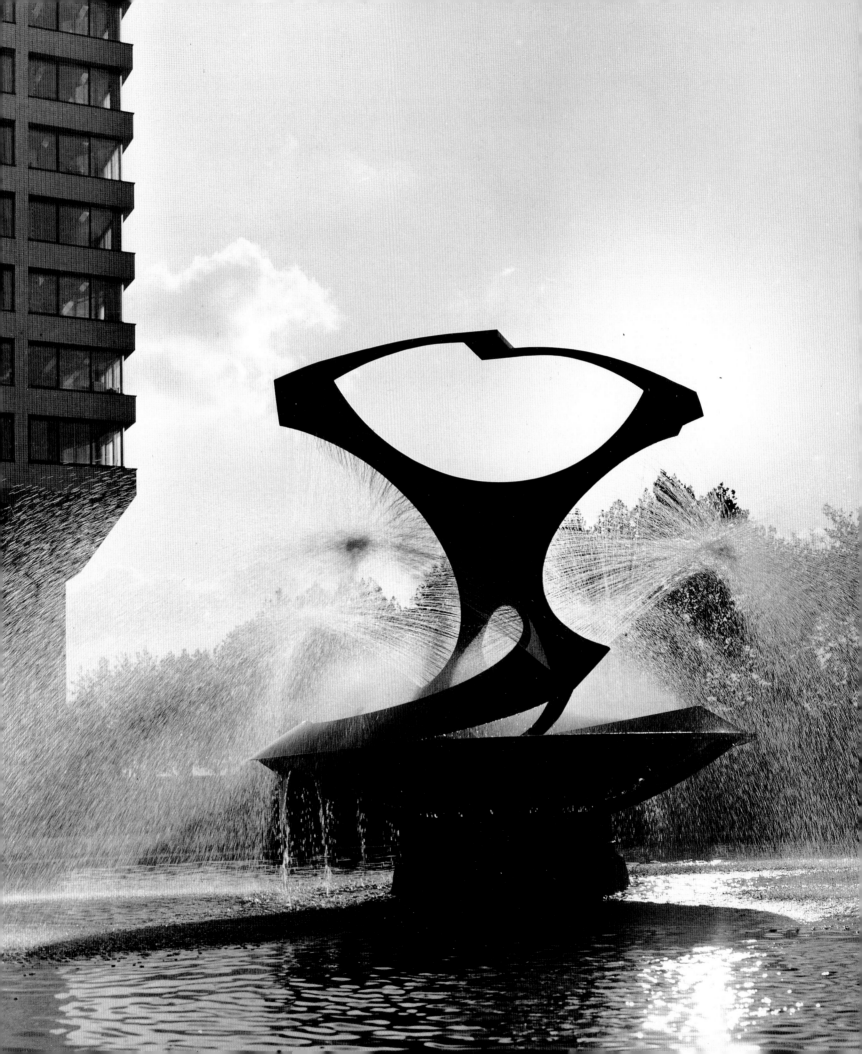

Architect's Choice

Art in Architecture in Great Britain since 1945

Eugene Rosenberg

Foreword by Sir Norman Reid
Text by Richard Cork

With 201 illustrations, 28 in colour

Thames and Hudson

'Art should attend us everywhere that life flows and acts....
at the bench, at the table, at work, at rest, at play, on working days and holidays....
at home and on the road....
in order that the flame to live should not be extinguished in mankind.'

NAUM GABO
The Realistic Manifesto 1920

It has been agreed that the whole Rosenberg photographic archive will be deposited in The British Architectural Library, Royal Institute of British Architects.

Frontispiece: Naum Gabo, *Revolving Torsion, Fountain*, 1976, outside St Thomas' Hospital, London. Architects: Yorke Rosenberg Mardall.

Contents

Preface

I am committed to the belief that the artist has an important contribution to make to architecture. The bond between contemporary art and architecture is not easy to define, but I believe they are complementary – that architecture is enriched by art and that art has something to gain from its architectural setting. If asked why we need art, I could give answers based on philosophy, aesthetics, prestige, but the one I put high on the list is that art should be part of the enjoyment of everyday life.

In recent years many reports have been published on the cultural and educational importance of the arts (Lord Redcliffe-Maud, the Arts Council of Great Britain, the Stuyvesant Foundation, Conservative, Labour and Liberal Parties), but very little has been said or published about what has actually been achieved in the post-war years. The material I have collected from a wide cross-section of architects, artists and clients proves that a large volume of work has been done, much of it of a very high standard. Contrary to belief, we have not lagged behind other countries, but few people seem to know this or give credit for it.

Instead of 'client', perhaps 'patron' would be a better word. Patronage has stemmed in the public sector from health, education and airport authorities, universities, local authorities, development corporations, and religious institutions; and in the private sector from large industrial concerns, developers, oil companies, banks, accountants and building societies.

It has been estimated that only some fifteen per cent of the population visit museums and art galleries. The vast majority – to quote Professor Gombrich – 'has found no access to art'. Yet there is ample ready-made space available for 'housing' the visual arts – in community centres, post offices, police stations, works canteens, offices, schools, universities and hospitals. Here people can be exposed to contemporary art, become familiar with it.

If we accept that art is a vital element in architecture, then we must understand clearly the aims and roles of the large numbers of people involved in the creation of our environment. Clients, architects, professional consultants and artists should work together to tackle the problems arising from the integration of art in architecture. In this, the architect can play a key role in commissioning and placing art in the buildings he designs. It is in the nature of things that when a building is completed, the architect usually has no further contact. However, once the basis of an art collection has been laid down – preferably in close collaboration with one or two people within the organization – it can follow that sufficient enthusiasm will be engendered to encourage the client to find ways of supplementing the collection. A standard is set which makes it easier to avoid acquisitions or donations of uneven or unsuitable quality.

Ozenfant said that art for architecture should be regarded as part of the cost price, in other words an integral part of the building. From my research on what has been achieved and from my own experience, I hope to demonstrate that it is possible to surmount the obstacles (often exaggerated), to stimulate enthusiasm, to find the money and to solve the mechanics of putting art into architecture.

Eugene Rosenberg

Foreword

I have experienced at first hand the benign explosiveness of Eugene Rosenberg's enthusiasm in fulfilment of an idea. In 1968 I came back from a visit to Naum Gabo in America with a project for a fountain which he had designed some years before with the intention of one day building it three metres high. I put the idea to Eugene Rosenberg, knowing his dedication to the siting of works of art in public places and that he had in his own collection a sculpture by Gabo which he had bought many years before. He was then involved in the rebuilding of St Thomas' Hospital and he persuaded Alistair McAlpine (now Lord McAlpine of West Green) to pay for the making of the fountain and the Special Trustees of the hospital to finance its installation on a splendid site in the hospital garden right opposite Big Ben.

With two such volatile characters as Gabo and Rosenberg I anticipated a bumpy ride, but in fact all went remarkably smoothly. London gained a splendid fountain which complements the remarkable collection of works of art within St Thomas' Hospital, built up by Rosenberg over a period of years. It is not really a collection in any ordinary sense of the word but a sort of continuous 'happening' which unfolds as you move through the buildings.

The conviction that works of art should be part of everyone's daily experience was integral to Eugene Rosenberg's thinking as an architect. He seized every opportunity to enrich the many public buildings for which he was responsible by persuading his clients to regard works of art as an essential part of the project. St Thomas' Hospital is simply the most notable example of the application of this belief. There the paintings and prints have become completely integrated into the life of the hospital – an art gallery which is open to the public twenty-four hours every day.

This is not to suggest that Rosenberg was alone among architects in being passionately concerned about placing works of art in and around his buildings. Many architects have welcomed paintings and sculpture, but Rosenberg's active involvement often continued, as at Warwick University and St Thomas', long after the buildings were complete.

Throughout his professional career he gathered a pictorial record of works of art in public buildings in Britain which grew to some three thousand items. He had it in mind to publish a selection of the most successful projects and when he retired he set about shaping his book and making final choices. In organizing this material he had the untiring help of Patricia Mowbray. Sadly, Rosenberg did not live to see his book in print, but he had the pleasure of seeing it through all but the very last stages.

Today, the search for patrons is more intense than ever, and Rosenberg's hope was that his book would not only demonstrate what had been achieved in siting works of art where they could be enjoyed as part of everyday life, but also encourage others to busy themselves in a field where he personally had achieved some remarkable successes and brought himself and others so much pleasure.

Sir Norman Reid

Introduction

I first met Eugene Rosenberg in the early 1980s, and immediately became aware of his passion for art. The paintings and sculpture surrounding him at home testified to the eagerness and discernment with which he had amassed his own collection. But I soon realized, during a conversation dramatically punctuated by his characteristic exclamations of delight in the works he owned, that Rosenberg was determined to find a public role for art as well. Unlike so many architects of his generation, he believed that artists could still play a viable part in the built environment. To that end, he commissioned a number of distinguished works for exterior and interior sites in the schools, hospitals and universities designed by his partnership. He also planned a pioneering book based on an archive of photographs painstakingly assembled over the decades, in the belief that more attention should be paid to the art installed in contemporary architectural settings throughout his adopted country.

Soon after Thames and Hudson invited me to write the following essay for his book in 1990, we met again. Although in poor health by this time, his enthusiasm for the project remained wholly undimmed. Looking through the layout of the principal illustrations, he was still able to convey his excitement about the work it surveyed. Rosenberg's choice of plates is very personal, clearly reflecting the preferences of an architect whose work is stamped by strong, single-minded convictions. So I set about producing an essay that would complement his selection, providing a more comprehensive historical review of the multifarious ways in which artists have worked in architectural contexts since 1945. It is, inevitably, a complex affair, involving frustrations and blunders as well as positive achievements. Although the disappointments often threatened to confound the hopes of everyone attempting to further the enterprise, the story deserves to be told. For if the relationship between art and architecture is to be fruitfully developed in the future, and its pitfalls avoided, we need to look back at the diverse initiatives undertaken during the post-war period and learn from the precedents they provide.

Richard Cork

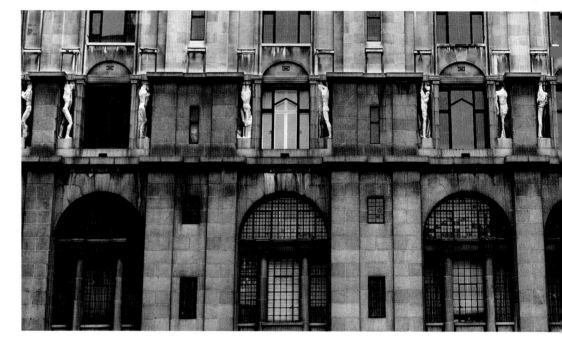

Jacob Epstein's figures, after their mutilation in 1937, on the former British Medical Association Headquarters in the Strand, London.

Towards a New Alliance

In 1937, thirty years after the young Jacob Epstein had accepted an invitation to carve eighteen figures for the British Medical Association's new London headquarters, a resolute group assembled outside the building. Led by its architect, Charles Holden, and the President of the Royal Academy, they mounted the scaffolding and began to inspect the statues, one by one. After Holden had tapped each figure with a hammer and chisel, identifying portions of stone that he believed to be decayed, they were hacked away. Heads, projecting limbs and symbolic attributes were all cut off, without any apparent regard for their sculptural significance.

The building's new owner, the Government of Southern Rhodesia, maintained that the carvings were a threat to pedestrians passing below. The statues' supposed frailty was seized on as an excuse to purge the building of unwanted nudity, and despite protests the brutal dismemberment was carried out. Holden later claimed, with astonishing complacency, that 'although some of the stones were disfigured in this process the general decorative character of the band of figures was not seriously destroyed, and they still convey something of Epstein's intention to portray the "seven ages of man".'[1] But the truth is that Epstein's noble scheme was reduced to ruin. The sculptor himself made no attempt to hide his mortification when he related how 'anyone passing along the Strand can now see, as on some antique building, a few mutilated fragments of my decoration'.[2]

As well as destroying the most memorable sequence of sculpture ever carved for the facade of a London building, the defacement inadvertently took on a wider symbolic resonance. For it coincided with a widespread readiness, among the most adventurous architects in Britain, to dismiss all thought of embellishing their buildings with art. The growing functionalist aesthetic demanded purity of surface, and the desire to reject ornamental detail resulted in stripped-down, streamlined frontages. Henry Moore, who was so appalled by the Royal Academy's involvement in the destruction of Epstein's figures that he refused ever to exhibit at Burlington House,[3] nevertheless

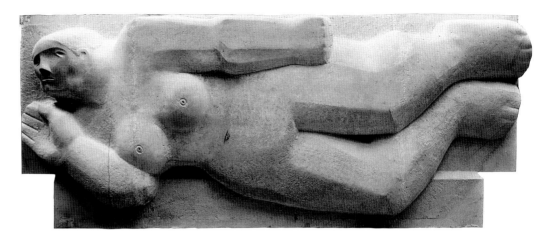

Henry Moore, *West Wind*, 1928, London Underground Railway Headquarters, Westminster.

agreed with the new philosophy. The architects he liked best 'were leaving all unnecessary (even some necessary) details off their buildings and they had no use at all for sculpture. This was a good thing then, both for the sculptor and the architect, for the architect was concentrating on the essentials of his architecture, and it freed the modern sculptor from being just a decorator for the architect.'[4]

Moore himself had good reason to be wary of playing a subservient role on a modern building. As a young sculptor in 1928, he had executed a large flying figure of the *West Wind* for Charles Holden's imposing new London Underground Railways headquarters in Westminster. Although Epstein had been commissioned to produce two prominent carvings of *Night* and *Day* over the building's doorways, Moore and the other five sculptors involved in the venture were relegated to the seventh floor. The primordial power of his *West Wind* was impaired by the location it occupied, high up on a building so immense that it overshadowed all the flying 'wind' figures lodged in Holden's austere stonework. Even if Moore learned a great deal about monumental form during the commission, it confirmed his instinctive belief that relief sculpture symbolized the humiliating subordination of the sculptor to the architect. When Holden invited him to carve eight seated figures for another lofty position on the facade of London University's Senate House in 1938, Moore abandoned the project after making some elaborate preliminary drawings of female figures holding books. He failed to sustain any excitement about the scheme, and his preoccupation with form in the round made

him reject the idea of devoting so much of his energy to a kind of sculpture he disliked. So the spaces reserved for his reliefs have remained blank to this day.

Since advanced opinion tended to side with Moore during the inter-war years, the prospect for the growth of a fruitful relationship between art and architecture seemed remote. There were signs, however, that even the most innovative contemporary buildings might still have a place for painting and sculpture. When Erich Mendelsohn, Serge Chermayeff and the outstanding engineer Felix Samuely collaborated on the

Jacob Epstein, *Night*, 1928–9, London Underground Railway Headquarters, Westminster.

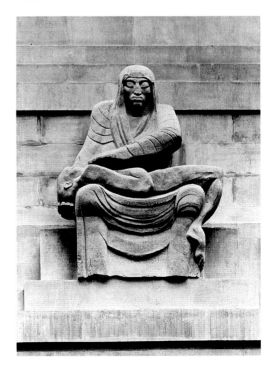

De La Warr Entertainments Pavilion at Bexhill-on-Sea in 1935, they produced a *tour de force* of clean-cut yet flamboyant geometry in the International Style. But room was found in Britain's first all-welded steel structure, with its audacious cantilevered staircase, for a large and exuberant mural on the cafeteria wall by Edward Wadsworth.[5] A couple of years later, a commanding affirmation of the shared concerns linking artists and architects was sounded in *Circle*, the 'International Survey of Constructive Art'. Edited jointly by Leslie Martin, Ben Nicholson and Naum Gabo, it announced that 'a new cultural unity is slowly emerging out of the fundamental changes which are taking place in our present-day civilization'.[6] *Circle*, asserted its editors, wanted 'to give to artists – painters, sculptors, architects and writers – the means of expressing their views and of maintaining contact with each other. Our aim is to gather here those forces which seem to us to be working in the same direction and for the same ideas, but which are at the moment scattered, many of the individuals working on their own account and lacking any medium for the interchange of ideas.'[7]

The climate of thought fostered by *Circle* and its contributors bore felicitous fruit the following year, when Chermayeff invited Moore to produce a carving for the grounds of Bentley Wood, a stern, rectilinear timber-frame house he was building for himself near Halland in Sussex. Conscious no doubt of Moore's belief that sculpture should no longer be '*on* a building but *outside* it, in a spatial relation to it',[8] Chermayeff gave the carving a position at the intersection of terrace and garden. Moore was able to charge his great *Recumbent Figure* with the sinuous rhythms of the Downs beyond, so that it became 'a mediator between modern house and ageless land'.[9] It introduced the humanizing element which would characterize Moore's subsequent work with architects, and confirmed him in the belief that sculpture should be free to enjoy 'its own strong separate identity'.[10]

Even if any architects had been prepared to provide further opportunities, their plans were curtailed by the advent of war. At a time when Britain's museums hid their collections in remote storage, to evade the threat of Nazi bombs, the whole notion of making art for architectural arenas seemed impracticable. Many artists were serving in the armed forces, where the chances of producing their own work were inevitably limited. Those who longed to work on an architectural scale had to content themselves with the realization that destruction in so many major cities would lead, one day, to substantial rebuilding throughout the nation. While the Blitz continued there was no hope of reconstruction, and Herbert Read sounded a note of understandable frustration when he declared in 1944 that 'the sculptor is essentially a public artist. He cannot confine himself to the bibelots which are all that fall within the capacity of the individual patron of our time. The sculptor is driven into the open, into the church and the market-place, and his work must rise majestically above the agora, the assembled people. But the people must be worthy of the sculpture.'[11]

Perhaps Read already knew, when he wrote those words, that his close friend Moore had been approached in the very same year to produce a major sculpture for Impington Village College. This propitious invitation came from Henry Morris, Chief Education Officer in Cambridgeshire before the war and one of the first to encourage the development of creative learning in schools. Like Read, whose 1943 *Education Through Art* had argued with intense idealism that art should be the basis of education, Morris attached enormous importance to the quality of the environment in schools. Hence his decision to employ Walter Gropius and Maxwell Fry on the college at Impington, founded in the belief that child and adult education should both be conducted within a single institution. Moore's abiding preoccupation with the relationship between offspring and parent attracted him to the project at once, and he prepared a remarkable range of drawings and maquettes based on the *Family Group* theme.

In the end, the county councillors of Cambridge denied Morris the funds for his proposed sculpture. Five years later, though, the Hertfordshire Education Officer John Newsom was able to finance the *Family Group* for a site outside the entrance of Barclay Secondary School in Stevenage, designed by the firm of Yorke Rosenberg Mardall (p. 49). The school, the first recipient of Hertfordshire's enlightened new policy, was also the first co-educational Secondary Modern school in the country. And Moore's bronze, installed in the autumn of 1950, unifies the array of motifs rehearsed in the maquettes through the arm of the father, who stretches out to rest a protective hand on his wife's shoulder. Since this binding gesture is only visible from behind, Moore felt uneasy about the architects' placing of a curved baffle wall between the sculpture and the school. In his view, it discouraged onlookers from viewing the bronze in the round.[12] Even so, the advent of this affirmative *Family Group* proved enormously influential, setting a beneficial example not only for subsequent Hertfordshire schools but post-war developments elsewhere in Britain as well.[13]

By 1951, when the Festival of Britain attempted to herald a new era of peace and reconstruction, the nation at last came nearer to achieving what Read had described seven years before as 'that spontaneous give-and-take of inspiration and appreciation which is the fundamental factor in a great period of art'.[14] The extensive site on the south bank of the Thames was filled with a heterogeneous yet stimulating abundance of buildings, and a corresponding profusion of artists found themselves commissioned to provide paintings and sculpture in a variety of media for the diverse locations on offer. Sir Gerald Barry, the Director General of the Festival, had argued at an early stage in the planning

Henry Moore, *Recumbent Figure*, 1938, Bentley Wood, Halland, Sussex.

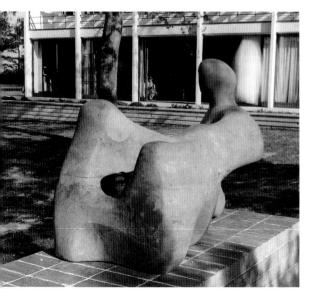

that 'the size of modern architectural projects enforces teamwork: the groups working together on them should include not only the scientist and the sociologist, but also the painter and the sculptor. This might bring the artist out from his seclusion, and give him a new place in the social order.'[15]

Barry's enthusiasm certainly ensured that the Festival of Britain, both within its proliferating pavilions and outside, was alive with the work of a remarkable array of painters and sculptors. But before it opened, a salutary note of caution was sounded by Graham Sutherland. Speaking at an RIBA symposium on 'Painting, Sculpture & The Architect', he asked: 'Are painters and sculptors prepared for collaboration?' The answer, according to Sutherland, was 'No. Most are prepared to do work for architects – only too eager: but few understand what collaboration means. It means very much more than just talking things over with the architect. There must be a closer relationship, involving a mutual attraction and understanding of work, and sympathy for the ideas and purposes held and intended by each.'[16] The ideal outlined by Sutherland could not, of course, suddenly be achieved during the brief and hectic period devoted to the Festival's planning. All the same, artists and architects alike found stimulus in the sense of excitement generated by planning an exuberant antidote to 'the national dinge'[17] of austerity-oppressed Britain. Misha Black, who was heavily involved in the co-ordination of design, went so far as to claim in retrospect that all the contributing artists 'carved, modelled and painted in complete unison with the architects who ensured that walls were available for murals and plinths for sculpture. Practically every concourse was designed to contain a major work; each building was a sanctuary for important works of art.'[18]

In reality, the outcome of collaboration on the Festival site was uneven and, at times, frankly disappointing. One of the most prominent sculptures, a colossal bas-relief by Siegfried Charoux gazing across the Thames from a position near the Dome of Discovery, was inflated and banal. Nor could anyone claim that Epstein's bronze *Youth Advancing*, balanced on a plinth by a pool between pavilions, was one of his most convincing post-war works. Hugh Casson, Director of Architecture for the Festival, subsequently

observed that some of the artists 'made the mistake of thinking that all that was wanted was their own gallery formulae writ larger'[19] – the result, in the main, of being left to their own devices after the commission was bestowed. It was a mistake often reiterated in subsequent public work by artists unprepared to acknowledge, and take full account of, the particular demands of the sites they dealt with.

All the same, the Festival did generate some memorable painting and sculpture. Moore managed to produce one of his finest and most disquieting recumbent figures – an etiolated presence who lifts her split head towards the sky with an unease still reminiscent of wartime anxiety. Moore's refusal to indulge in ill-founded optimism reflects his awareness of post-Hiroshima tension. The figure's unprecedented boniness is accompanied, nevertheless, by a sinewy resilience. She inhabits her plinth with the strength of a survivor, and asserted a commanding presence in front of Brian O'Rourke's Country Pavilion opposite the Festival main entrance. Moore chose the site himself,[20] whereas other artists' contributions were more closely allied with particular buildings. John Piper's characteristically theatrical panorama, an architectural medley celebrating the past rather than the present, was attached to the back of the Homes and Gardens Pavilion. An even more remote period was evoked by *The Origins of the Land*, a colossal mural-sized painting which Sutherland produced for the Land of Britain Pavilion. Layered in orange and yellow divisions like sections through the crust of the

Siegfried Charoux, *The Islanders,* 1951.

Henry Moore, *Reclining Figure,* 1951.

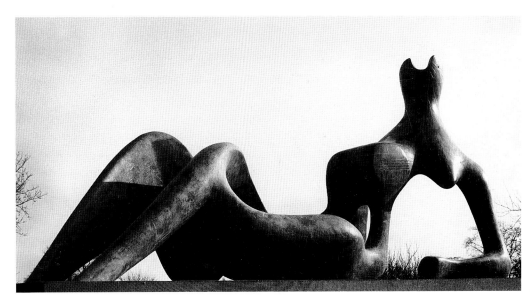

11

earth, the canvas is dominated by a leering pterodactyl with wings outstretched in flight. But Josef Herman countered this emphasis on prehistory, with a blunt, brooding panel of *Miners* for the Pavilion of Minerals of the Island. Although crouching in the shadows, the miners still seem full of latent strength and ready to spring up when the moment for action arrives.

The most memorable alliance between art and architecture occurred at the Festival's restaurants. Occupying an unpromising site abutting the arches of Hungerford Bridge, the Regatta Restaurant triumphed over its location and enlisted the services of a painter, a sculptor and a landscape architect. The grandest of their contributions was Victor Pasmore's ceramic mural on the south wall. Flanking the staircase entrance to the Festival from the bridge, it offered a large-scale opportunity to reveal what Pasmore described as 'the full implications' of the 'creative explosion in the visual arts which spread throughout the world following the renewal of free expression after the war'.[21] He realized that the uncompromisingly modern building, designed by Misha Black and Alexander Gibson, welcomed an assertion of the abstract language which had recently, and very controversially, invaded his own art. A year earlier he had executed a large relief-mural in buff and rust-red for the Kingston Bus Depot, but its severe rectangular and semi-circular forms were reticent to a fault in comparison with the Festival project. On the South Bank the spiral motifs already dominating his current paintings provided him with an image capable of 'exploding'[22] the Regatta Restaurant. Pasmore regarded the whirling, vortex-like lines of the black-and-white image as 'a jazz painting',[23] and he asked the architects to leave the tiles unpointed. Although the decision greatly distressed the tile craftsmen, he believed that 'the more uneven the tile grid the more movement we would get in the painting'.[24]

The sadly inadequate surviving photographs of the mural suggest that Pasmore succeeded in his aim, and the motif he chose was echoed elsewhere on the Regatta site. In the small enclosed garden designed by H.F. Clark and Maria Shepherd, Lynn Chadwick installed an interlocking sculpture called *Cypress*. Its verdigris green sheet metal integrated well with the foliage in the garden, and Clark observed that all the artists who had contributed to the restaurant from 'these widely dissimilar fields have consciously, or unconsciously, employed the same movement – the movement of a series of spirals or a coiled line, or, in the case of the garden, a series of serpentine and interlocking folds of water and plants'.[25]

A similar symbiosis was attempted by Jane Drew, the architect of the Riverside Restaurant. Undaunted by its awkward relationship with the underbelly of Waterloo Bridge, she produced a building of elegant distinction which owed a significant amount to the works of art commissioned for its exterior. Against one wall Eduardo Paolozzi erected a steel and concrete *Fountain*, his first monumental sculpture for a public location. Its reliance on a thin armature of upright and horizontal rods, within which the water-carrying cups and basins were lodged, owed a clear debt to Giacometti's *The Palace at 4am*.[26] But it showed an independent fascination with cage-like structures as well, and its incorporation of water's motion disclosed a kinship with the 'slowly moving mobile sculpture'[27] which Barbara Hepworth installed some distance from the restaurant's facade. Jane Drew afterwards explained, when asked how she had collaborated with the artists of her choice, that they were her friends and she went to stay with them.[28] While visiting Ben Nicholson in St Ives she invited him to make a curved mural for the restaurant's entrance. Although the sunken pebbles in front of the painting were placed there to help protect it from possible vandalism, they also chimed with the bleached, pared-down composition Nicholson produced. Its affinity with Hepworth's sculpture hardly needs stressing, but the tense linear structure which gives the mural its backbone possesses unexpected links with the 'scaffolding' employed in Paolozzi's *Fountain*.

The most intriguing of all the images spawned by the Festival was, however, produced by architects. Nearly two hundred entries were submitted to a competition for a 'vertical feature' on the site, and Powell and Moya's *Skylon* won the day. Its cigar-shaped form became popular at once, probably because it soared to a height of three hundred feet from its angular launching-pad like the space-rocket which the English could fantasize about but never afford to build. It coincided with the advent of Dan Dare, the

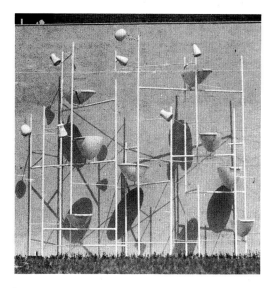
Eduardo Paolozzi, *Fountain*, 1951.

Lynn Chadwick, *Cypress*, 1951.

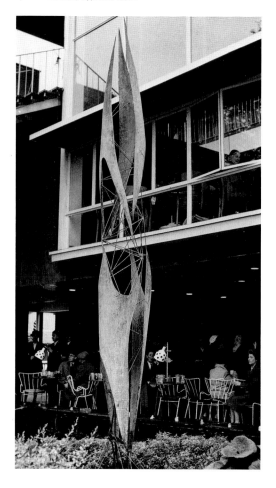

Pilot of the Future whose gung-ho exploits in the cosmos filled the front page of the new comic *Eagle*. The ingenious mounting devised for *Skylon* provoked the wry comment that 'like Britain it has no visible means of support',[29] but the Festival's visitors took it to their hearts. This phallic symbol for the technological age was a cross between Brancusi's *Bird in Space* and an elongated zeppelin turned on its head. Offering spectacular competition for Big Ben further down the river, and infinitely more spirited than its nearest present-day equivalent, the Post Office Tower, *Skylon* was one of those rare monuments which help to supply a city with its popular identity. Incandescent with light during the night, it appeared to hang weightless over the ground – as if trying to decide whether to shoot off towards the stars while refusing to be at all perturbed by its hesitation.

Structures like *Skylon* might not have been so invigorating in their design if the Festival architects had thought about permanence. Precisely because their buildings were temporary affairs, *jeux d'esprit* conceived for

a special occasion, they could afford to take risks and allow themselves the ebullience needed to produce Wells Coates's Telekinema or Ralph Tubbs's Dome of Discovery, which Misha Black recalled 'lying on the ground as though it had newly arrived from Mars'.[30] Even so, the subsequent destruction of every building on the site except the Royal Festival Hall was deplorable. An acute *rigor mortis* afterwards descended on the entire area, and the bunker-like structures erected there during the 1960s were characterized by an arrogant refusal to learn any lessons from the Festival's *élan*. Commissioned works of art were for a long time rigorously excluded from the chilling cultural complex, with its desolate and disorientating walkways. It is ironic indeed that a locality containing so many buildings dedicated to the nation's artistic vitality should have become such a no-man's-land. The whole site, marooned in unalleviated expanses of decaying concrete, implies that works of art have no role to play in public spaces today.

The South Bank site offers possibly the most lamentable example of the opportunities missed during the post-war reconstruction of Britain. An immense amount of building was undertaken throughout the nation, replacing bomb damage and at the same time sweeping away acres of Victorian architecture in the mistaken belief that only wholesale demolition would generate urban renewal. There were, however, isolated moments when individual patrons invited artists they admired to produce distinguished work for public locations. John Newsom, who had already achieved a signal *coup* by securing Moore's *Family Group* for Barclay School in Stevenage (p. 49), took the courageous step in 1952 of financing a younger, far more controversial artist to make a work for Hatfield Technical College. His decision to support Reg Butler may have been influenced by the knowledge that the sculptor was brought up in Hertfordshire and lived in Hatfield during the late 1940s. Far more important, though, was Newsom's awareness of Butler's rapidly rising reputation. His tensile *Birdcage*, poised acrobatically on its tripod base, had been given a prominent Thames-side position in the Festival of Britain, and Butler was among the most admired participants in the British Pavilion

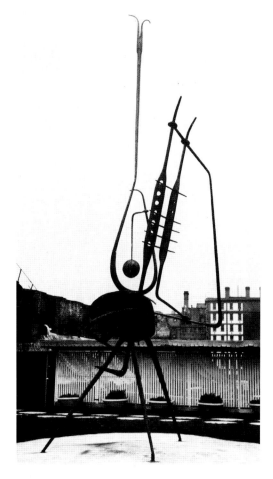

Reg Butler, *Birdcage*, 1951.

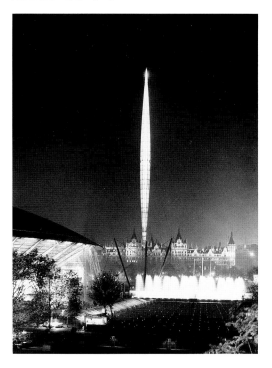

Powell and Moya, *Skylon*, 1951.

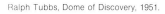

Ralph Tubbs, Dome of Discovery, 1951.

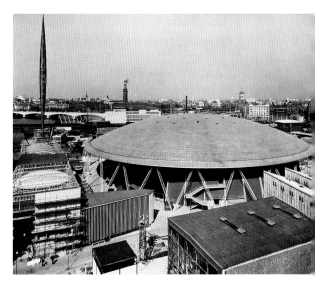

exhibition at the 1952 Venice Biennale, which furnished a new generation of sculptors with a precocious international reputation. When the architect of Hatfield Technical College, Howard Robertson, commissioned *The Oracle* for the entrance hall, Newsom therefore gave the idea his whole-hearted backing.

Although Hepworth carved two reliefs for the building's exterior, including a delicate work called *Vertical Forms*, Butler's contribution is the more impressive. His familiarity with the area made him acutely conscious of the part played by the college as a research and testing station for the local de Havilland aircraft factory. Aiming at a sculpture 'which would live in the heart of the building and symbolize the liaison between the building and its work',[31] he invested the low-lying shell bronze with an enigmatic combination of the animal and the mechanistic. While it is redolent of prehistoric life, with half-formed limbs and straggling feelers, *The Oracle* also suggests the technological world which Britain was then striving to enter. Lawrence Alloway, who thought it was 'the most brilliant of the commissioned sculptures in Hertfordshire', regarded *The Oracle* as 'an ambiguous and violent image, compounded of parts of a jet aircraft (suitable for a Training College) and organic forms which evoke a pterodactyl'.[32] Whether or not it was influenced by the dominant form in Sutherland's *The Origins of the Land*, this complex presence certainly reflected the biomorphic shapes of the latest jet aircraft. The alertness of its attenuated neck might even have been affected by Butler's habit of 'staring up into the sky'[33] to observe de Havilland Delta-wing jets undergoing test flights over Hatfield. This sense of vigilance lends the sculpture much of its sphinx-like quality, and it inhabited its original location with authority.[34]

Although *The Oracle* was vandalized the following March, little more than a week after Butler's winning entry for *The Unknown Political Prisoner* competition had been broken by a Hungarian refugee at the Tate Gallery, Hertfordshire County Council's commitment won widespread acclaim. Between 1949 and 1953 it allocated one-third per cent of each new school's cost to works of art – an initiative which compared very favourably with the sporadic, even haphazard commissioning of architectural sculpture in

the rest of the country. Outstanding achievements anywhere were few, but in 1952 Epstein completed a monumental bronze *Madonna and Child* for the north side of Cavendish Square in London. The architect, Louis Osman, had designed a bridge linking and supporting two blocks inhabited by the Convent of the Holy Child Jesus. The immense expanse of bare bridge wall seemed an ideal setting for sculpture, and Osman was prepared to commission an image with a powerful identity of its own. 'One cannot just apply a great work of art to a building and expect a happy marriage', he declared later. 'If the sculpture is important it must be given its head, like the role of a soloist in a concerto; the orchestra being like the architecture, with the solo instrument speaking its poetry; related but clear and independent.'[35]

His faith in Epstein's ability to fulfil such an exacting brief was borne out by the sculpture itself. With arms outstretched in a deliberately ambiguous pose, expressive both of a universal embrace and martyrdom on the cross, the child possesses a *gravitas* far beyond his years. But he is a frail figure, still dependent on his mother for essential

Geoffrey Clarke, Sculpture, Time and Life Building, Bond Street, London.

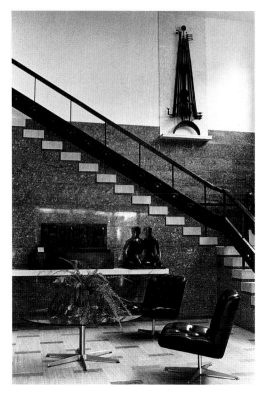

support as they appear to float free from the surface of the stone. Even though the bridge was a historicist exercise, intended to harmonize quietly with the Palladian buildings on either side, Epstein's eloquent bronze asserted the continuing viability of figurative sculpture in an unmistakably contemporary idiom.

By a fascinating coincidence, its unveiling occurred in the same year as the completion of Moore's far more abstract sequence of carvings for Time-Life's new London headquarters in Bond Street. They were supposed to form a stone screen protecting the balcony of the building within, but Moore once again resisted the constraints of relief. He wanted each of the four carvings to be almost as fully realized as the bronze reclining woman already made for the small garden terrace on the third floor. In order to reveal their full character, Moore toyed with the idea of rotating them regularly on a turntable. Cost and safety factors prevented the implementation of this ingenious scheme, and the carvings look confined within their allotted spaces. All the same, their formal severity accords well with the surrounding architecture by Michael Rosenauer, the man responsible for commissioning Moore's work as well as a mural-sized tempera painting by Ben Nicholson inside the same building. Having grown up and designed his first buildings in Austria, Rosenauer regarded architecture as an opportunity to create a *gesamtkunstwerk*.[36] His enlightened collaboration with Moore and Nicholson

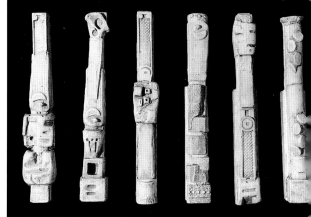

amply demonstrated the sincerity of his commitment to such an ideal.

The seriousness with which Moore approached his screen commission is attested by a letter he sent to Rosenauer in March 1952, when his four maquettes were completed. 'I had your perspective sketch by the side of me as I did each of them', he wrote, 'and my aim was to give a rhythm to the spacing and sizes of the sculptural motives which should be in harmony with your architecture so that the sculpture could really have some proper relationship to the building.'[37] The two men enjoyed working together, and in 1954 Rosenauer asked Moore to start planning eight colossal stone carvings for the proposed Marconi House extension of the English Electric Company headquarters in the Strand. Unlike the Time-Life screen, positioned so discreetly that pedestrians pass by without noticing it in the street below, the six upright forms in front of this facade were prominent and massive enough to command attention at once. Moore's maquettes, resembling totems or candles and incorporating 'found' objects like screws and files, fused the primordial with the mechanistic. Flanked by two bulky rectangular forms crowning the corner buttresses of the building, they would have furnished Rosenauer's chaste design with a potent sculptural presence. The idea of positioning these free-standing monoliths on tall piers rising through two storeys between each window bay was, however, too startling for the assessors of the competing designs.

They turned down the proposal, thereby depriving London of a radical attempt to bring modern architecture and sculpture into an audacious alliance on the grandest scale imaginable.

Moore proceeded to develop his maquettes in the form of independent bronzes, producing in the *Upright Motives* and the *Glenkiln Cross* some of his most memorable post-war images. But he would never again collaborate with an architect on a building in Britain – unlike his former mentor Epstein, who brought a major architectural project to a successful conclusion three years later. The commission this time came from the members of the Trades Union Congress. They wanted a memorial to commemorate the trades unionists who lost their lives in both world wars. The recently installed bronze group by Bernard Meadows outside the entrance of Congress House in Great Russell Street had turned out to be an awkward and strangely academic work, stylistically at odds with the language employed in Meadows's contemporaneous art. Epstein, though, armed with the TUC's promise that 'complete freedom is given in the conception'[38] of the memorial, suffered no such inhibitions when he tackled an immense carving for the internal courtyard. The space, designed by the building's architect David du R. Aberdeen, could hardly have been more imposing. It isolated the sculpture on a tall stone plinth against a pyramidal cliff of green marble,[39] and a lesser artist might well have felt daunted by its engulfing grandeur. But

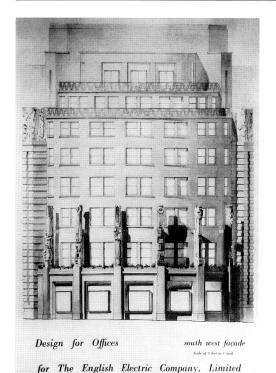

Design for Offices *south west façade*

Scale of 1 foot to 1 inch

for The English Electric Company, Limited

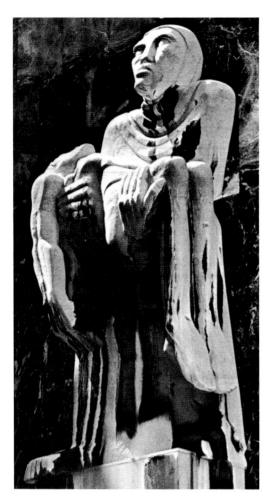

Jacob Epstein, *Trades Union Congress Memorial*, 1956/7, Congress House, Great Russell Street, London.

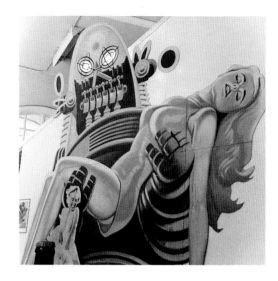

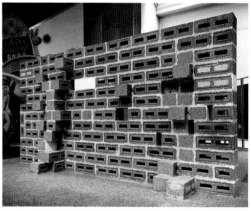

Richard Hamilton, John McHale and John Voelcker, *Group Two* installation (*top*) and Adrian Heath and John Weeks, *Group Eleven* installation, at 'This Is Tomorrow', 1956.

Epstein, now nearing the end of his long life, responded with seasoned assurance. Eschewing the rhetoric of military heroism, he concentrated instead on the human suffering engendered by war. Like his earlier *Madonna and Child* in Cavendish Square, a mother and son are presented here. Now, however, the woman looks upwards with a stare of horror and fierce accusation. Stricken by the death of the youth, she nevertheless retains enough strength to hold him in her arms and protest against his loss. The wistful gentility of so many war memorials is here replaced by anger, and Epstein's respect throughout his carving for the austere form of his Roman Stone block gives the carving a controlled, almost glacial intensity.

Most of the other architectural commissions of the period were far less successful – the victims, ultimately, of the withering of a tradition. Since artists and architects alike had lost the habit of collaboration, the intermittent attempts to revive the idea in the post-war world were bound to be uneven in their outcome. A growing number of practitioners recognized that the issues needed to be aired and debated in a more sustained manner, and the outcome of their resolve was an ambitious exhibition at the Whitechapel Art Gallery. The initial suggestion for a show demonstrating the collaboration of painters, sculptors and architects came from Paule Vézelay, the London representative of the Groupe Espace.[40] Hoping to find a kindred spirit, she contacted Sir Leslie Martin in the belief that his earlier co-editorship of *Circle* would ensure a positive response. Martin passed the proposal on to Colin St John Wilson, then working under him in the London County Council housing division, and the exhibition thereby fell into the hands of a younger generation. Although broadly divided in loyalties between the Constructivist tradition and the Independent Group, this heterogeneous assembly agreed that 'the space in the Whitechapel would be split up like market-stalls in a fair and autonomous groups should each do their own thing'.[41]

The plan worked well, revealing a variety of ways in which the putative collaboration could be achieved. At one extreme, James Stirling worked with the sculptor Michael Pine and Richard Matthews on a sculptural structure derived from a photographic study of soap bubbles. In this instance, sculptor and architect arrived at a total fusion of their respective activities, reflecting Stirling's belligerent willingness to pose an impatient question in his catalogue statement: 'Why clutter up your building with "pieces" of sculpture when the architect can make his medium so exciting that the need for sculpture will be done away with and its very presence nullified?' Pine, who later became an architect himself, presumably saw nothing wrong with Stirling's iconoclasm. But other artists in the exhibition must have balked at his prediction that 'if the fine arts cannot recover the vitality of the research artists of the '20s . . . then the artist must become a consultant, just as the engineer or quantity surveyor is to the architect'.[42]

Such a view did not square with the contribution made by Kenneth Martin, who hung a phosphor bronze screw mobile within an open framework of screens devised by himself, Mary Martin and the architect John Weeks. Nor would Stirling's views have recommended themselves to Robert Adams, who provided a distinctly sculptural, free-standing form for the Corbusian walk-through environment produced by Peter Carter, Frank Newby and Colin St John Wilson. Adams's concave aluminium sheets seemed to affirm the artist's right to retain a singular identity within the collaborative process. His stance was echoed by William Turnbull, who installed a typically totemic *Sungazer* sculpture in the section devised by Theo Crosby, Germano Facetti and Edward Wright. Victor Pasmore adopted a similar approach, installing an abstract relief in a square pavilion designed by Ernö Goldfinger.

Elsewhere, though, the Whitechapel survey was notable for its participants' willingness to experiment with new ways of arriving at interdisciplinary union. Painter and architect

merged in the projecting and receding blocks of a concrete wall made by Adrian Heath and John Weeks. As for the most notorious contribution to the show, Richard Hamilton merged himself very successfully with John McHale and John Voelcker to produce a structure riddled with provocative references to Duchamp, the Bauhaus and popular art as shameless as the sixteen-foot-high model of Robbie the Robot. Because this section dominated the publicity for the show, and played a large part in helping to attract nearly a thousand visitors a day, 'This Is Tomorrow' came with hindsight to be seen above all as a harbinger of Pop Art. But the truth is that collaboration remained the principal theme, nowhere more unpredictably than in the Patio and Pavilion exhibit. Here the architects Alison and Peter Smithson provided a space and shelter which the artists Nigel Henderson and Eduardo Paolozzi filled with objects and imagery. Having built the structure, with its secondhand wood walls and translucent plastic roof, the Smithsons left for Denmark after inviting the two artists to complete the interior. 'For in this way', explained the Smithsons, 'the architects' work of providing a context for the individual to realize himself in, and the artists' work of giving signs and images to the stages of this realization, meet in a single act, full of these inconsistencies and apparent irrelevancies of every moment, but full of life.'[43]

With impressed clay tiles, bricks, stones and plaster sculptures placed around the edges of a sand-covered floor, and Henderson's monumental *Head of a Man* photo-collage looming in a corner of the pavilion, this remarkable exhibit appeared almost eerily timeless compared with the rest of the show. It certainly excited *The Times*'s art critic, who decided that in the Patio and Pavilion 'the human and aesthetic issues with which the exhibition is concerned are symbolized with extraordinary imagination and authority'. Moreover, the entire exhibition was welcomed by the same reviewer, who set it in the context of twentieth-century experiment. 'Collaboration of this kind has been one of the dearest ideals of the modern movement in art', he wrote, 'at least of that side of it that has believed the easel picture and the gallery sculpture to be extinct and has considered that in the future art must not be about an

environment but must create an environment. Any tendency towards a synthesis based on collaboration of this kind between the more vigorous and imaginative of our artists is, of course, of immediate importance to the general public; however highbrow it looks at the moment it is bound sooner or later to reflect upon . . . the world outside art. This makes the present exhibition particularly important.'[44]

However correct *The Times*'s critic may have been in emphasizing the wider social implications of this memorable show, it generated disappointingly few commissions for architectural developments in 'the world outside art'. Apart from John Weeks, who immediately went on to work with Mary Martin on a hospital project, none of the architects in 'This Is Tomorrow' displayed any impassioned interest in the collaborative idea. The buildings which Goldfinger, the Smithsons and Stirling went on to design are notable for their dearth of commissioned works of art.

Lack of funds may help to explain why more architects failed to develop the possibilities opened up by the Whitechapel exhibition. When faced with the need to cut back on construction costs, developers in both the private and public sectors often resorted to paring away even the most carefully planned proposals for artists' contributions.[45] Moreover, some architects retained uncompromising views. 'There could be little accommodation', commented St John Wilson, 'between on the one hand an architecture whose proudest claim was a fierce extension of its means to become the sole mediator between a "user" and a prescribed set of "uses": and on the other hand a mode of painting that sought to purify itself through a reduction of means.'[46] Wilson himself, an avid and discerning collector of contemporary painting, never aligned himself with such a standpoint. But plenty of architects during this period were in sympathy with the sentiments expressed by James Stirling, who went so far as to claim in the Whitechapel exhibition catalogue that 'the painting is as obsolete as the picture rail. Architecture, one of the practical arts, has, along with the popular arts deflated the position of painters, sculptors, – the fine arts. The ego maniac in the attic has at last starved himself to death.'[47]

There were, mercifully, a few architects

who managed to resist the scornful aggression of Stirling's argument. As soon as John Weeks was commissioned by the Northern Ireland Health Authority to design Musgrave Park Hospital in Belfast, he made sure that Mary Martin became an integral part of the venture (p. 115). 'Mary and her husband Kenneth and I (together with Victor Pasmore and Adrian Heath) had been speculating about the possibility of a totally integrated art work and architecture for some years', he remembered, 'and this was the first opportunity of trying it.'[48] His enthusiasm was matched by Martin's, even though the cost of the work had to be wholly contained within the financial limits of the building contract. Weeks, who made the working drawings, enabled Martin to employ in her wall-screen the same bricks as those used in the construction of the building. The modular dimensions of Martin's work were likewise identical with those employed for setting out the hospital's structure. Moreover, Martin supervised the assembling of her steel and plaster relief on site, sitting through the winter in 1956 'in a little canvas shelter in the otherwise open building shell!'[49]

The maquette she produced for the screen demonstrates that the wall, constructed as she put it 'brick on brick without artificial support other than occasional horizontal wire mesh',[50] was intended from the outset to be an important part of the work. Although the two-sided final piece looks predominantly rectilinear inside the hospital's main entrance, she was inspired by the idea of a waterfall. 'Both architects and I felt that the wall must have a hole or holes in it to allow space to flow freely through it', she wrote, adding that 'it is also free-standing for the same reason.' Much of the work's tension derives from the contrast between the plaster areas, painted with white emulsion, and their stainless steel neighbours. According to the artist, the steel was 'polished with a satin finish so that it would not give a mirror reflection but would give the feel of water gliding over a surface, or, in the case of the strong verticals, suspended in a jet. The grain of the polish is vertical throughout but it gives off horizontal lights in the same way as water pouring down a vertical surface.'[51]

Weeks was not alone in his determination to give an artist a central, image-making part in an interior space. Only a year after 'This Is Tomorrow', the architect Michael Greenwood

displayed considerable boldness in commissioning the twenty-seven-year-old Gillian Ayres to paint a multi-part mural for an extensive, narrow space adjoining the dining-room at South Hampstead School for Girls. Although the panels were eighty feet long, she tackled the challenge with characteristic gusto. Recent experience gained from experimenting with pooled areas of paint on floor-based canvases gave her the confidence to carry out the dining-room project,[52] but she had never worked on the grand scale before. In the event, the sheer ebullience of her mark-making and sensuous colours gave the mural a boisterous conviction. Ayres, who had long been fired by a desire to go beyond the limits of easel painting, was instinctively suited to covering epic surfaces with aplomb. Although in places the mural is marred by excessive rashness, and has suffered considerable damage from the school's later attempt to cover it with wallpaper, it still conveys the irrepressible buoyancy of an artist who knew precisely how to measure herself against the liberating example of contemporary American painting.

Patrick Heron, *Horizontal Stripe Painting: November 1957 – January 1958*, at the offices of Lund Humphries, Bedford Square, London.

So did Patrick Heron, who in the same year was invited by F.C. Gregory to produce the largest of his stripe paintings for the reception room at Lund Humphries, the printers and publishers. Their premises at 18 Bedford Square were being converted by the architect Trevor Dannatt, and Heron responded by executing one of his most exuberant canvases. A photograph of the original installation discloses that the picture stretched from skirting-board to ceiling in a confined space uncomfortably close to a door. But nothing could curb the crimson and scarlet effervescence of Heron's blithely applied stripes, some of which are allowed to splash and dribble across their neighbours as they convey the energy and decisiveness of a lyrical painter at the height of his youthful vigour.

Both these paintings amounted to a remarkable act of faith in abstract painting's capacity to transform the modern interior. Around the same time, though, the continuing power of figurative art was reaffirmed when Stanley Spencer received an invitation to paint a monumental altarpiece for Aldenham School in Hertfordshire. Ever since the completion of his great painted chapel at Burghclere in 1932, he had yearned for another architectural space to line with images. Gloriously impractical plans to fill an entire 'church house' with paintings came to nothing, and so Spencer needed no prompting when asked to produce two canvases for the new chapel extension at Aldenham. The commission came from his friend and patron Jack Martineau, the Master of the Brewers' Company who funded the school. He must have realized the fervency of Spencer's longing to transform an ecclesiastical interior once again, and Martineau's wife recalled 'how thrilled Stan was, near the end of his life, to get this commission'.[53]

The smaller of the two paintings, *In Church*, was intended to be placed beneath *The Crucifixion* as a predella. But it was eventually positioned elsewhere in the chapel, presumably because Spencer had given this scroll-like scene a joy and intimacy wholly at odds with the harrowing tragedy enacted in the larger canvas. Based on a memory from childhood, *In Church* shows choristers moving through the candlelit and lily-bedecked nave at Cookham. Mothers savour the sight of their sons in

glowing surplices, and everyone attending the service appears to be caught up in the wonder of the event. Spencer may well have planned it as a deliberate foil to *The Crucifixion*, for the contrast between the two pictures could hardly be more intense. While the predella celebrates familial love within the womb-like warmth of a sacred building, the main picture exposes Christ to the disconcerting glare of a blustery day in Cookham High Street.

No comfort can be derived this time from Spencer's decision to locate the crucifixion in his cherished village. For he chose to depict a moment of drastic upheaval, when the whole street was dug up in order to lay the main drainage system in the mid-1950s. The mound of earth and stones where Mary Magdalen sprawls in shock becomes an uncompromisingly barren Calvary, and Christ is relegated to a humiliatingly low position compared with the two thieves. He is, moreover, viewed from behind, so that attention can be concentrated on the gleeful ferocity of the figures ranged against him. One of the thieves, his thick tendrils of hair streaming in the wind like the lashes of a cat-o'-nine-tails, pushes himself forward to scream at Christ through viciously brandished teeth.

In the end, however, his venom is less pernicious than the attitude displayed by the two carpenters, hammering their nails with such leering relish into the defenceless palms. The rows of other nails jutting down from their lips are based on Spencer's recollections of the village dressmaker, who held pins in her mouth while fitting his mother's hem in the family home. But this affectionate memory is used here to intensify an act of sickening sadism, and the mask-like faces gazing up at the cruelty from a nearby dormer window betray no hint of compassion. It is the most distressing image ever produced by an artist normally associated with redemptive paintings which shunned violence of any kind. The only solace here resides in Christ's blanched stoicism, as he keeps his eyes steadily on heaven rather than the callous antics of his tormentors. Their brutality dominates the scene, and Spencer made the painting even more corrosive by dressing the two carpenters in crimson brewers' caps – because, as he explained to the boys at Aldenham School, 'it is your Governors, and

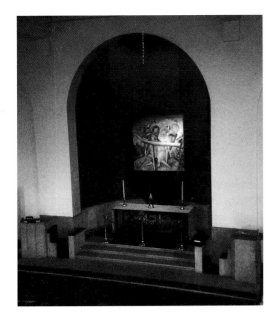

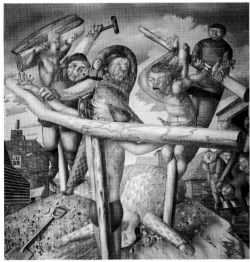

Top: Stanley Spencer, The Crucifixion, Aldenham School Chapel, Hertfordshire, with *In Church* positioned beneath the altar. *Above: The Crucifixion*, and (*below, right*) *In Church*, 1958.

you, who are still nailing Christ to the Cross'.[54] Suspended above the altar in a dramatically lit arched niche, this lowering image ensured that every member of the congregation was affected by its accusatory force.

Alongside these private acts of patronage, the London County Council now initiated a consistent commitment to art in its publicly funded architectural developments. Starting in 1956, the year of 'This Is Tomorrow', the LCC devoted the substantial sum of £20,000 a year to sculpture for its new schools and housing estates. As a result, works as various as Turnbull's rough-textured *Sungazer* (p. 35), Merlyn Evans's abstract *Screen* (pp. 46–7) and Elisabeth Frink's *Blind Beggar and Dog* (p. 53) found permanent homes, while one of Moore's most commanding classical figures from the 1950s, the great *Draped Seated Woman*, was positioned in the Stifford Estate, Hackney (p. 65). Ensconced on a low seat which obliges her to spread her legs sideways, as if in honour of Moore's favourite recumbent pose, this magisterial presence lends an air of both solemnity and bountiful Mediterranean fulfilment to an area of London otherwise associated with deprivation and post-war blight.

Not to be outdone, Harlow New Town now became a showpiece for contemporary sculpture. The idea of establishing a trust to obtain sculpture for the town came from Maurice Ash, a local businessman who later became head of the Town and Country Planning Association. But Sir Philip Hendy, the Director of the National Gallery, gave the fledgling trust unusual credibility by agreeing to serve as its Chairman. His long-standing friendship with Moore, who lived only a few miles away at Perry Green, ensured that Harlow soon acquired a *Family Group* carving for a landscaped setting in Mark Hall

North – a site later changed to a less exposed position in the Civic Square (p. 62).

Moore pointed out that Sir Frederick Gibberd, who prepared the original plan for the new town and then became responsible to the Development Corporation for its design, 'has been particularly concerned with the placing of the sculpture in the town's scenes'.[55] So indeed he was, serving as a member of the trust and attempting to ensure that all the acquisitions were installed 'at places where people meet'. Gibberd insisted that 'the purpose of the sculpture is not to decorate the town – it is not a sort of costume jewelry – but it is there to be enjoyed for its own sake as visual art and to add interest and visual diversity to the urban spaces in which it is set'. The subservience of art to architecture was thereby avoided, by a policy which emphasized the importance of allowing sculpture an independent existence in the round.

The weakness of such an approach lies, however, in its failure to develop a more integral accord between the art-works and the townscape they are intended to enliven. From the beginning, when Harlow obtained its first sculpture by securing Hepworth's *Contrapuntal Forms* from the dismantled Festival of Britain, the trust acquired pre-existing work rather than commissioning new pieces for particular sites. While the emphasis on young artists was praiseworthy, most of the sculptures possess only a very generalized relationship with their surroundings. Architecture and art at Harlow are kept at a safe and, in the end, rather numbing distance from one another. Gibberd admitted that Hendy's method was to purchase 'a number of interesting small works and if no site suggested itself, they were put into storage awaiting further development of the town'. A policy such as this is hardly calculated

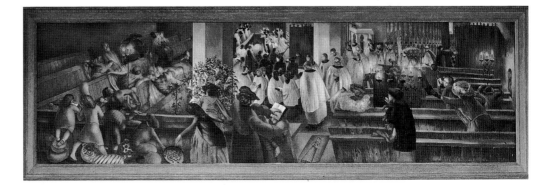

to foster unity between sculpture and its environment.

One of the few works produced for a specific space was Ralph Brown's robust *Meat Porters*, a subject suggested by the artist himself after visiting the town and discovering the vigorous role played by these men in the market area (p. 63). Clear of the stalls and opposite Broad Walk, the site was important. Gibberd recognized that a sculpture here, 'apart from being a focus of views in two kinds of civic space, a square and a street...could act as a pivot between them'.[56] *Meat Porters* fulfils this aim with energy, and a sense of conviction which must partially arise from Brown's ability to envisage the sculpture's precise function and destination as it developed. In the main, though, Harlow New Town reinforced a disappointingly unadventurous view of the potential alliance between art and architecture.

Its timidity becomes clearer still when set beside the extraordinary challenge presented to Victor Pasmore four years after he had produced his *Waterfall* mural for the Festival of Britain. In 1955, when Pasmore was Master of Painting at the Fine Art Department of Durham University, he was approached by A.V. Williams, the General Manager of Peterlee New Town. Berthold Lubetkin had recently resigned from the Peterlee brief after his plans were thwarted, but Williams remained determined to produce an architecture of distinction from the shambles left behind after Lubetkin's fiery departure. Having admired 'a big abstract collage'[57] of Pasmore's in an Arts Council exhibition, he came to the daring conclusion that here was an artist who could play a central part in shaping the architecture of a new town.

Pasmore's initial reaction was cautious: 'About a quarter of the town had already been built. Although round Durham it looks flat there are a lot of great gorges full of trees. And I saw this whacking great council estate swarming all over the countryside like measles, with no stop to it. They were all exactly the same council house type s.d.'s. I thought to myself, this is a challenge I can't refuse if I'm supposed to be an artist. But I made three conditions. I wanted to start from scratch in designing a completely new section of the town. I wanted a team of architects, of which I was the chairman, to work under me. And finally, I said I should

not be under the chief architect but under Williams himself as general manager. He said, O.K. He got out a plan of the south-west area and he said, "I was just about to send this to the ministry." He tore it up in front of me and said, "You can start again there." '[58]

Having so dramatically been given full executive powers to work on the south-west region of the town, Pasmore spent the next six months going over the site with the architects responsible for the area and making models. 'This really suited me as an ex-landscape painter', he explained: 'I was planning a whole new environment, the architecture of a whole area.' Although the Ministry and the RIBA were horrified by his appointment and tried to get rid of him, Williams remained firm and gave Pasmore his head. As the layout cartoon for the area reveals, the houses are arranged in clusters reminiscent of a De Stijl painting.[59] Their geometric rigidity is contrasted with the undulating lines formed by the roads, so that extremes of stasis and kinesis are played off against each other throughout the site. 'I designed the outside of the houses with flat roofs and a slightly modernistic front', Pasmore explained. 'But this was just superficial. The facades were really just to make the thing look modern; but the actual arrangement of the housing is completely new. I got rid of the idea of houses lining the roads; there's always a completely different view as you walk or drive through. The real advance of the Peterlee South-West area was the environmental layout, not the housing architecture which was just a facade.'[60]

The experience of working on the team's first plans, formally accepted in 1957, transformed Pasmore's own art as well. He abandoned his interest in the relief and returned to painting, stimulated by the realization that 'Peterlee gave me a sense of multi-dimensional space, mobile, modern space, not the confined space of the Renaissance.'[61] But his most ambitious architectural experiment at Peterlee was only carried out at the end of the following decade, after he had submitted a design to an international competition for a new museum of art and science in a Chicago district redeveloped by Mies van der Rohe. Although the submission was turned down, Pasmore resurrected it in the form of a pavilion for Peterlee. 'Williams wanted the landscaping to be taken as seriously as the

architecture', Pasmore remembered. 'He had a lake constructed in a valley with housing all around. I thought to myself, "This is just the place to put a pavilion." So I said to Williams, "Once the houses are around the lake, it is going to lose all its focal and social significance. Why don't you crown it with something like a great sculpture?" After a lot of arguments, he agreed....I wanted a reinforced concrete structure cantilevered out as far as possible over the lake....We produced a heavyweight piece of pure architecture: there were no windows and it was open to the sky in parts. We had to get the Ministry to agree, so we made it into a bridge over the lake...but it didn't really have any utilitarian function.'[62]

Since the pavilion lacked any easily discernible purpose, it inevitably became a butt of local criticism. Journalists in the area tried to condemn it as an unnecessary and expensive folly, and after Williams retired his successor declared at one point that he wanted it blown up. Physical decay and graffiti impaired its once-pristine forms and the painted image which Pasmore intended as 'an important feature'[63] on one side of the structure (pp. 56,57). All the same, it stands today as a fascinating example of how contemporary artists can translate their concerns into wholly architectural terms, and how even the restricted budget of a new town is able, given the necessary degree of commitment, to yield funding for a purely imaginative feat. Pasmore, who regards the pavilion as 'my "pièce de résistance"' among the work he has produced for architectural contexts, summed up the aspiration behind it by describing the structure as 'a sort of temple to raise the quality of a housing estate to the level of the Gods!'[64]

The advent of the 1960s did not bring any other opportunities for artists to emulate Pasmore in his attempt to produce 'a huge piece of sculpture on an architectural scale'.[65] It did, however, enable Barbara Hepworth to complete the first of two large works for new London buildings. The architect of State House in High Holborn envisaged from the outset that a sculptor could play a prominent part outside his building. Hepworth was invited to visit the site during the early stages of construction, and then produce a five-foot maquette of the bronze *Meridian* which would eventually be

three times the size. The model's surface, smoothed out in the final version, is allied to a form redolent both of growth and enclosure (p. 155). Hepworth was always fascinated by the theme of womb-like containment, and the close cooperation she enjoyed in the State House commission enabled her to invest it with something of the erect, enigmatic presence she admired in the prehistoric standing stones of Cornwall and her native Yorkshire.

When *Meridian* was unveiled in 1960, Hepworth may have allowed herself to hope that the new decade would bring further commissions for work in public spaces. So it did; but her second invitation, from the John Lewis Partnership, turned out to be for the east wall of an Oxford Street store which was already completed. Collaboration with the architect had been effectively pre-empted, and she was also obliged to resist the strained proposal that her sculpture should 'express the idea of the firm's partnership'.[66] Although John Lewis then agreed to drop this potentially disastrous idea, her first maquette, a brass *Three Forms in Echelon*, was rejected. Eventually they settled for an enlargement in aluminium of a *Winged Figure* made in 1957, long before the Oxford Street project was even mooted (p. 155). Small wonder that its relationship with the building looks tenuous, and that the rest of the bleak side wall appears oblivious of this patently appended image.

A more vigorous approach to the problem of animating the blank surfaces of brutalist office-blocks had been adopted two years earlier. The headquarters of Thorn Electrical Industries in Upper St Martin's Lane desperately needed sculptural alleviation, and in 1961 Geoffrey Clarke's *Spirit of Electricity* was installed on a windowless wall of uncompromising starkness. Although the title of the sculpture sounded absurd, Clarke made sense of the venture by basing his work on light-bulb filaments. Hence the curious blend of aggression and delicacy in his bronze, resembling a shield pierced by a spear which dangles its spiky, eighty-foot length from a support high on the east wall of Thorn House.[67] Clarke, who had been one of the new generation highlighted by the 1952 British Pavilion in Venice, never surpassed the tensile force displayed in this strange fusion of scientific prowess and primordial even martial vigilance.

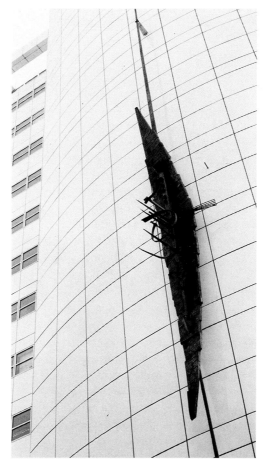

Geoffrey Clarke, *Spirit of Electricity*, 1961, Thorn House (now Orion House), Upper St Martin's Lane, London.

Andrew Renton, the architect responsible, was at that time a partner in Basil Spence's firm, and in 1962 their most celebrated building was consecrated on the site of Coventry's old gothic cathedral. Blitzed during the war, its ruins had become a national symbol of suffering and regeneration alike. Spence won the competition to design a new cathedral in 1951, and he echoed the optimism emanating from the contemporaneous Festival of Britain by deciding to fill his building with images from some of the country's most prominent artists. In this respect, the resurgent cathedral at Coventry became the place where many of the hopes raised by the Festival reached permanent fulfilment. But Spence, whose choice of painters and sculptors also seems to have been influenced by the range of artists who received Festival commissions, was unable to realize all his plans. When he approached Moore with the idea of carving

eight large reliefs in the cathedral's nave, each one installed within a well-lit recess called a 'hallowing place', the sculptor advised him to abandon the scheme.[68] Moore's resistance to architectural reliefs had not abated since the 1930s, and so Spence commissioned incised biblical texts from Ralph Beyer instead.

The architect enjoyed a warmer reception from Epstein, who was invited to produce an independent sculpture for the red sandstone facade. Reservations voiced in the Reconstruction Committee about Epstein's Jewishness were counterbalanced by the enthusiasm of Bishop Gorton, who was taken to view the Cavendish Square *Madonna and Child*. Looking up at the suspended figures, their fully modelled heads so well allied to bodies whose flatness chimes with the wall behind, the Bishop declared: 'Epstein is the man for us.'[69] Compared with the delicate preliminary maquette for the Coventry sculpture, where an attenuated saint presides over a haggard and crestfallen devil, the final bronze is marred by muscular rigidity (p. 124). St Michael's face, however, modelled from Epstein's son-in-law Wynne Godley, is one of his most complex characterizations – at once triumphant and burdened with a melancholy awareness of war's destructive power.

This ambiguity of emotion suits the Coventry site, where the tragedy of the gutted cathedral is movingly juxtaposed with the affirmation of its successor. Inside, a jubilant mood is announced by John Hutton's engraved glass screen, and confirmed when visitors encounter the sunburst in the centre of John Piper's immense and unashamedly blazing Baptistery window. The preponderance of stone mullions in this curved expanse of glass prompted him to make an abstract design celebrating the light of the Holy Spirit shining through the complexity of the world. The decision freed Piper and his collaborator Patrick Reyntiens from the danger of resorting to the kind of enfeebled figurative idiom so often deployed in modern church art. On a bright day the window's colours resound like a fanfare above the promise of renewal symbolized by the font below, a rough sandstone boulder specially transported from the Valley of Barakat near Bethlehem.

If the Baptistery glass is a *tour de force*, the principal image inside the cathedral

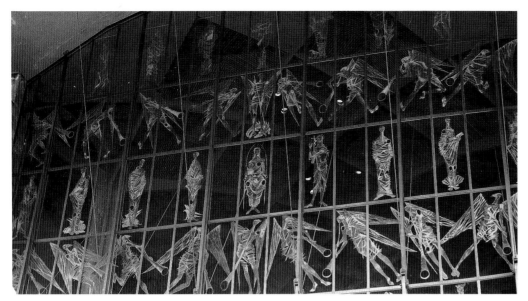

John Hutton, The 'West' Wall – The Great Glass Screen, c. 1961, Coventry Cathedral.

Graham Sutherland, the first cartoon for the Coventry tapestry, 1953.

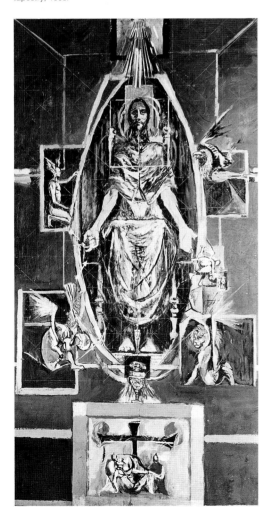

a face instinct with both severity and compassion.

The extraordinary amount of space which Spence was prepared to give his chosen artists ensures that, whatever its defects, Coventry Cathedral amounted to an unequivocal affirmation of the alliance between art and architecture. Sutherland's towering tapestry is allowed to dominate the interior with a force which makes the building subordinate to its hovering presence, and Spence must have realized that his nave would be regarded above all as a receptacle for a painter's vision. With hindsight, the cathedral's interior and its contents can be seen as the climax of the enthusiasm for public art generated by the Festival of Britain. But Spence, who was here enough of a traditionalist to have taken his architectural inspiration primarily from the great gothic cathedral at Albi, was by this time out of step with the most influential forces in his profession.

One of the few architects in Britain who shared his eagerness to become involved with artists was Eugene Rosenberg, whose firm had been responsible for the Stevenage school where Moore's *Family Group* was installed in 1950. A man with a limitless enthusiasm for collecting works of art by his contemporaries, Rosenberg seized every chance he could to incorporate painting and sculpture within his architectural commissions. When Yorke Rosenberg Mardall was engaged on the Altnagelvin Hospital in Derry, he lost little time in obtaining the services of his close friend F.E. McWilliam. A sculptor with an unusually strong interest in architecture, McWilliam had already collaborated on the design of his own house in New Malden with the architect H.A. Townsend.[71] So he was delighted by the invitation to produce a tall bronze figure for a prominent position outside the main entrance of the hospital (p. 110). The subject was Princess Macha, a legendary Celtic character who is supposed to have founded the first hospital in Ireland. Renowned for her golden hair and tireless beneficence, she is seen by McWilliam as an erect, attenuated and decidedly hieratic woman. Holding a bird in one hand while opening the other in implicit recognition of human needs as well, she sits with commanding stillness on an antique stool. Without impairing her absolute composure, McWilliam succeeds in making

remains less convincing. The amount of elaborate preliminary studies Sutherland devoted to his vast altar tapestry demonstrates the seriousness with which he approached this awesome task. But they also reveal the anxiety it caused him, as he struggled to produce a design rooted in the Byzantine tradition and yet rethought for a late twentieth-century audience. The subject he was given, Christ in Glory in the Tetramorph, led him to surround the central figure with a mandorla and four panels containing the Emblems of the Evangelists. Sutherland could not, however, decide on Christ's pose. Successive studies show him experimenting with lowered, outstretched and even folded arms, while the figure's legs waver between sitting and standing. The tapestry itself, a commanding presence nearly seventy-five feet high, fails to resolve the problem (p. 125). Christ's raised arms seem curiously tentative and cramped, while the ballooning form of his draperies cannot disguise the anatomical diffidence afflicting the position of his legs. The attendant panels and crucifixion beneath are more assured and convincing, suggesting that Sutherland felt less daunted by the subservient sections of a work which became the largest tapestry anywhere in the world. Like Epstein's St Michael, the figure of Christ is at its most persuasive in the head. Sutherland disclosed that Christ's features 'really derived from a hundred different things – photographs of cyclists, close-ups of people, photographs of eyes, Egyptian art, Rembrandt and many others'.[70] He nevertheless managed to make this plethora of conflicting sources cohere in

her legs tense enough to convey an immense latent energy. Princess Macha's serenity is balanced by an alertness which would predispose her, at a moment's notice, to rise from the seat and become actively immersed in the healing process.

Not content with enlivening the hospital's exterior, Rosenberg then invited William Scott to paint a mural forty-five feet in width for the entrance hall (p. 117). But the brief for the project was completely at odds with the prevailing abstract character of Scott's current painting. Eric Jones, the Secretary of the Northern Ireland Hospitals Authority, was an erudite historian who had already provided detailed background notes for McWilliam's *Princess Macha*. Now he called for historical references in the mural 'to the City of Londonderry, including the traditional shirt factories, naval associations, the apprentice boys of course, and...more recent organizations including cadets, boy scouts, girl guides and others'.[72] If such a convoluted programme had been insisted on, Scott could not possibly have made sense of the commission. Rosenberg, however, was able to overcome Jones's pedagogic proclivities and give the painter a free hand. As an artist particularly alive to the texture of stone walls, and windows that dissolve the barrier between outside and inside, Scott felt at home in the space provided by the hospital. Looking back on his work of this period, he described how 'the pictures were now larger and a process of elimination again took place – hardly with my awareness. I had returned to a new phase of abstraction with the difference that I was now prepared to leave larger areas of undisturbed colour'.[73] The hospital commission must have hastened this development, convincing Scott that the 'larger areas' could be permitted to inhabit the mural without undue distraction. They certainly dominate the expanse of wall on which his specially prepared blockboard panels were placed, even if the forms vary considerably as our eyes traverse the full width of the painting. Linear elements are juxtaposed with immense fields of colour, while Scott indulges in a range of mark-making from scoring and scribbling to a pronounced use of impasto. He was content to let the decoration generate its own meanings, unaided by any representational clues. 'I no longer worry about whether a

painting is about something or not', he wrote later; 'I am only concerned with the expectation from a flat surface of an illusion.'[74]

Rosenberg's willingness to let Scott work on a scale far greater than anything he had attempted before was now almost without parallel among architects. During the 1960s the brutalist aesthetic gained dominance, affecting the design of everything from grand cultural monuments to the most routine housing estate. Although Denys Lasdun incorporated Keith New's blend of old and new stained glass in his Royal College of Physicians (p. 151),[75] he showed no appetite for commissioning art when the National Theatre presented him with major opportunities throughout its extensive terraces and plentiful interior spaces. Nor did the architects responsible for the Hayward Gallery nearby, despite the fact that it was intended as a showcase for painting and sculpture. Bareness became *de rigueur*, and by 1965 was so widespread that it prompted Herbert Read to arrive at a gloomy conclusion. 'It is impossible', he decided, 'to assimilate the essentially free art of sculpture to the strictly functional needs of modern architecture.' Even though Read went on to point out that 'such assimilation was possible in the past...because architect and sculptor were inspired by identical artistic ideals',[76] he held out no hope for the recovery of these shared concerns. The future appeared to belong to an ever more minimalist momentum, shorn of all embellishment and dedicated, in essence, to the Stirlingesque notion that architecture's inherent sculptural properties could best be revealed in utterly unadorned buildings.

Even the sculptors who shared Moore's preference, and placed their work at a remove from architecture, found themselves increasingly beleaguered. The Festival of Britain had established modern sculpture in the public mind as a source of excitement, and Richard Calvocoressi was broadly right to claim that 'in the fifteen years or so after the end of the Second World War this country experienced a renewal of interest in the possibilities of sculpture as an outdoor public art such as had not been seen since Victorian times'.[77] Now, however, popular sympathy began to turn violently against the works of art installed in some of the wholesale council-estate redevelopments

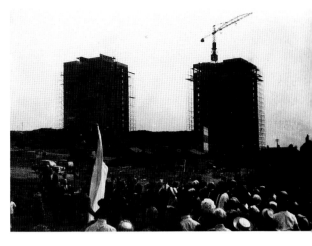

Jimmy Forsyth, 'The Willows' (unveiling ceremony, 1962).

which proliferated during the decade. Jimmy Forsyth, whose photographs of life in Newcastle's Scotswood Road provide a remarkable record of working-class society throughout this period, watched askance as his neighbourhood was demolished and replaced by impersonal tower blocks. In 1962, near a high-rise slab inappropriately named The Willows, he photographed the unveiling of 'a prize-winning bronze sculpture'. The ceremony was deemed important enough to be attended by T. Dan Smith and Hugh Gaitskell, who doubtless hailed the event as a sign of cultural resurgence in the North-East. But Forsyth wrily recalled that 'we nicknamed the statue "The Monstrosity". It wasn't there long, someone said it had been stolen and melted down for scrap.'[78]

As disillusionment with the anonymous and increasingly dehumanized character of urban redevelopment accelerated, so did hostility towards the kind of sculpture which tended to accompany it – abstract, often mechanistic and seemingly impervious to its surroundings. Part of the problem lay in the unfamiliarity of such work, suddenly invading cities where the term 'public art' had until then been associated with war memorials and dignified effigies of bewhiskered grandees brooding on their plinths in civic squares and thoroughfares. Jeremy Rees pointed out that 'the public at large has very little contact with recent developments (or documentation of developments) in sculpture. The reaction of the public, in part at least, is genuine bewilderment rather than just pure bloody-mindedness.'[79] But the trouble with

such arguments, usually reliant on a well-meaning yet rather naive faith in the power of education to open closed minds to modernism, was their refusal to concede that the art itself may sometimes have deserved adverse criticism. In reality, much of the large-scale abstract work deposited in civic spaces during the 1960s resembled what the architect James Wines once pithily described as 'the turd in the plaza'. Far from humanizing the city, and making sculpture a welcome part of everyday life, these presumptuous objects managed merely to aggravate the popular public mistrust of contemporary art. Although most people were prepared to acknowledge that the passing of the bronze statue had opened the way to more resourceful alternatives, not enough thought was given to the city's specific requirements. The outcome often looked as if it had been dumped down, by arrogant practitioners who considered that they needed to do little more than expand their studio-based work to jumbo dimensions. The particular needs of a given location were seldom considered closely enough, and the identity of the surrounding architecture was rarely taken into account. They had no viable connection with the buildings, and often ended up making an overbearing frontage even more oppressive.

The crisis came to a head near the end of the decade, when a flurry of exhibitions attempted to familiarize city-dwellers throughout Britain with contemporary sculpture. In 1968 London, Bristol, Nottingham and Coventry all sited works in prominent urban areas and publicized their presence as loudly as possible. On the whole, though, the sculpture was not commissioned for the purpose. Existing objects, made without any thought of the sites they now occupied, were expected to play a persuasive role in settings which dwarfed their modest dimensions. Even when an Arts Council exhibition called 'New Sculpture 1969' tried to ameliorate the problem by specially commissioning sculpture from five artists based at the Stockwell Depot in London, the works were toured to different locations throughout the country. Adrift in settings for which they could not have been devised, the grievously displaced exhibits symbolized the gulf now separating art from the architectural contexts it was supposed to inhabit.

Other, less confrontational ventures proved, however, that there were no grounds for despair. Stewart Mason, one of the selectors of sculptors for the Stuyvesant scheme, had already demonstrated that contemporary art of a consistently adventurous kind could find a permanent and cherished public home in schools throughout Leicestershire. Before the war he befriended the inspirational Henry Morris at Cambridge, and when Mason was appointed Leicestershire's Director of Education in 1947 he was determined to implement the kind of thinking behind Morris's creation of the village college. While both men agreed with Herbert Read's assertion, in *Education Through Art*, that 'the best pictures to decorate a school are the children's own pictures', they also shared Read's belief that 'children should, of course, be shown the work of mature artists, both of the past and of the present (and preferably not reproductions), but these again should be treated with respect, and shown in an appropriate setting. But it should always be remembered that the school is a workshop and not a museum, a centre of creative activity and not an academy of learning.'[80]

Accordingly, until his retirement in 1971, Mason built up a handsome collection of original art for distribution among Leicestershire's 476 schools and colleges. The purchasing budget was never large, so he made a virtue of necessity by offering welcome patronage to young artists who needed support at that stage of their careers. The bulk of the collection, which ranges from Moore to the emergent artists of today, was obtained with means so slender that even the most hard-pressed education committees could be inspired by its example. Many schools would only think of hanging an art work in the most formal and dignified area of the building, but in Leicestershire they set no such arbitrary limits on the positioning of their collection. Paintings and sculpture are displayed on gymnasium walls and library floors as well as grand arenas like the circular centre of Countesthorpe College, where one of Phillip King's most sprightly and lyrical works presides with delightful *brio* (p. 45). King himself considered that the position which *Dunstable Reel* occupies at the heart of the college can be counted among 'the most successful sitings of any of my works',[81] and the Principal of

Countesthorpe believed that it played an enormously satisfying part in the life of the institution. 'There you have, in hard-edged sheet metal, the symbolizing of the dance', he explained, 'and *that* seems to me to be what education is essentially about.'[82]

In one of the appendices to *Education Through Art*, Read reprinted a lecture he had once given on 'The Place of Art in a University'.[83] It was principally concerned with teaching art history, but the post-war boom in university building was accompanied by a certain amount of purchasing of painting and sculpture. Most of the acquisitions were restricted to the idea of placing a bronze by an accepted British sculptor in the grounds surrounding the campus, and few of these works were specially commissioned for the spaces they occupied. There were, however, outstanding exceptions like Mary Martin's severe yet glittering wall construction in anodized aluminium and wood, running along the sixty-foot width of a dining-room wall at the University of Stirling (pp. 84–5). Occasionally, too, painters of considerable stature were offered interior spaces to animate. Peter Lanyon produced a characteristically boisterous mural for the Arts Building at Birmingham University, and Ivon Hitchens's almost feverish *Day's Work* was installed in the University of Sussex (p. 81).

Such initiatives, which depended for their success on establishing mutual trust and sympathy between artist and patron, helped to keep the alliance alive at a time when its future seemed so uncertain. In 1975, soon after my appointment as editor of *Studio International*, I devoted an issue to the interaction between art and architecture. But my editorial complained that 'the hoped-for dialogue rarely evolves beyond a very superficial level: architects seldom regard the areas in their buildings earmarked for artists as anything more than decorative ghettos, and artists have nothing but scorn for the great mass of commercially motivated architectural developments'.[84] Whenever leading artists accepted public commissions, like the two flamboyant sculptures produced by Phillip King for the estate of Clark's factory at Street in Somerset, they were relieved to be able to position their work in landscaped settings clearly distanced from buildings in the vicinity. Bernard Meadows was indeed fortunate when he made one of

Phillip King, *Diamond*, 1975, Clark's Factory Estate, Street, Somerset.

his finest sculptures for the headquarters of Eastern Counties Newspapers in Norwich (pp. 160–1). For although his contribution entered into a close relationship with the building, the architect ensured that Meadows's work retained its own robust identity as well.

As the 1970s proceeded, more opportunities began to arise for the development of a sustained relationship between an artist and a new town. At Glenrothes, David Harding was able during the decade to produce a series of deliberately varied works for a community he grew to understand with exceptional intimacy (pp. 67, 70–3). Some were free-standing, others adhered to the surfaces of buildings and bridges. But they were all informed by a knowledge of the locality as it evolved, and this sense of engagement compared very favourably with the suspicion which blighted other attempts at collaboration between artists and architects of the period. Most community-based initiatives lacked the advantages which Harding enjoyed in his attachment to a new town. Deprived of such a context, they resorted to painting murals during the latter half of the decade on the gable ends and side walls of buildings

erected, for the most part, many years before.[85] Although they sometimes produced results as heartening as the revitalized playground and painted facade of Laycock Primary School in Islington, where David Cashman and Roger Fagin were able to work with the children over an extended period,[86] architects played no part in these ventures. Many of them amounted to little more than well-meaning attempts to 'brighten up' dilapidated inner-city areas. Before succumbing to vandalism, decay and demolition, their ubiquitous presence in blighted neighbourhoods managed only to highlight the divorce between artists and the bare, unalleviated surfaces of new buildings in more prosperous locales.

The extent of this malaise only became clear when an architect and artist who shared the same vision came together and produced a powerful reaffirmation of the alliance's continuing viability. Naum Gabo, who had not been invited to make a public sculpture in Britain at any time during the forty years since he co-edited the optimistic *Circle*, finally managed to fulfil this frustrated ambition two years before his death. Late in 1975, the ageing and infirm sculptor travelled to London for the installation of his last outdoor work at St Thomas' Hospital (p. 109). He was delighted that Sir Norman Reid and Eugene Rosenberg, the architect of St Thomas', had enabled him to find such a spacious riverside destination for his *Revolving Torsion, Fountain*.[87] Writing to his old friend Lewis Mumford, Gabo explained that producing this sculpture amounted to the realization of 'a dream which I have been carrying with me ever since 1929 and before'.[88] In the grounds of St Thomas' he was able to see the gleaming structure of *Revolving Torsion, Fountain* spurt thin jets of water from the outer edges of its ribs, creating a fine linear tracery in a timed pattern which harmonizes with the motion of the sculpture's upper half. The sharp-edged angularity of its steel components is held in elegant tautness, contrasting with the evanescence of spray caught by the prevailing Thames-side winds. Patients fortunate enough to look down on this graceful fountain from the hospital windows surely never tire of its intricate permutations, while the modernity of Gabo's materials and form-language offers an implicit, bracing challenge to the Victorian magnificence of

the Houses of Parliament on the other side of the Thames. The setting could hardly be more propitious, enhancing a joyful work which celebrates Gabo's lifelong commitment to the belief that art 'should attend us everywhere that life flows and acts.'[89]

The inspirational example of Gabo's swansong proved that great works of art can still flourish in an enriching relationship with contemporary architecture. Its outstanding quality may have helped to persuade British sculptors to involve themselves with architectural projects in the following decade, and its presence outside a hospital drew timely attention to the need for art in long-overlooked areas beyond the predictable boundaries of the civic centre.

By the autumn of 1980, a grand initiative seemed to be underway. Determined at last to alleviate the chronic disrepair of its tube stations, London Regional Transport launched with Arts Council help a competition for the decoration of the vaulted ceilings of Holborn Station's two staircases and the concourse between them. They constituted one of the most desolate sights on the Underground, and many of the entries exhibited at the Whitechapel Art Gallery in August responded keenly to the possibilities on offer. Fired by the prospect of installing his work in a space the size of five tennis courts, with a guaranteed audience of thirty-four million passengers a year, Ron Haselden produced a prizewinning proposal centred on an electrical model studded with tiny light-bulbs. These winking points of colour were attached to two grids which penetrated each other, and responded

Ron Haselden's prizewinning proposal for the escalator ceiling in Holborn Underground Station, 1980.

directly to the presence of the Tube passengers. Haselden suggested that a photo-electric cell would detect everyone arriving at the escalator, and activate a band of bulbs which followed the traveller up and down. The more crowded the staircase, the busier Haselden's ceiling would become with kinetic light activity.

In the end, London Regional Transport decided not to proceed with the scheme on financial grounds. But it did commission a variety of artists to transform other stations. Although most of the results failed to rise above the level of cheerful competence, Paolozzi was given his head at Tottenham Court Road. Since executing the fountain sculpture for the Festival of Britain, he had been obliged to rely on continental patronage for large-scale work in public spaces. Now, however, he was given virtual *carte blanche*, and LRT's faith in his abilities paid off. The glass mosaics, especially on the Central Line platforms where his imagination is at its most unbridled, demonstrate the artist's ability to charge a formerly dreary and dilapidated locale with a new identity (p. 99). Drawing his inspiration from the Tottenham Court Road area itself, as well as from a lifelong preoccupation with the theme of the machine-age city, Paolozzi gave the station interior a sense of place. Emblazoning escalator arches, corridors and the entrance lobby as well as platforms, the mosaics countered dehumanized bleakness at every turn. He explained that his aim was to restore 'the right of the individual to recognize his place in the city by landmarks especially created by art within the architecture'.[90]

Ultimately, though, even Paolozzi's scheme was limited, and at times frustrated, by the problems involved in dealing with a building constructed half a century earlier. Charles Jencks was right to complain that 'what is missing in this collaboration is a response to the [art] in the architecture'[91] – a failing which he avoided himself when commissioning Paolozzi to make a *Black Hole/Spiral Galaxy* mosaic for the bottom of the Solar Stairway designed by Jencks and Terry Farrell for Thematic House. Jencks worked throughout the house on a series of symbolic programmes with artists, craftsmen and other architects. Their coming-together appeared to signify an altering mood, and in 1981 the Romulus Construction Company

Phillip King, *Clarion*, 1981, Fulham Broadway, London.

fortified it by commissioning Phillip King to produce his typically flamboyant painted steel *Clarion* for a development site in Fulham Broadway. Trumpeting in scarlet and black from a traffic island, it seemed like a harbinger of a new spirit longing to be released elsewhere in the cityscape during the decade ahead.

As if in response to the shifting attitudes, the ICA's Exhibitions Director Sandy Nairne attempted early in 1982 to focus attention on the issues with a conference and exhibition. Appropriately enough, the introductory debates on the climate of change in architecture and art were introduced and chaired by Sir Hugh Casson, who had done so much to give the Festival of Britain its vitality thirty-one years before. But an impressive array of younger architects, artists, historians and critics also contributed to the conference, which dealt with themes like art and development, professional collaboration, structure and decoration, persuasion and provision, and arts projects in hospitals. Unafraid to tackle questions as awesome as 'How Can Art Work in Public?', the entire weekend provided a nourishing accompaniment to the exhibition.[92]

Its title, 'A New Partnership', was more resounding than the work on display. Far smaller than its predecessor, 'This Is Tomorrow', the survey displayed the results of tentative collaborations between five pairs of British artists and architects. One team, Ed Jones and Ray Smith, revealed their

scepticism by erecting a funerary monument to the impossibility of working together: Smith laid a cut-out reclining skeleton across Jones's wall-size drawings of a tomb. Their sombreness contrasted with the throwaway wit of Tony Cragg and Piers Gough's exhibit, where eight shelves were shaped according to the outside contours of wine bottles heavy with echoes of traditional still-life subjects. Even here, though, the overall effect was austere, and exuberant colour could only be found inside the 'magic box' made by Sarah Greengrass and Richard MacCormac, who invited the visitor to look through an eyehole at the miniature maze of painted glass and mirrors inside. Caro returned the exhibition to monochrome with his 'bridge' sculpture, a proposed link between the old Los Angeles Central Library and Barton Myers's new extension. Although the bridge would be functional, Caro retained his swashbuckling style intact amid the otherwise reticent surroundings. But John Miller and Paul Neagu escaped from the notion that artists must always add something distinct to an architectural environment. Nobody could tell precisely how each man contributed to the appearance of their massive and mysterious altar-like table, with a plumbline suspended over its centre. It was a complete amalgam of art and architecture, and its unclassifiable strangeness suggested that if the barriers separating the two disciplines were broken down, the outcome would be impossible to predict.

Just as the architects in 'This Is Tomorrow' largely failed to pursue the implications of their proposals after the exhibition had closed, so their successors in 'A New Partnership' seemed loath to develop its suggestions in their subsequent work. Only Caro went further, creating a *Child's Tower Room* for an Arts Council exhibition two years later[93] which demanded exploration by climbing up, into and through the sculpture. 'The work is at one moment sculpture and at another architecture', he explained. 'In architecture the eye encompasses a whole, then focuses on detail. The tower room really only becomes a sort of architecture when one mounts the stairs, or enters below them.'[94] Soon afterwards he coined the term 'sculpitecture' to describe the new development, and went on to work with the architect Frank Gehry on a complex 'sculptural village'. Like his working models

Anthony Caro, *Child's Tower Room*, 1984 (*top*), and *Architectural Village*, 1987 (in collaboration with Frank Gehry, Sheila Girling, Jon Isherwood, Paul Lubowicki and Susan Nardulli).

Right: Kevin Atherton, *A Body of Work*, 1982, Langdon Park School, Poplar, London.

for a *Lakeside Folly* and *Pool House*, the village itself has yet to be realized. But Caro, who declared that he wanted 'to expand the boundaries of sculpture by making something on an architectural scale', did succeed in installing a full-size 'sculpitecture' called *Sea Music* at Poole Harbour in 1991.

Such an endeavour bears out Richard Rogers's belief that 'architecture has become closer to sculpture, sculpture has become closer to architecture and the previously well-defined relationship has been destroyed.'[96] Neither Rogers nor any other architect of his persuasion has, admittedly, been very willing to make works of art an integral part of a building. They prefer to keep their streamlined technological monuments free from embellishment, and Norman Foster spoke for many in his profession when he likened decorative enrichment to smearing 'lipstick on the gorilla'. But for all their inevitable limitations, the ICA's exhibition and conference were still symptomatic of a genuine stirring of dissatisfaction with the old prejudices. Purist dogma, which had for so long sided with Adolf Loos's insistence that ornament was a crime, gave way in the 1980s to a widespread revulsion against hard-line functionalist aesthetics.

All the same, opportunities for artists to work with new buildings remained rare. Most of the time they had to content themselves with awkward sites on or near edifices erected many decades earlier. Some of these locations were so uncongenial that they ensured a compromised outcome before the art-work was even commenced. The experience proved dispiriting for any artist who cared about a coherent relationship between an image and the place it inhabits. The most fruitful tactic, in these circumstances, often turned out to be wittily subversive. Confronted by the task of uniting the disparate collection of Victorian buildings and later additions at Langdon Park School in Poplar, Kevin Atherton came up with an unpredictable solution. Plaster casts were taken from the body parts and belongings of nine pupils across the entire age-range. After casting them in bronze, these fragments of limbs, clothing and equipment were installed in walls throughout the site. 'The placing *was* the piece', Atherton explained. 'In a school one is always going from one point to another and I liked the idea that the activity

would stitch the parts together.'[97] The feet, arms and heads emerge from and disappear into the buildings at will, as if defying the physical constraints which normally govern life in the school. As well as lending an identity to otherwise anonymous spaces, these quirky apparitions embody a spirit of freedom guaranteed to appeal to pupils bounded by institutional precepts.

A related sense of *élan* characterizes Graham Crowley's decoration in the Out Patients' Department of Brompton Hospital. Selected from four entries after extensive consultation with patients, staff and visitors, the enamelled metal cut-outs of birds, trees and leaves gain additional buoyancy from the fact that they project four inches from the wall. Crowley extended these Matissean forms on to nearby pillars as well, helping to unify his darting elements with the sturdiness of the interior they animate. But the impact of the work is still marred by visual impediments in a room never intended to house such an elaborate decoration.

Despite the difficulties attendant upon commissioning art for old buildings, the demand for such projects substantially increased in the early 1980s. They were nurtured in large measure by the consultative bodies set up to mediate between patron and artist. Lesley Greene, who as Visual Arts Officer for the Greater London Arts Association had helped to finance ventures like Crowley's at Brompton Hospital, founded the Public Art Development Trust in 1983. It rapidly became established as an indispensable means of facilitating often very complex negotiations, especially when a large and committee-bound institution set about deciding how best to

procure art for its premises. From the outset, the Trust also aimed in the widest educational sense at generating an awareness of all the responsibilities involved in the commissioning process. This initiative has been extended by the eleven other bodies subsequently founded elsewhere in the country, including Edinburgh's Art in Partnership, Birmingham's Public Art Commissions Agency, Cardiff's Welsh Sculpture Trust, Sunderland's Artists Agency and, more recently, Manchester's Arts for Health and the British Health Care Arts Centre based at Dundee, where sustained efforts have been made to implement a carefully organized public arts programme in regenerated sites throughout the city. The extraordinary proliferation of these agencies is an encouraging sign that the initiatives they steer to realization have become a steadily expanding and permanent part of British art practice, rather than a fluctuating phenomenon at the mercy of fashion and the vagaries of the national economy.

Alongside this development, commissions for painting and sculpture in new architectural interiors suddenly became more audacious. Rather than thinking in terms of modest dimensions, and sites so discreet that the images they contain invariably pass

Kenneth Martin, *Screw Mobile*, 1959.

unnoticed, commercial schemes began to make room for works of monumental proportions in their most prominent spaces. Balraj Khanna was invited to produce his largest painting for the reception area of Elven Precision Ltd in Crawley, West Sussex. Taking his cue from the sea's proximity he made a characteristically delicate, dreamlike picture animated by indefinable creatures hovering in a region redolent of sand, water and sky. The following year Kenneth Martin installed an elaborate and yet structurally limpid *Screw Mobile* in the atrium of Victoria Plaza in London (p. 165). Its steel components chime so completely with the roof girders above that the sculpture seems like an extension of the architecture. Here, towards the end of his life, Martin fulfilled the ambition announced in 1956, when 'This Is Tomorrow' included a far smaller mobile in an environment designed by himself, his wife Mary and John Weeks.

The most spectacular of these commissions was undoubtedly Patrick Caulfield's painting for the London Life Assurance Headquarters in Bristol. Although he had never worked on such a colossal scale earlier in his career, Caulfield responded to the invitation with aplomb. For many years his work had been preoccupied with architectural subjects, whether of forecourts and entrances or the interiors of restaurants and bars where kitsch tourist-brochure photo-murals are transformed into surprisingly mysterious, even enticing images. Now he had the chance to place one of his own paintings in a real office, and the outcome was admirably assured (p. 139). No one who enters the building can avoid encountering this billboard-size still life, placed so provocatively in the foyer and flanked by two escalators which provide their users with ever-changing views of the immense canvas in its mighty wooden frame. Peppered with references to local landmarks and Bristol's mercantile history, including the slave trade, Caulfield's painting is nevertheless an imperious work, boldly articulated by thick contours which accentuate the sonorous colours they enclose.

If an established artist like Caulfield now found himself granted an unprecedented opportunity to extend his work in the grandest manner imaginable, young members of an exceptionally fertile

Nicholas Pope, *The Sun Life Stones* (installation, 1980), Sun Life Assurance Headquarters, Bristol.

generation of sculptors were likewise invited to work in proximity to buildings. The Forest of Dean stones installed by Nicholas Pope in the courtyard of the Sun Life Assurance Headquarters, Bristol, retained their independence from the building by asserting a rough-hewn, boulder-like identity far removed from the architecture behind. A related sensibility informed the group of gracefully chiselled Portland stone presences which Peter Randall-Page produced for another exterior site, at Leicester Royal Infirmary. In both instances a clear alternative to the building was proposed, as if the sculptor had aimed at providing an image of an order he missed in the architectural part of the site. Antony Gormley appears to have been impelled by a similar desire in *Places to Be*, a three-figure sculpture made for a landscaped location beside Monkstone House in Peterborough. The aspirational lead man who stands on the grass, with arms outstretched and head raised to the sky, is communing with natural forces rather than the rectilinear geometry of the uncompromisingly urban buildings beyond.

In all these cases, sculpture is still regarded as a relatively isolated work installed in a special space reserved for art. But in 1984, the same year that Gormley's

Antony Gormley, *Places To Be*, 1985 (*top*), and Michael Craig-Martin, Untitled, Colchester Hospital, 1984.

Richard Deacon, untitled maquette for Euston Road competition, 1984–5.

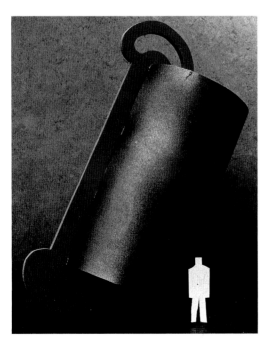

work was positioned at Peterborough, a remarkable attempt to spread art throughout a new building was unveiled. At Colchester General Hospital, no fewer than sixteen paintings, photographic murals and sculptural courtyard environments were produced specifically for interior and exterior sites alike. Many local artists were involved in the project, and they took as their starting-point the Essex rivers whose names are used to identify the wards. The standardized anonymity of the modern hospital was thereby countered from the very inception of a scheme funded largely by public subscription through Eastern Arts.[98] The most satisfying alliance of image and wall was achieved by Michael Craig-Martin. His graceful linear interweaving of everyday objects floats with balletic aplomb on the Blackwater floor of the hospital, giving the adjacent children's wards a spirited sense of well-being.

By no means every initiative in the 1980s enjoyed such a felicitous outcome. Halfway through the decade an ambitious competition was held by Legal & General Assurance and the Greycoat Group for an immense sculpture outside the reflecting glass office block in the Euston Road. Despite submissions from artists as outstanding as Richard Deacon, whose typically arresting maquette tilted as if in response to its windblown site, nothing was ever erected. Nor did Antony Gormley's attempt to build a brick titan at Leeds, with the active encouragement of British Rail, get beyond the stage of a scale model endowed with an Egyptian air of *gravitas*. But the momentum was now so powerful that the unfortunate failure of these schemes could not stop other ventures from arriving at a successful realization. One of the most prominent, at street level in High Holborn, presents to passers-by an over-lifesize Paolozzi bronze of *The Artist as Hephaestus*. Commissioned by London and Bristol Developments for the facade of their new building, the partially fragmented and robotic figure holds out an enigmatic surrealist mechanism for our contemplation. Hephaestus himself, the Greek god of fire, was celebrated as a maker of elaborate, life-enhancing works in gold, silver and bronze,[99] but Paolozzi gazes out at the late twentieth-century machine-age metropolis with an altogether more ambiguous offering in his hands.

The Hephaestus sculpture, made from one of the most traditional of sculptural materials, occupies a single, clearly defined position within the facade of a building otherwise untouched by Paolozzi's intervention. Bruce McLean's restaurant-bar for the Arnolfini Gallery in Bristol, by contrast, deploys a multiplicity of media to activate an interior designed in collaboration with the architect David Chipperfield (p. 136). The commission arose after Barry Barker, then the Arnolfini's director, saw the furniture sculpture which McLean exhibited in his 1987 one-man show.[100] Using materials as diverse as reconstituted stone, acrylic, terrazzo and steel, he turned the sculpture into fireplaces, tables and a large structure with bolted-girder shelving called *A Place for a Lean*. They exemplified his long-term preoccupation with social posing and the modification of everyday behaviour by domestic objects and props. Together with the flamboyant ceramics and drawings for imagined interiors included in the exhibition, they also suggested that McLean possessed a versatile ability to activate architectural space. So indeed it proved at the Arnolfini, where the bar counter is transformed into an unpredictably curving surface bearing mask-like faces, hands and limbs. The solidity of this gleaming, speckled structure is played

Eduardo Paolozzi, *The Artist as Hephaestus*, 1987, London and Bristol Developments Building, High Holborn, London.

Bruce McLean, *A Place for a Lean*, 1987, Anthony d'Offay
Gallery, London.

Michael Sandle, *St George and the Dragon*, 1988,
Dorset Rise, London.

off against the linear acrobatics of the steel-
work beneath and behind the bar, lodged
among the shelves like an anarchic effusion
between orderly ranks of glasses and bottles.

The outcome is a congenial and suitably
exuberant ambience, testifying with wit and
panache to the vitality which can be
generated when an artist as committed to the
collaborative principle as McLean works on
an architectural project. Its completion
happily coincided with a sign that the
government had at last been persuaded to
take the whole issue seriously. For 1987
witnessed the publication, by the Department
of the Environment, of a 'handbook' called
Art for Architecture. Compiled and edited by
the artist Deanna Petherbridge, it arose from
extensive research commissioned by the
Department in association with the
Gulbenkian Foundation. The Minister of State
for Housing and Planning joined the Minister
for the Arts in writing the foreword, which
declared that the purpose of the publication
was 'to encourage patrons and developers,
artists, craftsmen and architects to
incorporate works of art and craft as an
integral part of new building and renovation
schemes'.[101] To that end, the main emphasis
was placed on enabling: Petherbridge
explained that the book should be used as 'a
practical guide for potential patrons
interested in commissioning'.[102] But she
provided this information in the belief that the
projects so far undertaken 'tend to be
predictable, conventional and bland'. For the
most important recommendation of the Art &
Architecture Research Team who worked on
the publication was a concerted attempt to
escape from the disastrous habit of adding
art as a cut-price afterthought to buildings. 'It
is essential', she wrote, 'that architect and
client plan for commission(s) at the initial
design stage, so that close collaboration can
take place between designer and artist to
make the work truly site-specific or integral
with the architecture, and the cost can be
part of the overall budget and not an optional
extra. Consultation over the development of a
commission needs to be mutual, with the
architect as open to suggestions and
modifications as the artist is to meeting the
requirements of the brief.'[103]

It was a salutary point to emphasize, but
such an understanding between artist and
architect is still all too uncommon. Most of
the works commissioned for new buildings

retain a more conventional, distanced
relationship with their surroundings. Michael
Sandle's *St George and the Dragon*, a thirty-
five-foot-high bronze unveiled in 1988, was
commissioned for a development near Fleet
Street after a limited competition
recommended by the Public Art Development
Trust. Sandle chose the subject himself,
having nurtured the idea of a satirical
sculpture on this theme 'since the advent of
Thatcherism'. He wanted at first to turn the
tables on tradition and show the monster
winning, with 'no prizes for guessing the
identity of the Dragon who has St George by
the balls'.[104] By the time he submitted his
proposal for the Dorset Rise competition,
however, Sandle had modified his ideas and
settled for a seemingly more orthodox
approach. The towering green bronze looks,
initially at least, anomalous among the office
blocks, like an unaccountable throwback to
the heroic age of Victorian sculpture.
Bestriding his mount and raising himself up
in the stirrups, the armoured figure thrusts
down fiercely on his coiled antagonist. It
appears to be a gesture of triumph, affirming
that the forces despised by Sandle will
eventually be ousted.

After a while, though, the sculpture
becomes more ambivalent and disturbing.
The saint and his arch-necked steed are
balanced on a platform tilting at a giddy
angle to the column below. Sandle makes the
animal's position still more perilous by
dividing up the platform into an open grid, so
the horse has to ensure that his hoofs do not
plunge through the gaps in the lattice-like
structure. Viewed in this light, the outcome of
George's struggle begins to seem far less
certain than any Victorian artist would have
dared to indicate, and the dragon refuses to
conform to sculptural precedent as well.
Instead of brandishing its wings and
presenting the saint with an ostentatious
target, the monster assumes the guise of a
devious serpent who could rapidly glide
away from the spear. The encounter has yet
to be resolved, and the saint may find
himself confounded after all.

The cost of *St George and the Dragon*, and
Giuseppe Lund's accompanying railings,
amount to one per cent of the total budget at
Dorset Rise.[105] Elsewhere in London, though,
an even healthier appetite for art is
manifested at Broadgate. Sculpture plays an
inescapable part in the network of alleys and

squares which Rosehaugh Stanhope Developments, following the old tradition of the city's structure, are building around a splendidly restored Liverpool Street Station. The devotee here is Stuart Lipton, who clearly believes in the artist's ability to transform the sequence of monumental offices he is erecting on this twenty-eight acre site. In 1984, before most of the commissioning began, he declared that 'one can never have too much art around. The more we have, the more the debate, and hopefully the more sensitive we'll become.'[106] Since then, he has lived up to those words with unflagging enthusiasm, nowhere more riskily than in the octagonal space at the main entrance to the complex. Far from plumping for an object guaranteed to cause no offence, he boldly commissioned a colossal sculpture from Richard Serra.

The gamble paid off. Serra's monolithic *Fulcrum*, a cluster of rusted cor-ten steel plates, rises from the ground with a resounding sense of finality (pp. 166–7). Like much of his work, it looks dangerous. The plates appear to be leaning against each other for support, and inside they threaten to collapse and crush the onlooker with their weight. The menace is illusory, of course. *Fulcrum* has been installed according to the most rigorous safety standards, and twenty-seven Australians once felt safe enough within it to sleep there for a night. Even so, anyone standing at its dark centre and looking upwards is likely to be overawed by the vertiginous thrust of its soaring components. They dominate the spectator like skyscrapers in the most canyon-like of Manhattan avenues.

The austere theatricality of this lean exercise in minimalism is an ideal preparation for the great circular arena lodged in Broadgate Square beyond. Here, in the development's most welcoming space, shops and restaurants look down on a sunken ice-rink, and regular lunchtime performances are held by Afro-Caribbean bands, dance groups, opera companies and street entertainers. It can be a festive location, and Barry Flanagan's *Leaping Hare on Crescent and Bell* confirms the holiday mood. Having originally placed this athletic bronze down by the rink, Lipton then decided to reposition it further up. Using the top of the crescent as an improvised lever, the hare

seems to be launching itself towards the rink with infectious abandon.

All the same, Flanagan's sculpture was not commissioned for Broadgate. Nor were George Segal's *Rush Hour* and Jacques Lipchitz's *Bellerophon Taming Pegasus*, both of which occupy positions nearby. What Lipton has not chosen to support, moreover, is the cause of bringing artists and architects closer to each other. Commissioning at Broadgate follows the familiar pattern of bringing in the art after the buildings have been designed and erected. There is still a great need for a concerted, nationwide attempt to bridge the damaging divide between the two professions, so that a convincing aesthetic coherence can be achieved when they do manage to work rewardingly with each other.

The urgency of such a priority was recognized in 1990 by the publication of an important document entitled *Percent for Art*, the report of a Steering Group set up two years before by the Arts Council with the Council of Regional Arts Associations, the Welsh and Scottish Arts Councils, and the Crafts Council. The Steering Group's chairman, the architect Richard Burton, had already defined his position by ensuring that his new St Mary's Hospital at Newport on the Isle of Wight will boast an abundance of artworks throughout its interior and the landscaped surroundings beyond. Moreover, one of the three artists who made up the Group was Tess Jaray, then in the midst of designing the paving, railings, seating, light-fittings and planting for the immensity of Birmingham's Centenary Square, situated at the heart of the most desolate of post-war urban disaster areas.[107] No wonder that the Group was determined from its inception to aim at the very least for a narrowing of the chasm between art and architecture.

To that end, a seminar on the education of both professions was held at the Royal Institute of British Architects in May 1989. Leading members of both professions, along with writers and teachers with a particular interest in the issue, were among the two-hundred-strong invited audience who attended the day's proceedings. It marked, revealingly, the first formal contact between the RIBA and the Arts Council for forty years. Although there was general agreement about the value of the event, everyone there remained conscious of the dearth at most

Barry Flanagan, *Leaping Hare on Crescent and Bell*, 1990, Broadgate Square (*top*), and Stephen Cox, *Ganapathi and Davi*, 1989, Sun Street Roundabout, Broadgate.

Tess Jaray, Paradise Bridge, 1991, Birmingham.

universities and polytechnics of formal arrangements facilitating fruitful contact between artists and architects. The emergence of such cross-fertilization at Kent Institute, the Royal College of Art, Manchester Polytechnic, the Slade and the Bartlett School of Architecture, while gratifying in itself, only threw into relief the extent of the educational reform needed elsewhere.

Accordingly, the Steering Group insisted on arguing in its report that 'the general picture of mutual indifference is damaging to visual culture as a whole. As a result, trainee architects tend to undervalue the possible contribution of artists, while young artists often assume that they have no role in the highly regulated discipline of professional architecture. Both views are false. And yet since architectural education was hived off into the domain of science in the 1960s there has been little encouragement for flexible, cross-curriculum experiment.'[108] The last of the report's ten recommendations sought to remedy the malaise by proposing joint courses for architects, artists and craftspeople on a pilot basis in selected centres of higher education.

Without a concerted attempt to prepare such a seed-bed for future collaboration, any bid to forge an alliance runs the risk of foundering in an aesthetic quagmire. The report was right to point out the shortcomings of *ad hoc* commissioning, largely 'undertaken at the end of the design stage, often when buildings have been completed'.[109] There will always be a place for such projects, so long as they are carried out with the sensitivity and flair shown at Edward Cullinan's outstanding Lambeth Community Care Centre, where Tom Phillips was invited by the architects to paint a suite of pictures for particular places within the building.[110] However well Phillips succeeded in his desire to 'bring Nature into the only part of the building which Nature didn't occupy',[111] though, the idea of involving an artist after the building has been finished hardly provides a viable basis on which to proceed in the future. 'The sense of a lost opportunity, born of a "hit and miss" approach to commissions', declared the report, 'has led to a widespread feeling that a more rigorous approach is necessary. What is needed is a method whereby the talents of artists can be assured an integrated place in building design.'[112]

Rather than trying to spell out what that method might be, however, the report preferred to concentrate on how art and architecture could play more of a part in the £40 billion which Britain annually invests in the maintenance of buildings and new, mainly urban developments. The first and principal recommendation roundly proposed that 'all public building schemes and public works whose contract price is at least £3 million should adopt Percent for Art on a mandatory basis at a level not less than 1% of the total cost'.[113] Although forty local authorities have so far adopted such a policy on a voluntary basis through the planning system, Britain has yet to take a national initiative to set aside a proportion of the capital cost of buildings and environment schemes for commissions to artists and craftspeople. Despite the supportive sentiments voiced by the two ministers in their foreword to *Art for Architecture* in 1987,[114] government departments still have no policies committed to the systematic introduction of art- and craft-works at the design stage of public sector buildings. The fact that the new British Library has commissioned major site-specific works of art from Kitaj, Paolozzi and Gormley is due not to the enthusiasm of government, but to the individual commitment of an architect who has long been a leading collector of contemporary British art.[115] The contrast with France, where artists are continually invited to make work for government offices, could scarcely be more extreme. So the Steering Group decided that 'capital spending plans for Departments and Executive Agencies should include Percent for Art on a mandatory basis from 1992, thereby bringing Britain into line with practice elsewhere in Europe.'[116]

If such a move were extended to private sector buildings, and imposed on unwilling developers with no interest in arranging a marriage between art and architecture, the outcome could easily be disastrous. Too many execrable blunders have already been perpetrated during this century in the name of 'public art', and no good can come from forcing works into spaces where they merely devalue the whole notion of architectural enrichment. Disillusion would quickly follow, and the Arts Council Report is wise to favour 'a gradual approach' which involves 'a hybrid of possibilities, combining a measure of

Artist's impression of the western wall of the entrance hall of Colin St John Wilson's new British Library, showing the tapestry of R.B. Kitaj's *If not, not.*

compulsion with voluntary action where appropriate'.[117] Even so, using the term 'compulsion' is enough to engender qualms in anyone anxious to avoid a proliferation of art operating on the level of *musak* in an airport lounge. John Willett, the author of a pioneering book on *Art in a City*,[118] warned in the Orwellian year of 1984 that compulsory allocation of a percentage of some building costs 'can sometimes be positively damaging, because they too easily mean the imposition of second- or third-grade work which the afflicted community does not want and may justifiably dislike...The danger is not just that the environment won't be exactly improved by the results, but that any new awareness will be switched off in self-defence, and boredom pile up unless (or until) it is relieved by the kind of cultural backlash which we saw in Germany and Russia in the 1930s. Even vandalism is a form of critique, of comment, of frustrated participation.'[119]

The truth is that introducing any element of compulsion to the 'per cent for art' debate remains a high-risk undertaking. Unless it is accompanied by a profound change in attitudes, especially among architects and developers, calamity threatens. Nobody wants to be surrounded by tepid art-works reluctantly tacked on to buildings by people who resent being obliged to commission anything. They are bound to opt for the cheapest, most anodyne course of action, and as Charles Jencks has pointed out, one per cent is a 'pitiful amount...no civilization

worthy of the name spends, in its significant buildings, less than twenty per cent of the budget on the arts'.[120] Only a generous, well-informed and discriminating enthusiasm for restoring the alliance of art and architecture can ensure that authentic acts of collaboration take place. Although many of the works reproduced in this book suffer from the absence of such a nourishing interrelationship, the finest owe a substantial amount of their success to a wholehearted rapport between the participants.

No confining limits should be set on the kind of artist best able to work on an architectural scheme. Those who regard such work as their special province often resort to formulae, and artists who have never ventured beyond the gallery's boundaries should be warmly encouraged to do so. We need to aim at a greater freedom of manoeuvre, a more extended interplay between public and private realms. Imaginative artists who have spent their whole careers showing in galleries and museums might produce exuberant work when invited to work with an architect on a suitably stimulating project. If the collaborative ideal is to flourish properly, it must attract the energies and resourcefulness of those most likely to infuse it with a vitality which spurns hackneyed, glib solutions.

Richard Deacon is just such a sculptor, and the installation of his steel *tour de force* at Warwick University campus in February 1991 was a hugely invigorating event. Deacon has produced an arresting image for this, his first public commission (pp. 78–9). On one side, an upright form in mild steel undulates gently within a cage. But the sense of confinement is broken at the top, where the form bursts out of its container. In a development which gives the work much of its explosive dynamism, a horizontal ladder of twisting stainless steel shoots like an electrical discharge to the other side of the sculpture. There, the voltage seems to surge unchecked through the entire length of the second large form. It threatens to buckle under the impact of the tremor, but it also appears to be exhilarated by its freedom from the cage. At first, the sculpture seems to set up a straightforward duality between imprisonment and liberty. An escape is apparently being celebrated, and the gymnastic zest of the connecting ladder

crackles with a sense of vitality released from its confines. Deacon may have been thinking about a student's natural desire to leap out of the straitjacket imposed by institutional authority – an urge defined far more openly in a preliminary drawing where most of the sculpture erupts from a far smaller cage.

The final work is, however, too ambiguous to be saddled with such a narrow meaning. Besides, the title Deacon has given it sounds a note of warning: *Let's Not Be Stupid*. While this might apply to imprisonment, it could equally well refer to the dangers of total freedom. The unconfined side of the sculpture is, after all, still connected as if by an umbilical cord to the other half. The tension between them is palpable, and they seem to be engaged in a tug of war. Even as the liberated side rejoices in unshackled space, it still remains dependent on its link with the caged form. They are evenly matched, and the sculpture implies that both sides would suffer if the bridge between them were severed.

Although Deacon did not collaborate here with an architect, *Let's Not Be Stupid* is alive to the buildings grouped around it. In particular, the low-lying minimalism of the Rootes Building furnished him with a strong context; and Eugene Rosenberg, who designed it in the late 1960s, would surely have approved of this buoyant new sculpture. Its arrival at Warwick vindicates Rosenberg's faith in the nourishing potential of the alliance, even though he did not live long enough to see the work in position. His appetite for painting and sculpture, along with his belief that 'the artist has an important contribution to make to architecture',[121] was fired by the kind of passionate commitment which alone can ensure that the relationship between them grows with the requisite amount of vigour and conviction in the future.

Reflecting on the problems involved in developing such a *rapprochement*, Colin St John Wilson once made the important point that it 'is not something that can be willed: it must be a response to a need . . . and trust, authenticity, good faith are the heart of the matter. And as for architecture, it too could easily serve that cause if only the occasion could occur, the intentions be clarified and the limits of its discipline specified.'[122] The attainment of that proper place and occasion,

Richard Deacon, presentation drawing for *Let's Not Be Stupid*, 1987.

which Wilson described as 'the missing factor', cannot be brought about overnight. It will take time to discover the most potent ways of shaping a more humane environment, where artists and architects work in symbiotic union rather than ignoring or antagonizing each other. Much remains to be done, especially if the habit of expecting artists to graft their work on to alien surfaces is ever to be eradicated. But the alternative is unacceptable. For the realization is growing that our surroundings, particularly in the urban areas which suffered most grievously from the barbaric effects of post-war rebuilding, are in need of the imaginative affirmation that art can offer. As the new millennium approaches, everyone stands to gain from finding the right way forward.

Richard Cork

1 Schools and Colleges

When Henry Moore's bronze *Family Group* was installed outside Barclay Secondary School in Stevenage, it inspired other educational authorities elsewhere in the country to think about enlivening their buildings with art. The year was 1950, and the post-war programme of new school construction had just commenced. So the advent of Moore's sculpture was propitiously timed, proving that an ordinary school could furnish itself with a memorable work by an outstanding contemporary artist.

There had been attempts, earlier in the century, to produce significant work for educational institutions: Evelyn Dunbar, who would later become one of the first women appointed as an official war artist, expended much of her energy between 1933 and 1936 on an ambitious series of murals for Brockley School in Kent. The most remarkable post-war acquisitions by schools tended, however, to be sculpture rather than painting. Moore's *Family Group* demonstrated that the identity and purpose of a building could be announced at once by a prominently displayed exterior work.

Bronze was durable enough to withstand even the most aggressive vandalism, and a year later Moore's former assistant Bernard Meadows installed his *Bird in a Pool* in the grounds of Crown Woods School. By that time, Moore's humanist concerns had given way to the next generation's preoccupation with spiky winged forms. The Stevenage *Family Group* emphasized the parental role played by a school, and celebrated the protective warmth enfolding a child. Meadows' work was less reassuring, but it has probably proved just as accessible in meaning to the pupils who play round the pond and see his sculpture from the school windows.

William Turnbull's *Sungazer*, positioned outside Kingsdale School in south London in 1959, is far more enigmatic. It nevertheless signifies an admirable willingness, on the part of the London County Council's Architect's Department, to expose children to the most challenging and experimental manifestations of contemporary art. It is patronizing to suppose that pupils should only be presented with the most straightforward of representational images. Children's art often proves that they are instinctively attuned to adventurous forms of expression, and schools would be ill-advised to shy away from innovation when selecting work for their premises.

To their credit, educational authorities were quick to embrace new ideas when British sculpture was revolutionized in the early 1960s. Although Anthony Caro never had the opportunity to instal his work in a school, the sculptural initiatives he pioneered soon found their way into a surprisingly diverse range of colleges and schools throughout the country. Phillip King was one of the most inventive exponents of this buoyant new sculpture, with its preference for pared-down abstraction, industrial materials and exuberant colour. *Declaration*, acquired by the enterprising Leicestershire Educational Authority for Burstall Stonehill School, is a relatively severe and compressed example of King's early work. But it was a landmark in his development, and led eight years later to the outright *joie de vivre* of *Dunstable Reel*. Its red and green forms are linked in a dance as expansive and irresistible as Matisse's late paper cut-outs. Moreover, the space occupied by the sculpture in Countesthorpe College releases the work's energies to the full. Lodged at the heart of an extensive circular arena, and bounded by the architecture of the institution it animates, *Dunstable Reel* charges the surroundings with a tonic sense of *élan*.

WILLIAM TURNBULL
Sungazer **1959**
Kingsdale School,
London
LCC ARCHITECT'S DEPARTMENT

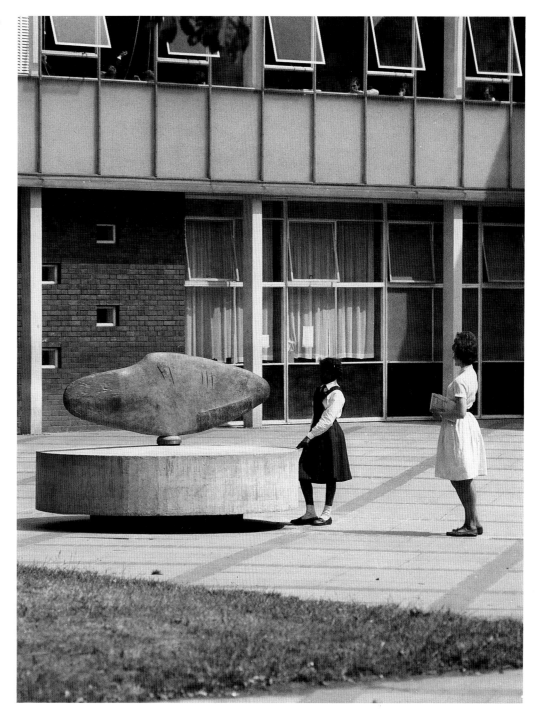

BARRY FLANAGAN
Portoro I 1973
Quorn Rawlins Upper School,
Leicestershire
FORMER COUNTY ARCHITECT'S DEPARTMENT

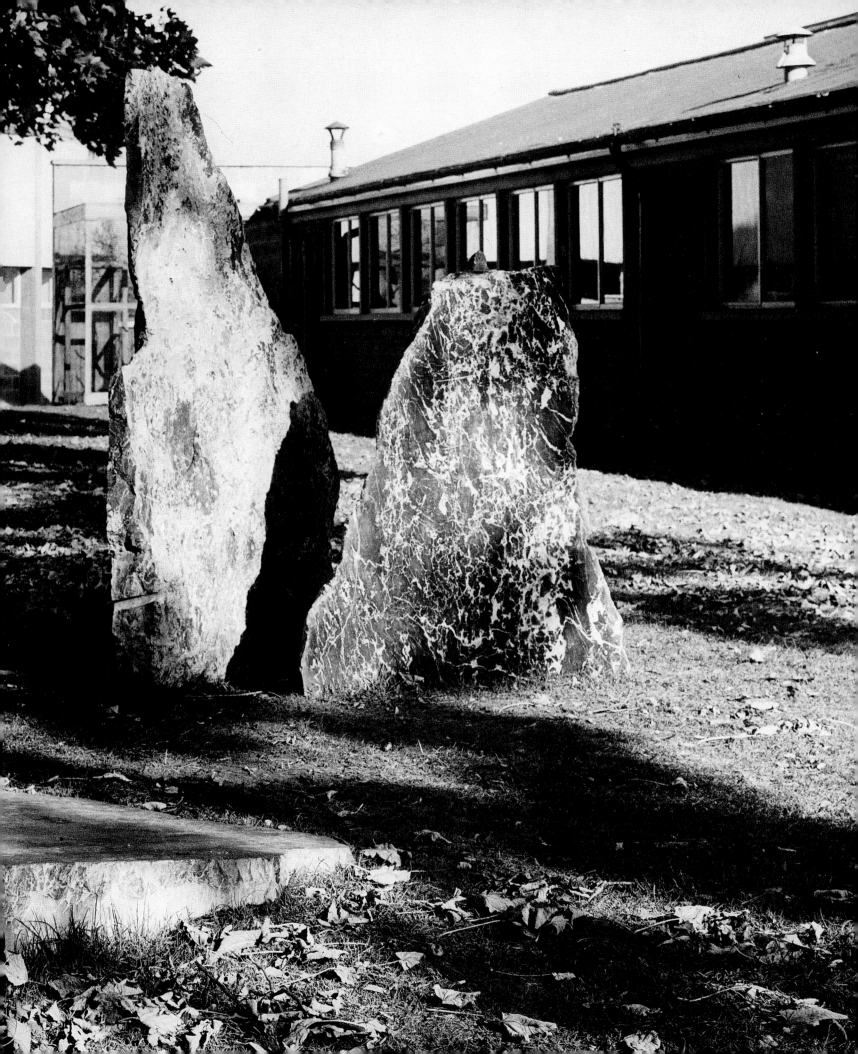

Opposite **BRYAN KNEALE**
Left *Time Balance* **1964**
Market Harborough Upper School,
Leicestershire
GOLLINS MELVIN WARD & PARTNERS
Right *Pivot II* **1974**
Loughborough Technical College,
Leicestershire
GOLLINS MELVIN WARD & PARTNERS

NEVILLE BODEN
Lyre **1970**
Coalville Upper School,
Leicestershire
DENIS CLARKE HALL

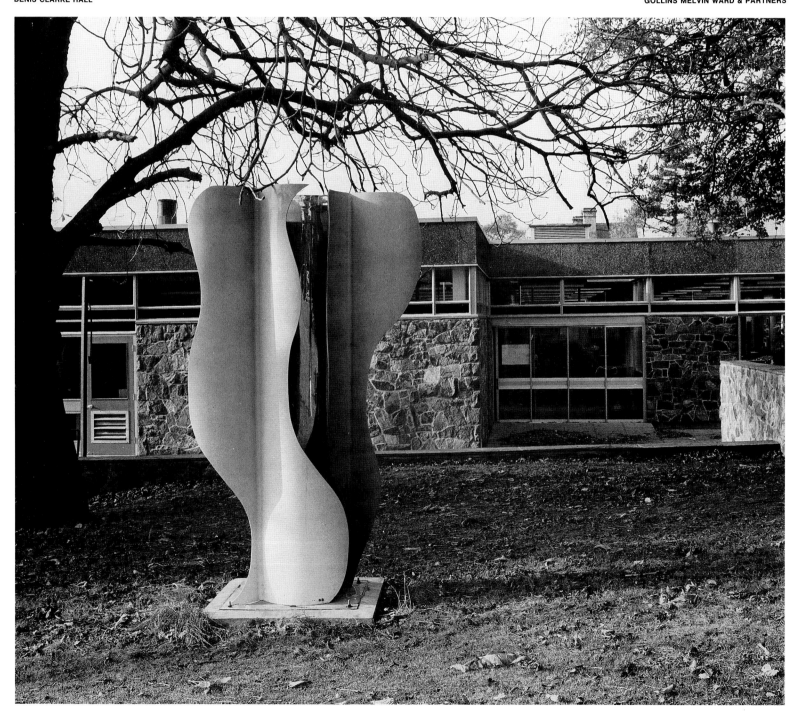

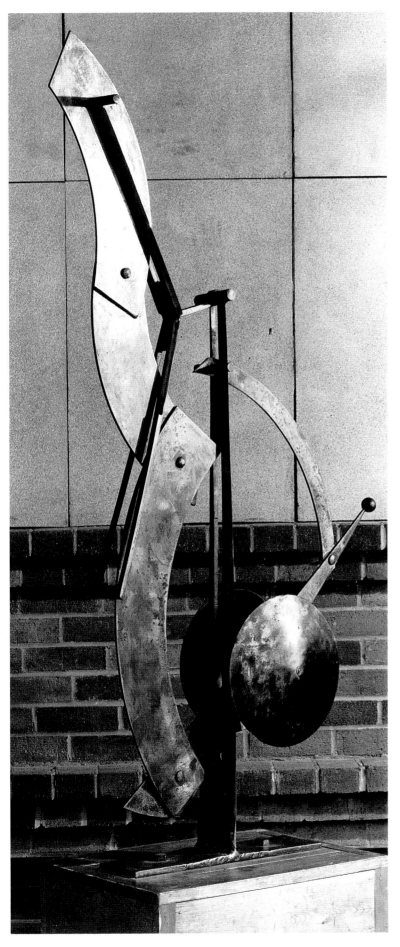

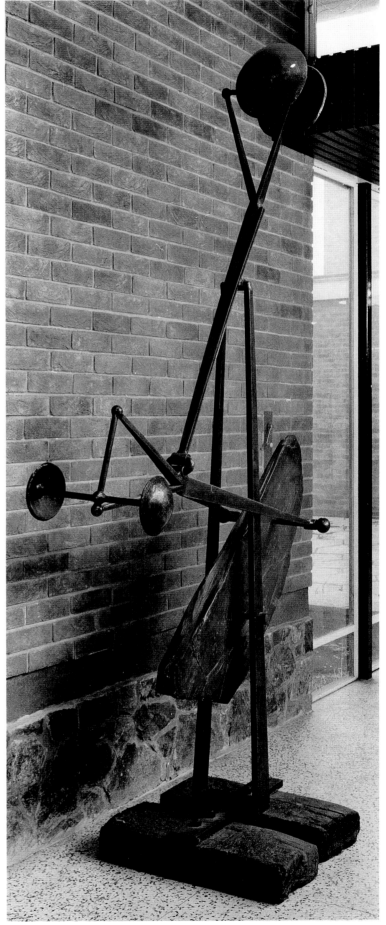

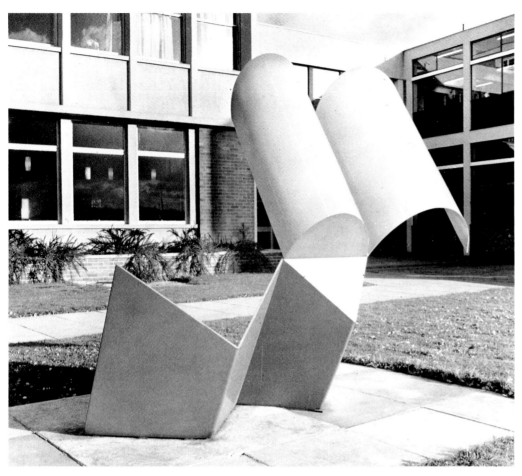

ISAAC WITKIN
Angola **1966**
Loughborough College of Further Education,
Leicestershire
GOLLINS MELVIN WARD & PARTNERS

DAVID ANNESLEY
Big Ring **1966**
Lutterworth High School,
Leicestershire
FORMER COUNTY ARCHITECT'S DEPARTMENT

PHILLIP KING
Declaration **1961**
Burstall Stonehill Upper School,
Leicestershire
FORMER COUNTY ARCHITECT'S DEPARTMENT

GOLLINS MELVIN WARD & PARTNERS
Aviary 1970
Desford Upper School,
Leicestershire
GOLLINS MELVIN WARD & PARTNERS

BERNARD SCHOTTLANDER
3BII Series 1970
Desford Upper School,
Leicestershire
GOLLINS MELVIN WARD & PARTNERS

Above **JESSE WATKINS**
Scorpio Major **1970**
Exhall Grange School,
Coventry, Warwickshire
COUNTY ARCHITECT'S DEPARTMENT

PHILLIP KING
Dunstable Reel **1970**
Countesthorpe College,
Leicestershire
FARMER AND DARK

MERLYN EVANS
Screen 1967
Blakesley Street Comprehensive
School for Girls, London
LCC ARCHITECT'S DEPARTMENT

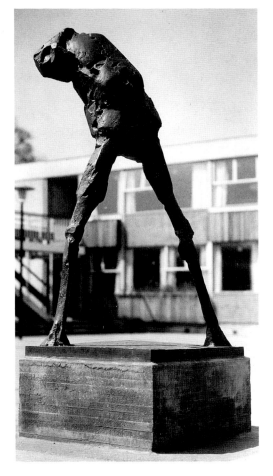

OLIFFE RICHMOND
Striding Man **1961**
William Penn Secondary School,
London
LCC ARCHITECT'S DEPARTMENT

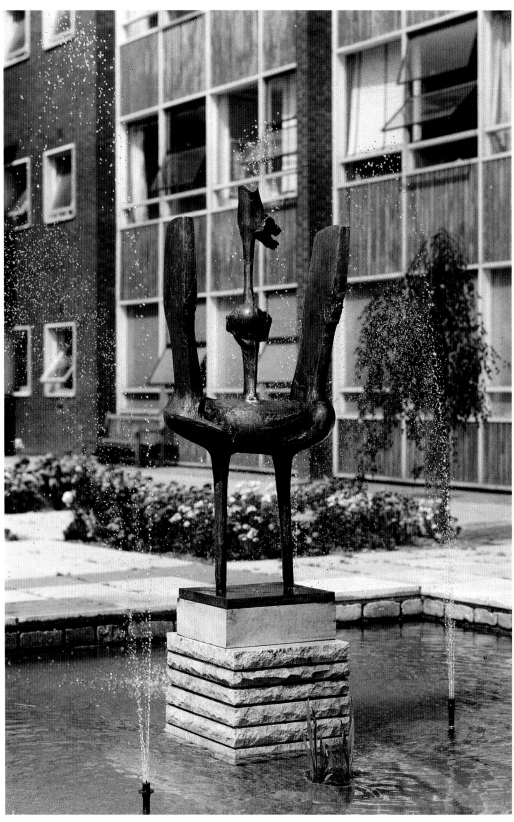

BERNARD MEADOWS
Bird in a Pool **1951**
Crown Woods Comprehensive School,
London
LCC ARCHITECT'S DEPARTMENT

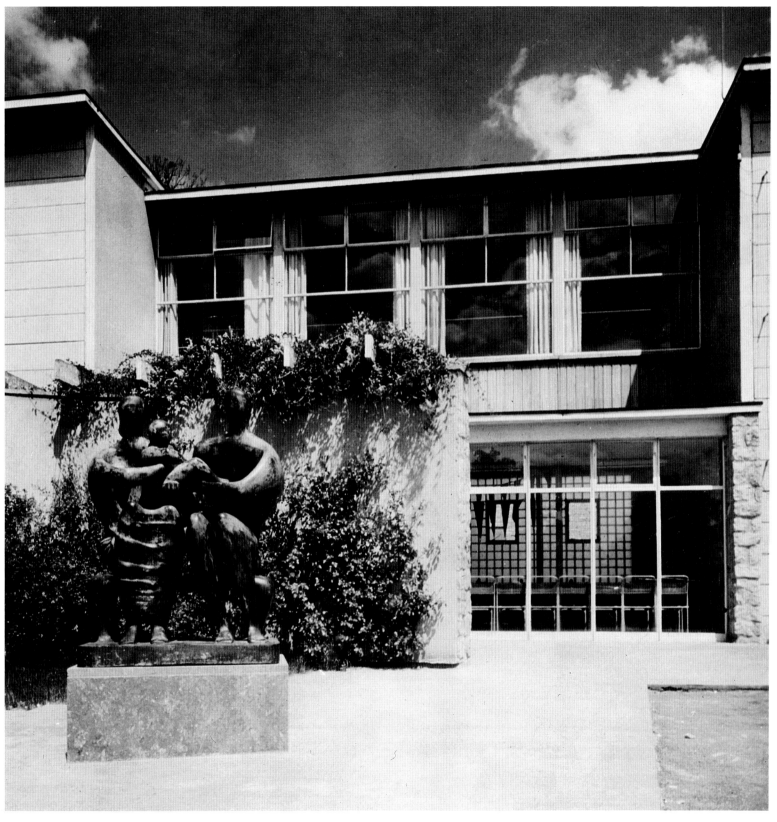

HENRY MOORE
Family Group 1948/50
Barclay Secondary Modern School,
Stevenage, Hertfordshire
YORKE ROSENBERG MARDALL

FRED MILLETT
Mural 1964
Kings of Wessex School,
Cheddar
A.J. HAM

KENNETH ROWNTREE
Mural 1949
Barclay Secondary Modern School,
Stevenage, Hertfordshire
YORKE ROSENBERG MARDALL

2 Housing and New Towns

The most lauded marriage between art and a new town occurred at Harlow, which grew very rapidly from a small, scattered rural population to a thriving centre for over 70,000 people. It eventually acquired a sculpture collection larger than any other British town of a similar size, but during the same period an equally remarkable array of work was installed in housing estates by the London County Council. The idea of placing sculpture at a remove from buildings, so that it offered an independent alternative to the architecture nearby, held particularly strong appeal for Henry Moore. From an early stage in his career, he resented the notion that architecture was 'the mother of all the arts', and never felt wholly at ease with making relief sculpture for a building. It symbolized for him 'the humiliating subservience of the sculptor to the architect', and the monumental *Draped Seated Woman* he placed on an estate in east London contrasts pointedly with the housing around it. Although somewhat hieratic and remote in bearing, his classical figure has a sensual, burgeoning amplitude lacking in the architecture of the estate as a whole.

Whether consciously or not, a younger generation of sculptors appeared more willing to come to terms with the everyday reality of the urban context inhabited by their work. Elisabeth Frink's *Blind Beggar and Dog* could easily have been based on her first-hand observation either of an inhabitant of the area, or someone wandering through it in search of help. Lynn Chadwick's *The Watchers* at Roehampton may not belong to twentieth-century existence in the same way, but their angular vigilance still seems appropriate. Life on large estates can be hazardous, as their occupants often discovered after the initial rash of post-war

idealism gave way to growing disenchantment. So Chadwick's alert triumvirate might be assuming a protective role as they scan the vicinity for possible signs of trouble. Their neighbourly concern could hardly be further removed from the almost comic belligerence of Robert Clatworthy's *Bull*, who raises his tail in apparent readiness to charge at the tower blocks confronting him.

The stance adopted by Clatworthy's animal serves as a reminder that none of these works arose from collaboration between artists and architects. But while the installation of art on the LCC's properties was entrusted to the Arts Council, the Housing Division agreed to try out a more experimental scheme as well. Oliver Cox, who between 1956 and 1960 headed the Division's Research and Development Group, was responsible for building technique and design in all the housing then being erected by the LCC. 'I was able at that time', he recalled, 'to convince the Housing Division that … it would be desirable to have on the staff of the Department artists who would work within the cost ceilings that the architects had to work to, on murals and other permanent work in key positions on housing estates.'

For a while at least, the fear of subordination to architecture voiced by Moore had subsided. Victor Pasmore was able to go one step further than Cox's artists, not only working in an architect's office but designing his own buildings at Peterlee. The most memorable outcome of this unusual venture was the Apollo Pavilion, which Pasmore described as 'a heavyweight piece of pure architecture'. The precedent it established probably helped to pave the way for David Harding's full-time employment with

the Architecture and Planning Department at Glenrothes, where he was able during the 1970s to instal a series of site-specific works as the new town developed.

ELISABETH FRINK
Blind Beggar and Dog 1957
Tate House, Cranbrook Estate,
Bethnal Green, London
LCC ARCHITECT'S DEPARTMENT

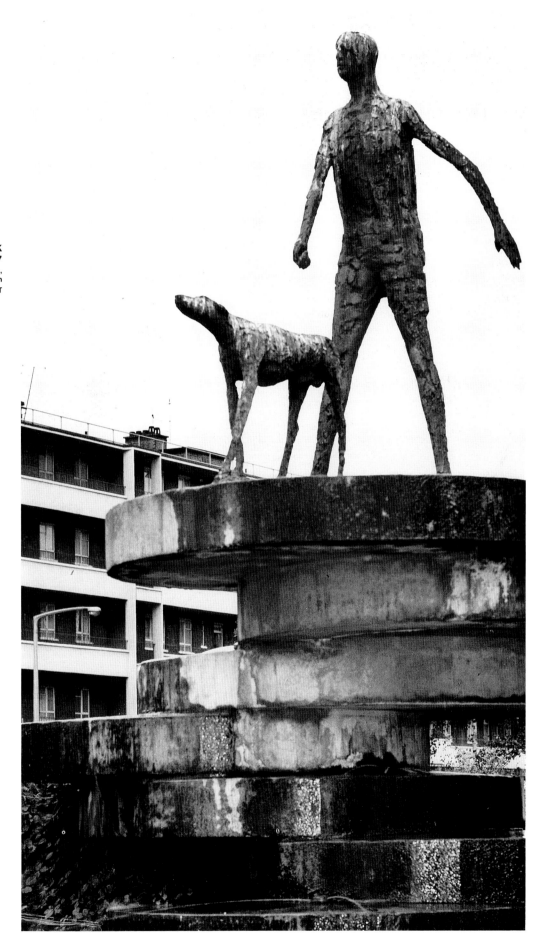

ROBERT CLATWORTHY
The Bull 1961
Alton Estate West,
Roehampton, London
LCC ARCHITECT'S DEPARTMENT

Opposite **LYNN CHADWICK**
The Watchers 1960
Alton Estate West,
Roehampton, London
LCC ARCHITECT'S DEPARTMENT

Right, and opposite **VICTOR PASMORE**
Apollo Pavilion 1963
Peterlee, Co. Durham
PETERLEE DEVELOPMENT CORPORATION

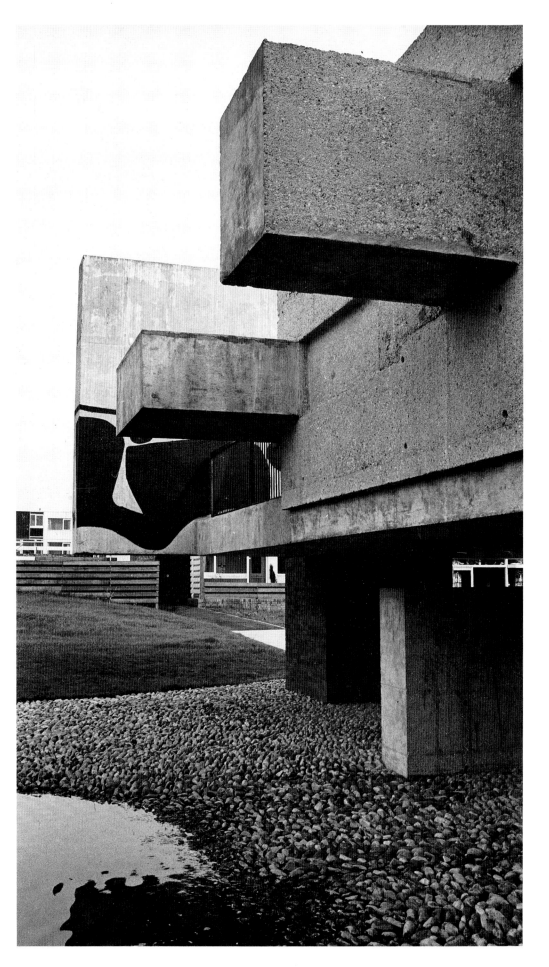

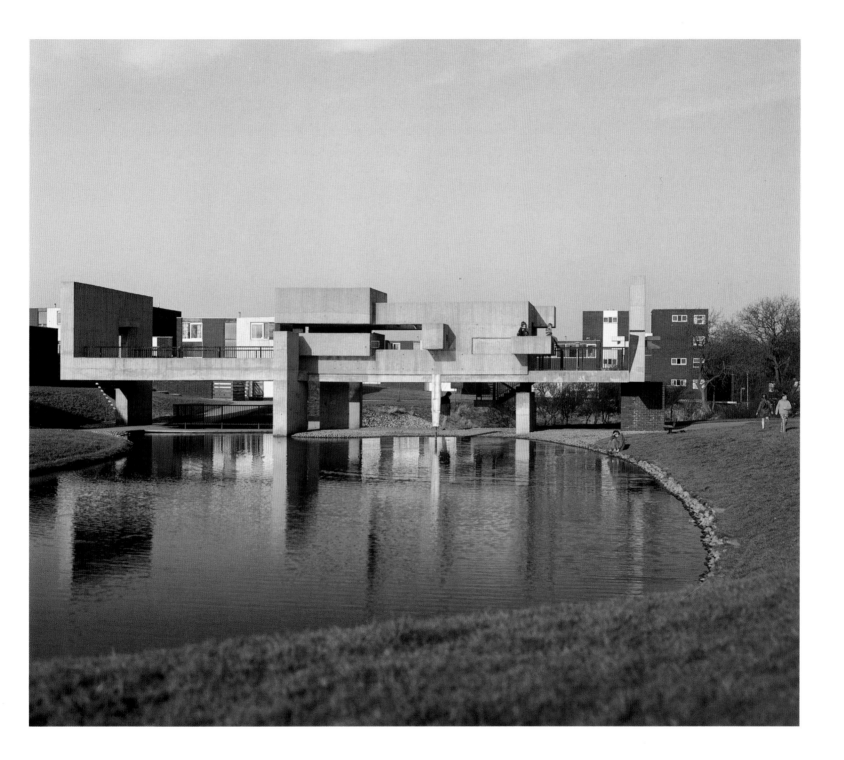

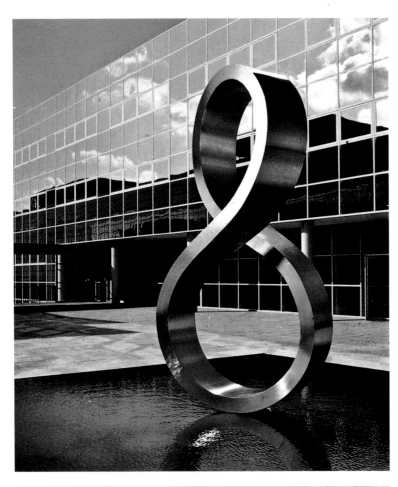

WENDY TAYLOR
Left **Octo** **1981**
Milton Keynes
MILTON KEYNES DEVELOPMENT CORPORATION

Below, left **Armillary Sundial** **1988/9**
Basildon New Town, Roundacre
BASILDON DISTRICT COUNCIL

ANDREW MYLIUS
Time to Look No. 2 **1974/8**
Livingston,
West Lothian
LIVINGSTON DEVELOPMENT CORPORATION

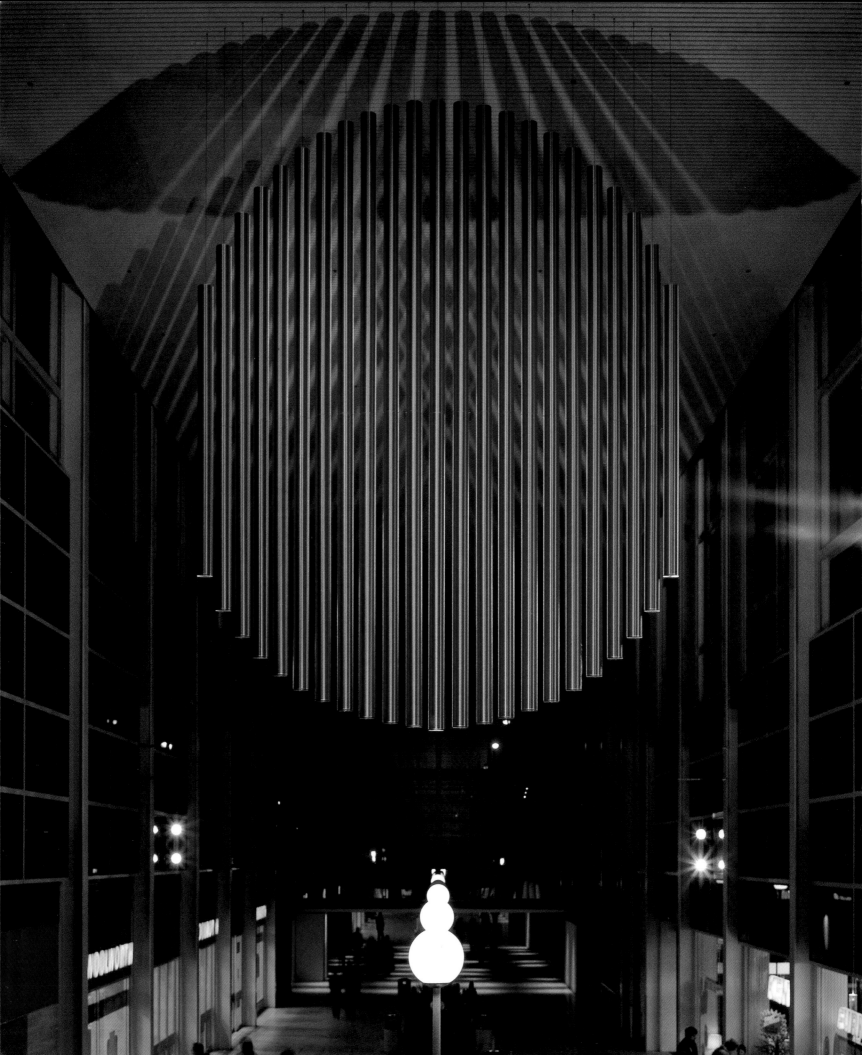

Opposite **LILIANE LIJN**
Circle of Light **1980**
Central Milton Keynes
MILTON KEYNES DEVELOPMENT CORPORATION

BERNARD SCHOTTLANDER
3B Series **1967**
Milton Keynes Development Corporation
Headquarters

2MS Series No. 3 **1970**
Milton Keynes
MILTON KEYNES DEVELOPMENT CORPORATION

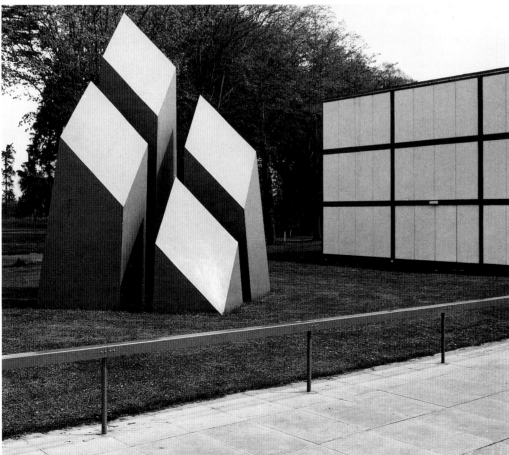

HENRY MOORE
Family Group **1954/5**
Harlow Civic Centre
HARLOW DEVELOPMENT CORPORATION
FREDERICK GIBBERD

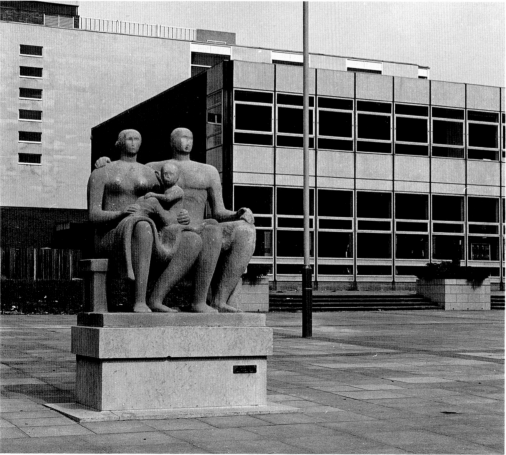

HENRY MOORE
Upright Motive No. 2 **1956**
Harlow New Town
HARLOW DEVELOPMENT CORPORATION
FREDERICK GIBBERD

Opposite **RALPH BROWN**
Meat Porters **1960**
Harlow Market Square
HARLOW DEVELOPMENT CORPORATION
FREDERICK GIBBERD

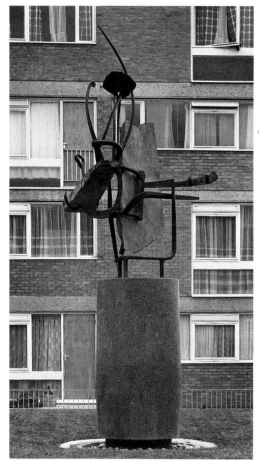

BRYAN KNEALE
Sculpture **1962**
Fenwick Place,
London
LCC ARCHITECT'S DEPARTMENT

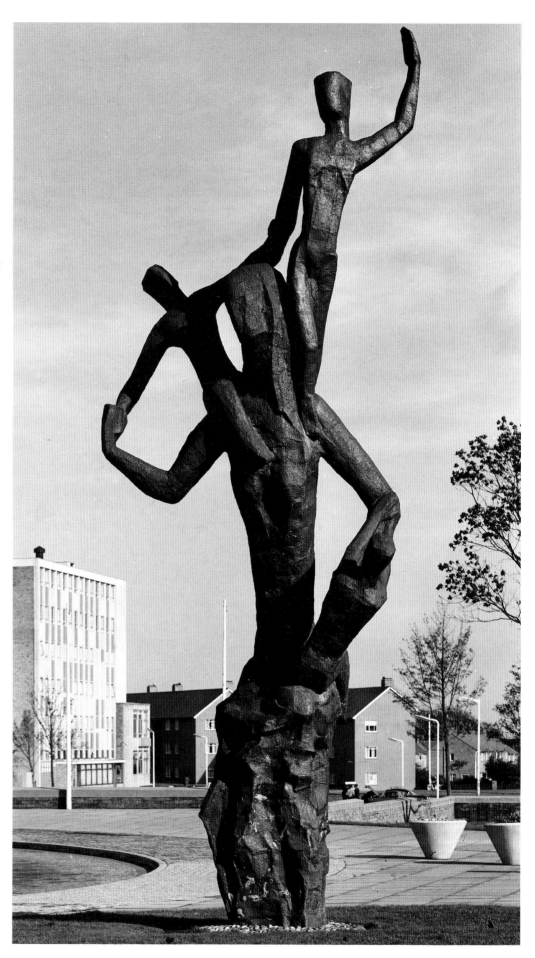

Right **BENNO SCHOTTZ**
Ex Terra **1965**
Glenrothes
GLENROTHES DEVELOPMENT
CORPORATION

HENRY MOORE
Draped Seated Woman **1957/8**
Stifford Estate,
Hackney, London
LCC ARCHITECT'S DEPARTMENT

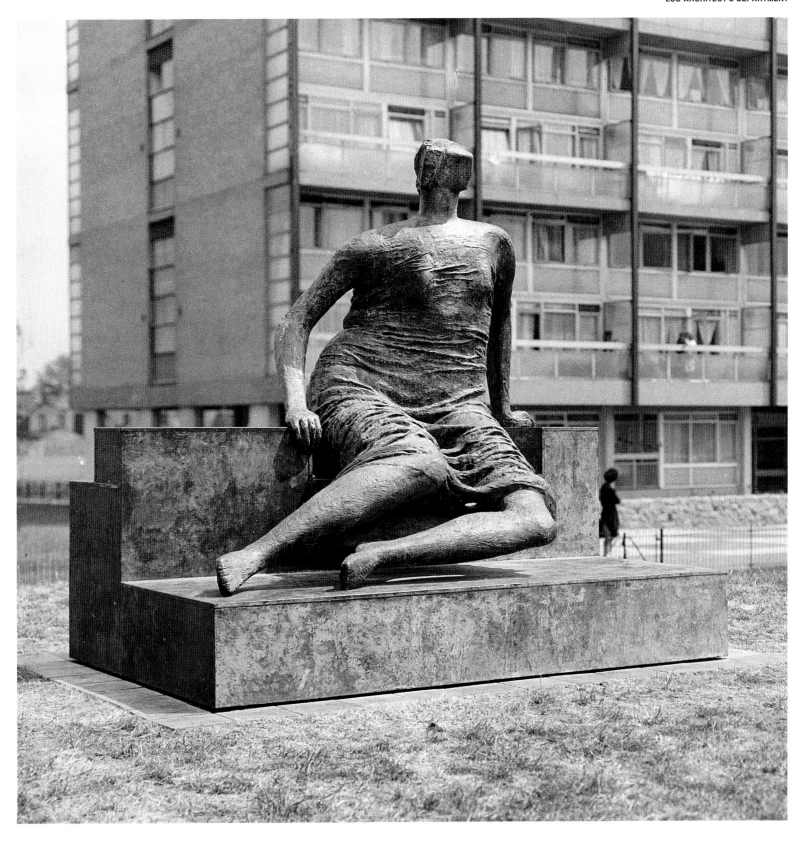

FRED MILLETT
Sculpted wall 1965
Raglan Estate,
Kentish Town, London
GLC ARCHITECT'S DEPARTMENT

BRIAN YALE
Play area 1972
Drysdale Road,
Lewisham, London
GLC ARCHITECT'S DEPARTMENT

DAVID HARDING
Totem Sculpture **1972**
Pitteucahar Housing Precinct,
Glenrothes
GLENROTHES DEVELOPMENT
CORPORATION

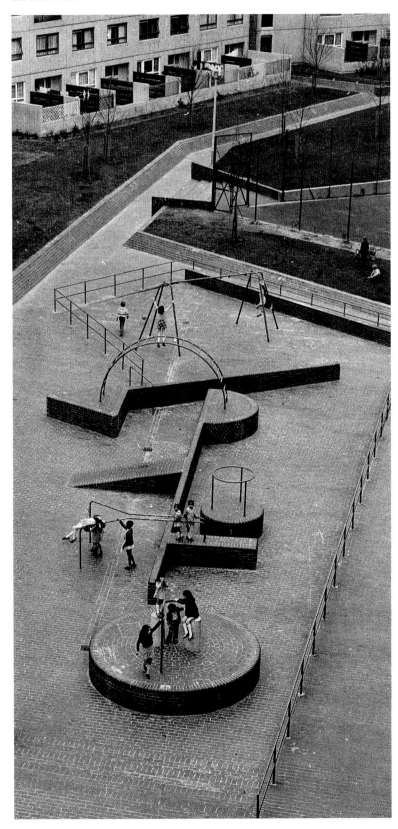

STEVE SMITH
Mural 1977
Southway,
Skelmersdale Town Centre
SKELMERSDALE DEVELOPMENT CORPORATION

MIKE CUMISKY
Conquest **1972**
Railway Road,
Skelmersdale
SKELMERSDALE DEVELOPMENT CORPORATION

DAVID HARDING
Below **Henge** **1973**
Bottom **Twa Heids** **1973**
Opposite **Heritage** **1976**
Glenrothes
GLENROTHES DEVELOPMENT CORPORATION

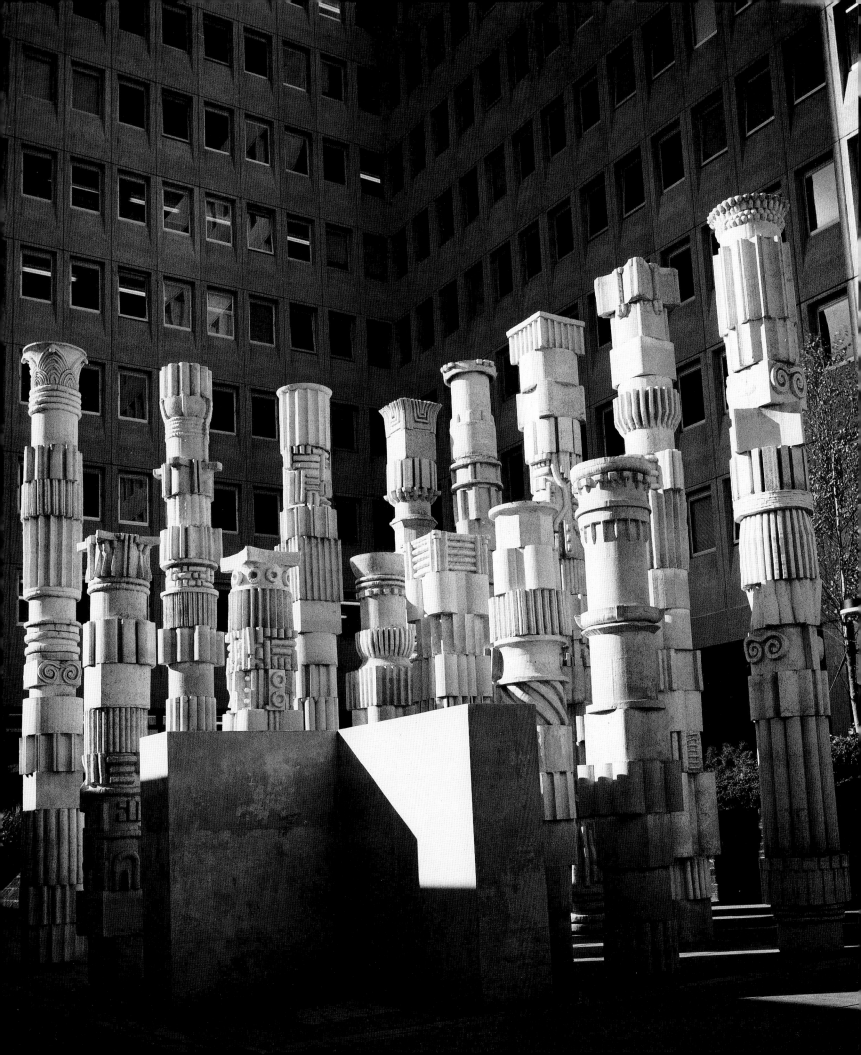

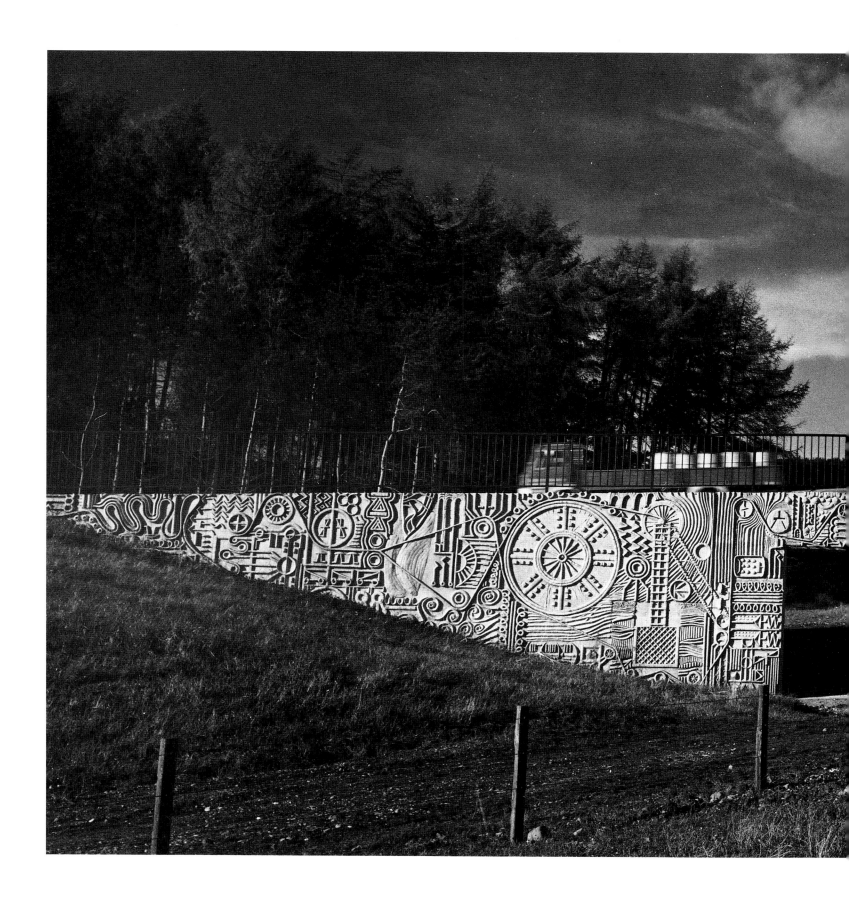

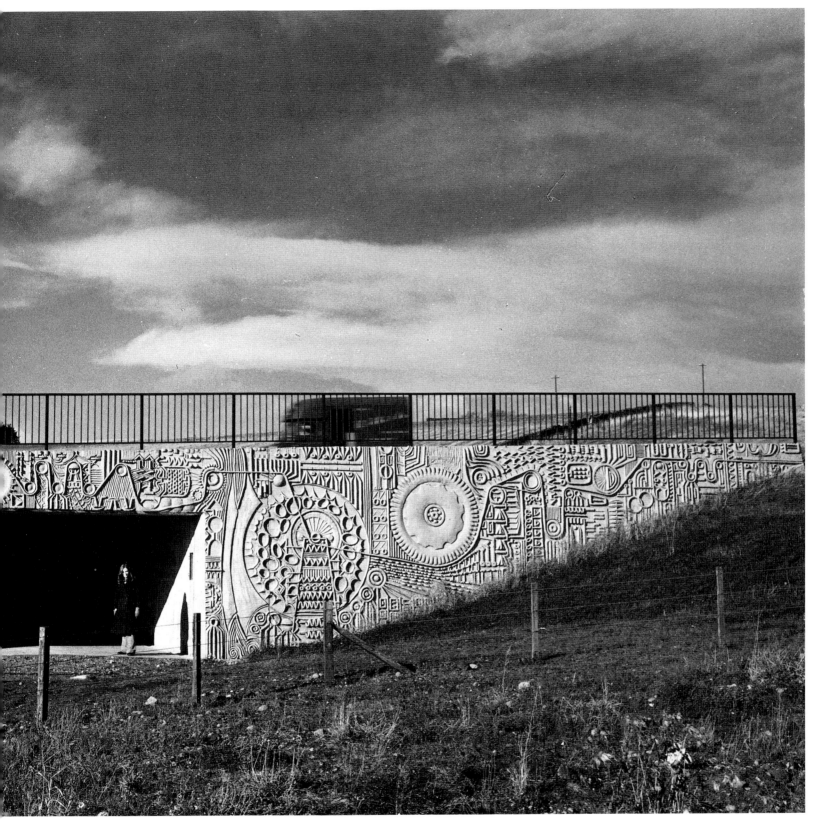

DAVID HARDING
Work **1970**
Underpass, Glenrothes
GLENROTHES DEVELOPMENT CORPORATION

3 Universities

The dramatic expansion in university building after the war led to an acknowledgment, among some institutions at least, of the need for art on the campus. Older universities tended to resist the idea of acquiring contemporary work, although Henry Moore's *Seated Man* and Barbara Hepworth's *Figure (Archaean)* were admitted to the grounds of modern college buildings in Cambridge and Oxford respectively. New universities proved more willing to welcome modern sculpture, regarding it as a manifestation of their commitment to cultural vitality.

Limited construction budgets meant that ambitious plans were often curtailed, and few architects entered into active collaboration with the artists whose works were installed in university locations. Sometimes, however, surprisingly bold projects did reach fruition, nowhere more spectacularly than at the University of Stirling. Here, for a wall of the dining room, Mary Martin produced an anodized aluminium and wood relief extending sixty feet in width. Glinting and reflecting in the light from the windows around it, this *tour de force* of 'constructive' art constitutes a high point in Martin's development. In 1957, twelve years before this work was installed, she wrote that 'there is still exploration to be made on that tenuous border between art and architecture where the abstract artist and the architect speak a common language'. At Stirling she put that belief into convincing practice, and her relief inhabits its space with a greater sense of inevitability than another university dining-room commission — Ivon Hitchens' boisterous *Day's Work* at Sussex, where painting and architecture do not achieve the same oneness of purpose.

Many universities contented themselves with positioning a single sculpture in their grounds, and sometimes the outcome attained a satisfying sense of unity between freestanding image and nearby building. Hepworth's *Four Square (Walk Through)* chimes remarkably well with the proportions and formal organization of Churchill College. Elsewhere, though, bronzes often look unrelated to their surroundings in any coherent way, and their placing seems merely predictable. In a praiseworthy attempt to escape from such a formulaic approach, John Maine uses his multi-part *Aston Cross* as a cue for greater integration with the grounds of Aston University. Gerald Laing's *Callanish* likewise occupies its allotted territory with inventiveness at the University of Strathclyde.

Although the size of the new universities usually obliges artists to work on a monumental scale, modest aims can have more effective results. Ian Hamilton Finlay's sundial at the University of Kent makes no vaunting claims for itself. Caught intriguingly between the status of sculpture and time-keeping implement, it makes the most of this ambiguity. The carving's practicality means that the elegance and lyricism of Finlay's incised design provide unexpected pleasure. It seems preferable to the pretensions of large but less successful works, which can easily be weighed down by their ponderous gigantism.

One of the most outstanding university commissions, however, arrives at a thoroughly convincing state of grandeur. To stand underneath Richard Deacon's *Let's Not Be Stupid* at Warwick campus is to be caught up immediately in the drama he directs with such aplomb. Deacon was galvanized by the chance to manipulate form on a flamboyant scale. There is a swashbuckling assurance about the way he engineers the airborne transition from one side of the sculpture to the other. He treats the mound as an arena, where a titanic encounter is enacted with immense theatrical flair. But his instinctive feeling for spectacle is not marred by staginess or overkill. The contrast between the two forms is defined with lean athleticism, purged of superfluity and yet retaining its complex dynamism intact.

WENDY TAYLOR
Triad **1971**
Somerville College,
University of Oxford
ARUP ASSOCIATES

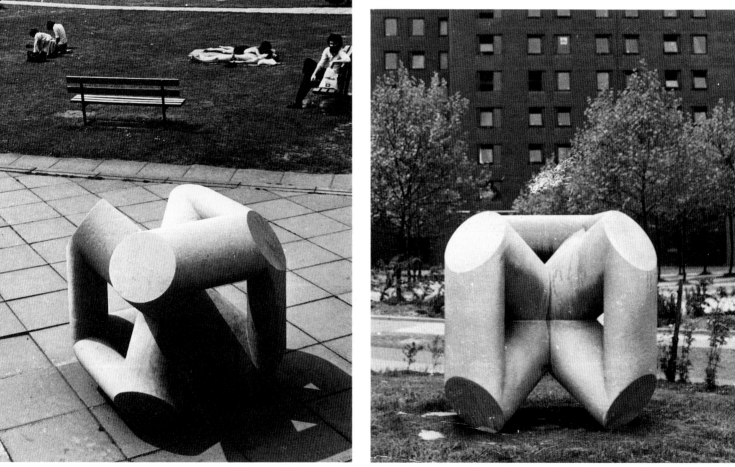

JOHN MAINE
*Aston Cross (Five Pieces on
a Campus)* **1976/7**
University of Aston,
Birmingham
**ROBERT MATTHEW JOHNSON-MARSHALL & PARTNERS
SIR BASIL SPENCE GLOVER & FERGUSON**

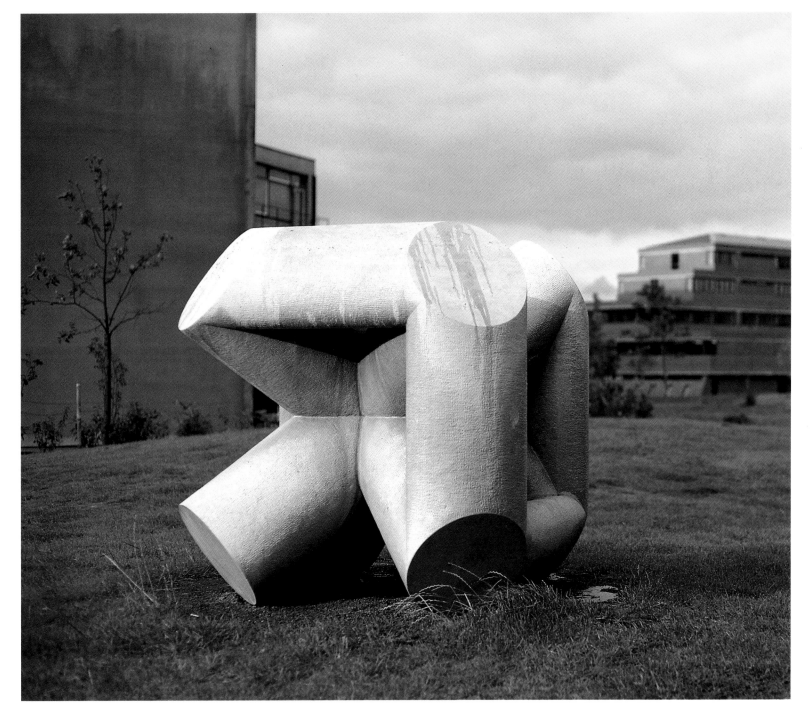

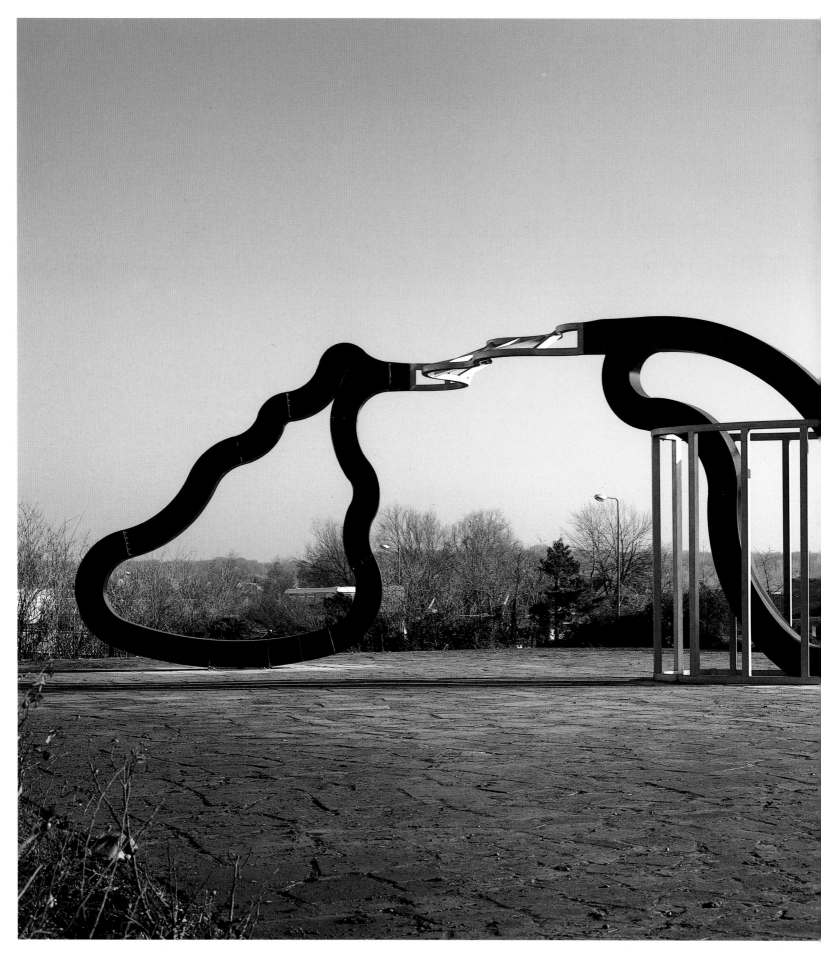

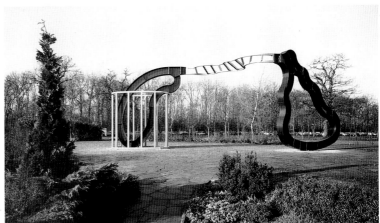

RICHARD DEACON
Let's Not Be Stupid 1985/91
University of Warwick
RENTON HOWARD WOOD LEVIN PARTNERSHIP
YORKE ROSENBERG MARDALL

VICTOR PASMORE
Point of Contact **1965**
PATRICK HERON
Orange and Lemon Yellow with White **1965**
Four Vermilions **1965**
University of Warwick
YORKE ROSENBERG MARDALL

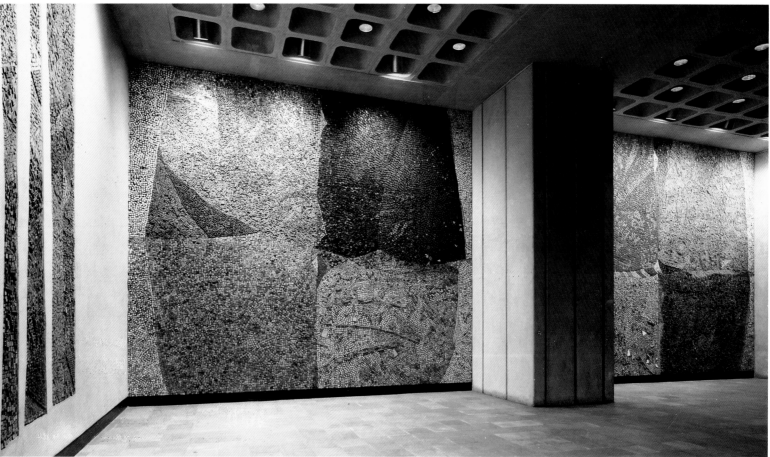

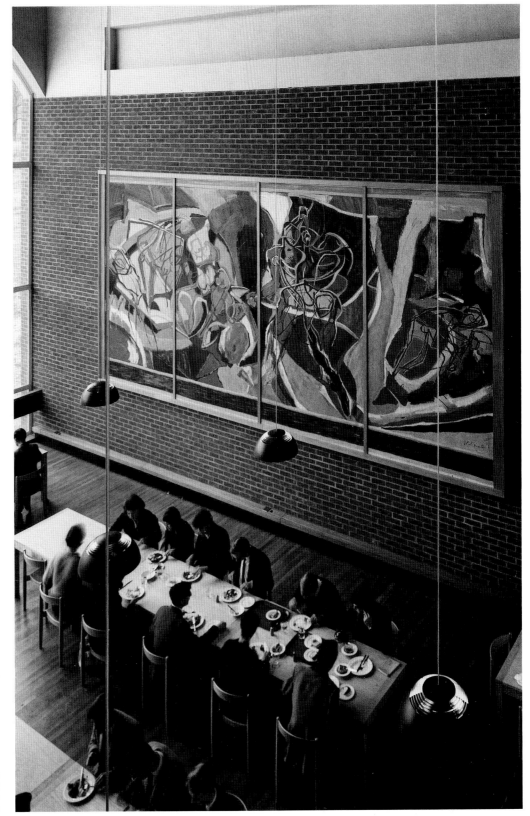

Above **BERNARD COHEN**
Garrick No. 2 **1964**
PAUL FEILER
Enclosed Forms Brown and Blue **1965**
University of Liverpool,
Electrical Engineering
and Electronics Department
YORKE ROSENBERG MARDALL

Opposite **HANS TISDALL**
The Alchemist's Elements **1967**
University of Manchester,
Science/Technology/Chemistry Departments
FAIRHURSTS

Right **IVON HITCHENS**
Day's Work **1966**
University of Sussex Refectory
SIR BASIL SPENCE

ANDREW YATES
Mural 1971
Brunel College,
Uxbridge, Middlesex
RICHARD SHEPPARD ROBSON &
PARTNERS

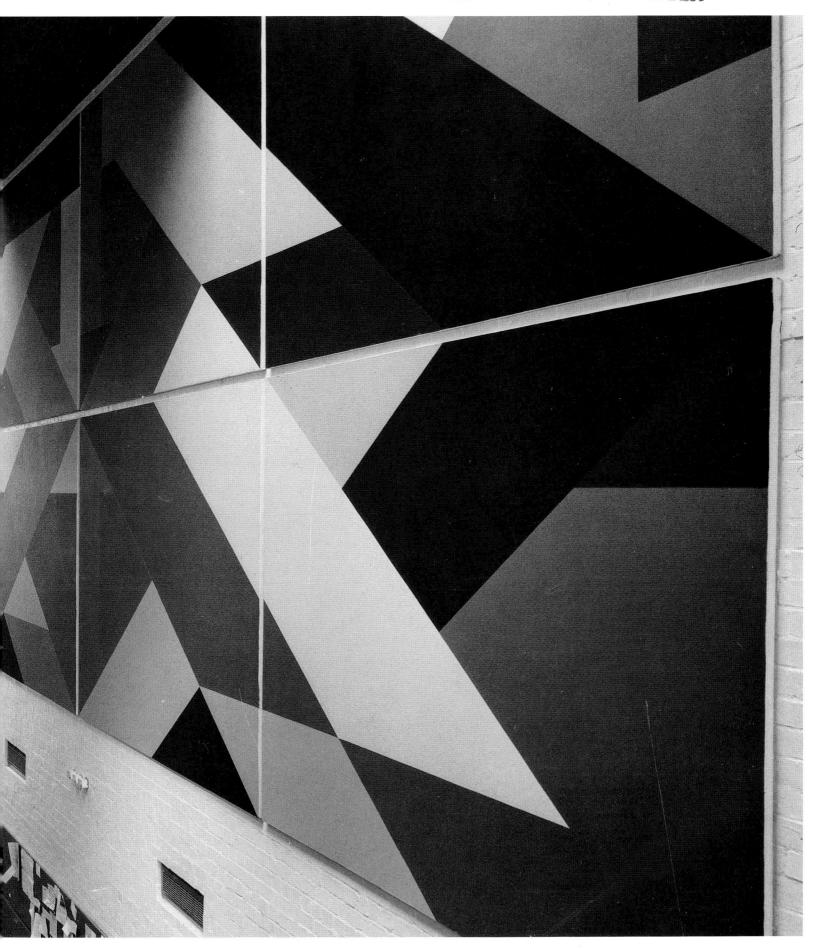

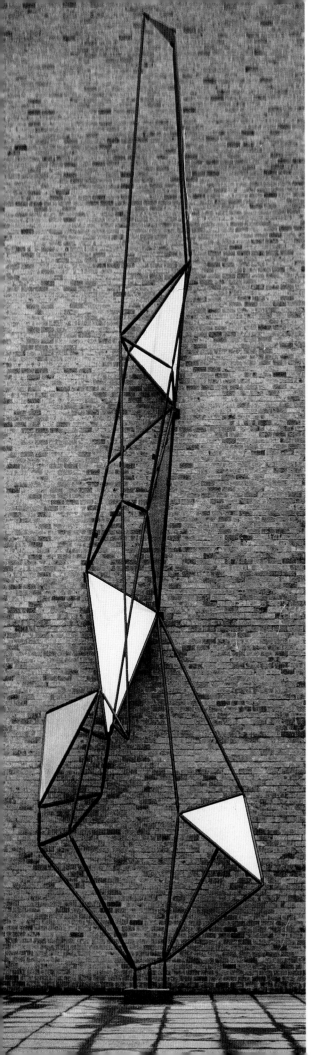

Left **JOHN HOSKIN**
Sculpture 1973
University of Lancaster,
Physics Building
TOM MELLOR & PARTNERS

MARY MARTIN
Wall construction 1969
University of Stirling
ROBERT MATTHEW JOHNSON-MARSHALL
& PARTNERS

GERALD LAING
Callanish **1974**
University of Strathclyde
Campus buildings, left to right:
FRANK FIELDEN
G.R.M. KENNEDY & PARTNERS
WALTER UNDERWOOD & PARTNERS

F.E. McWILLIAM
Pûy de Dome **1962**
University of Southampton,
Arts Faculty
SIR BASIL SPENCE BONNINGTON
& COLLINS

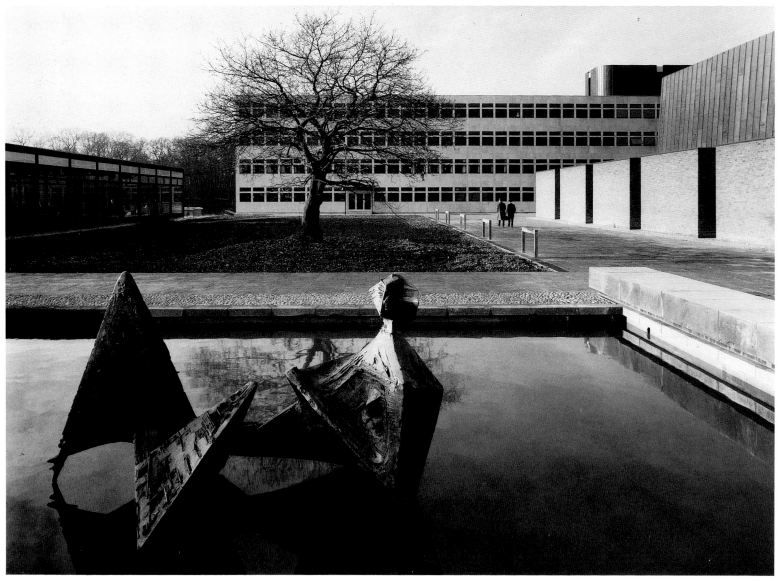

JUSTIN KNOWLES
Two Stainless Steel Forms with
White 1969/71
University of Stirling,
MacRoberts Art Centre
SIR ROBERT MATTHEW JOHNSON
MARSHALL & PARTNERS

HENRY MOORE
Seated Man 1964
Corpus Christi College,
University of Cambridge
ARUP ASSOCIATES

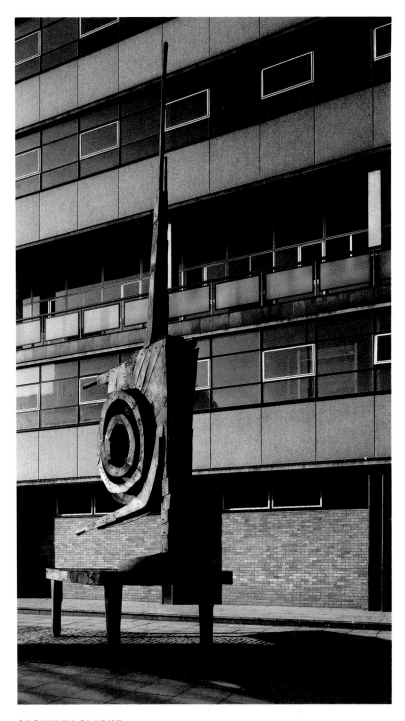

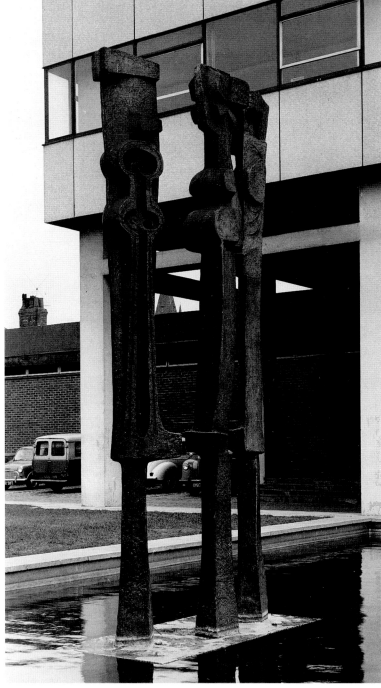

GEOFFREY CLARKE
Swirling Nebulae **1962**
University of Newcastle,
Physics Building
SIR BASIL SPENCE GLOVER & FERGUSON

HUBERT DALWOOD
Sculpture 1959/60
University of Liverpool
Physics Building
SIR BASIL SPENCE GLOVER & FERGUSON

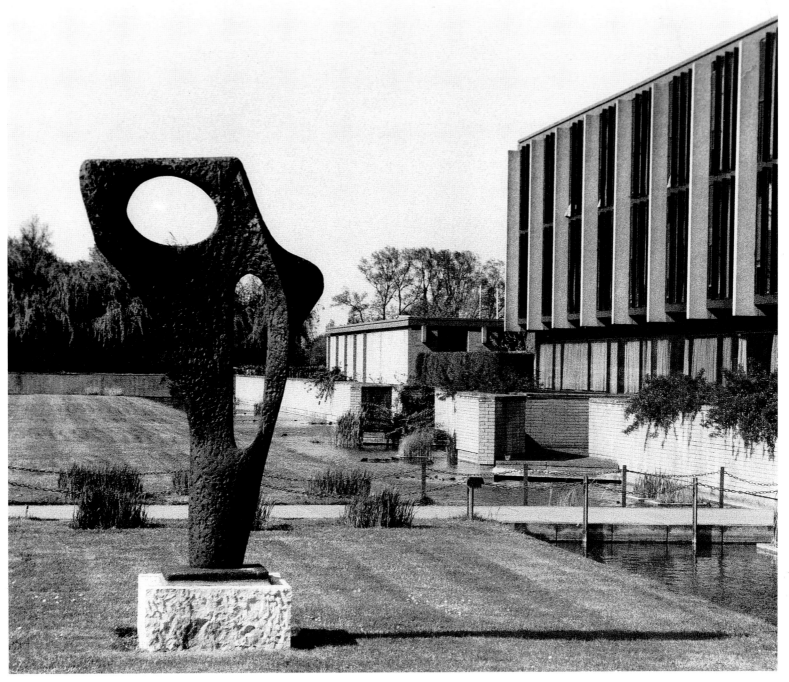

BARBARA HEPWORTH
Figure (Archaean) **1959**
St Catherine's College,
University of Oxford
ARNE JACOBSEN

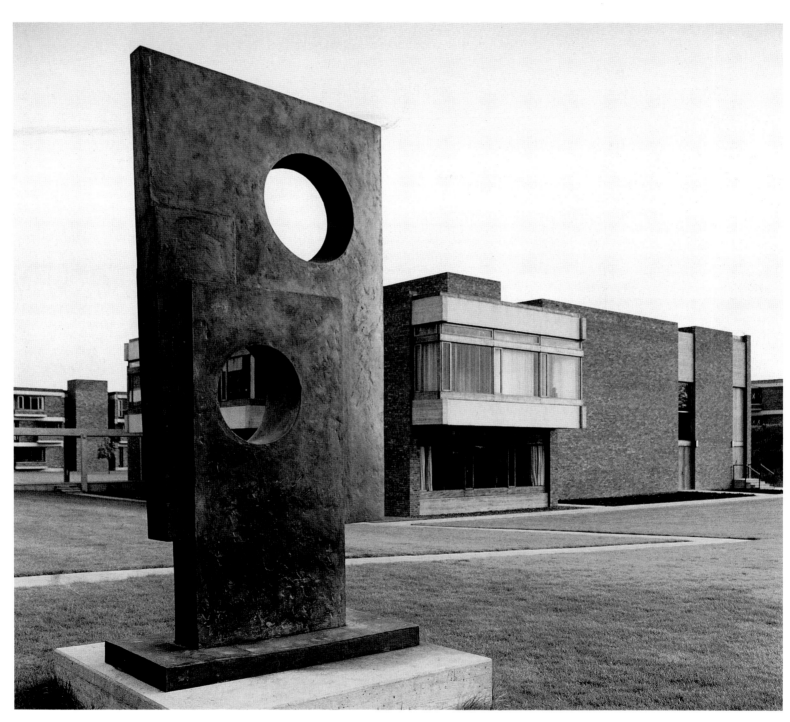

BARBARA HEPWORTH
Four Square (Walk Through) **1966**
Churchill College,
University of Cambridge
RICHARD SHEPPARD ROBSON & PARTNERS

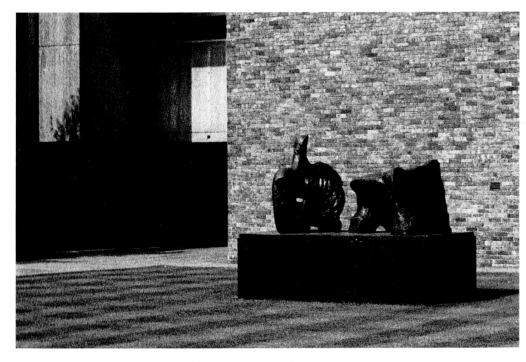

HENRY MOORE
Three Piece Reclining Figure
No. 2 **1961/2**
Churchill College,
University of Cambridge
RICHARD SHEPPARD ROBSON & PARTNERS

Below **IAN HAMILTON FINLAY**
Sundial **1978**
University of Kent
WILLIAMSON FAULKNER BROWN & PARTNERS

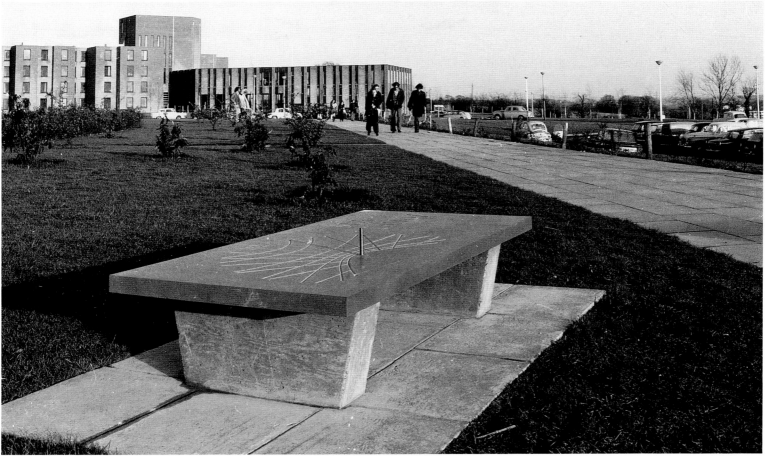

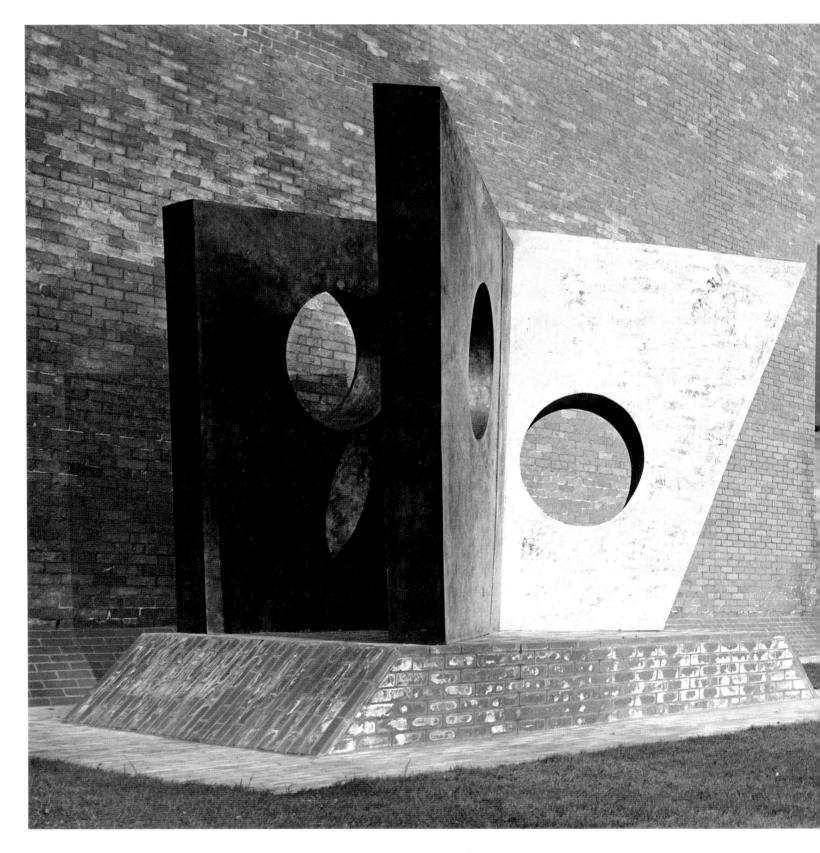

BARBARA HEPWORTH
Three Obliques (Walk in) 1968
Cardiff University College
School of Music
ALEX GORDON & PARTNERS

4 Public Services

Passengers on the London Underground are given scant reason to take an interest in their dismal surroundings. A glance out of the carriage window is usually prompted only by the need to make a swift check on a station's name. At Tottenham Court Road, however, the prevailing dreariness has given way to a more bracing alternative. Eduardo Paolozzi's glass mosaics emblazon the platforms with richly coloured decorations. They proclaim the identity of the station with gusto, evident even in the few seconds' pause before the train moves to its next stop on the Central Line.

Anyone getting out at Tottenham Court Road quickly appreciates that Paolozzi has charged his elaborate scheme with multi-layered references to the area of London above. Saxophones celebrate the neighbourhood's music shops; an Egyptian mummy-case acknowledges the British Museum; and more abstract, staccato forms refer to the video and computer shops which now dominate so much of the area. Moreover, the opulence of the colour testifies to the pleasure with which Paolozzi, born in Edinburgh of Italian parents, views the multi-cultural diversity of London life.

The exuberance and thoughtfulness of the Tottenham Court Road mosaics compare very favourably with the other tube stations redesigned in the 1980s. Most of them are half-hearted affairs: gift-wrapping is defined with slickness at Bond Street, and Sherlock Holmes' ubiquitous profile is exploited at Baker Street. Both these designs are uninformed by the sense of energy and personal engagement which Paolozzi brought to his commission. Although he was constrained by the difficulties involved in working with a cramped building constructed decades earlier, the outcome demonstrates how even the most unprepossessing of public-service interiors can be transformed with the requisite amount of imaginative resolve.

Such objects require constant maintenance if they are to withstand their exposure to daily use. Tottenham Court Road is one of London's most intensively crowded tube stations, so the mosaic pieces must be replaced when they suffer damage. Other locations are far calmer, and the security on hand at Newcastle's Civic Centre ensures that Victor Pasmore's serene yet physically fragile painting on glass has survived with ease since its completion in 1961.

Exterior works cannot be given the same degree of protection, however. While John Piper's extensive fibreglass murals on the British Gas Research Station in Fulham are high enough from the ground to be safe from vandalism, such immunity is not enjoyed by David Binnington and Desmond Rochfort's Mexican-inspired murals at Paddington. Painted underneath the Westway flyover in the toughest of materials, both these murals have suffered from graffiti and seem unlikely ever to benefit from the restoration they need. In an age of accelerating urban violence, no artist should be expected to produce work in vulnerable locations. Better by far to make safety a priority from the outset, so that Hugh O'Donnell's *Regis Novar* can assert its Delaunay-like optimism at a prudent distance from the floor of the Regis Centre at Bognor Regis. William Pye's water sculpture at Gatwick may be passed by multitudes each day, but the position it occupies within the airport guarantees that *Slipstream* will remain untouched long after many street murals have been irretrievably defaced.

HUGH O'DONNELL
Regis Novar **1979**
Regis Centre,
Bognor Regis
FARRINGTON DENYS & FISHER

JOHN PIPER
Mural 1962
British Gas Corporation
Research & Development Division
Fulham, London
COLLISTER & PARTNERS

Opposite **EDUARDO PAOLOZZI**
Murals 1984/5
Tottenham Court Road Underground Station,
London
LONDON UNDERGROUND LTD

Below **DAVID BINNINGTON AND**
DESMOND ROCHFORD
Murals 1977
Royal Oak Flyover,
Paddington, London
GLC ARCHITECT'S DEPARTMENT

WILLIAM PYE
Slipstream 1988
Gatwick Airport
YRM

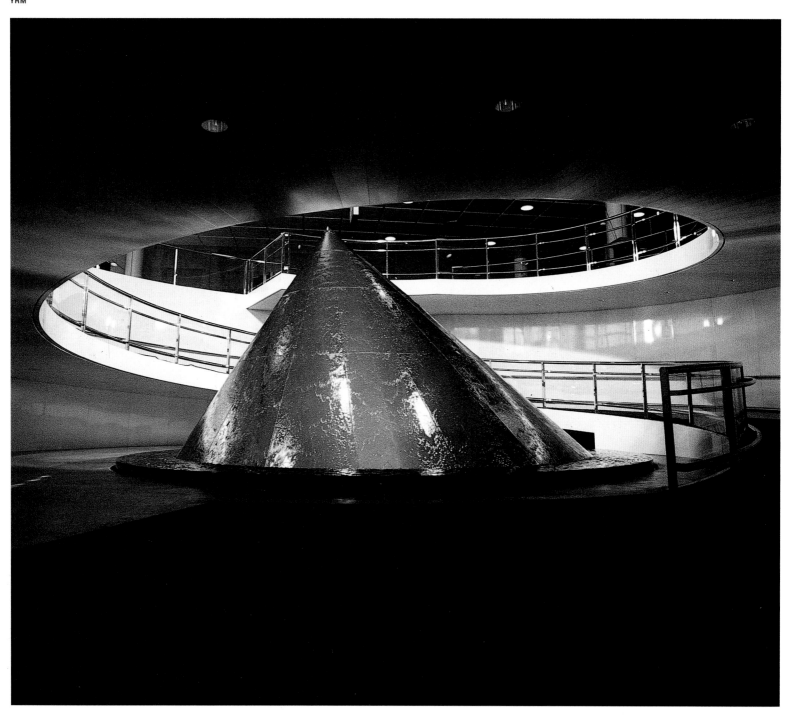

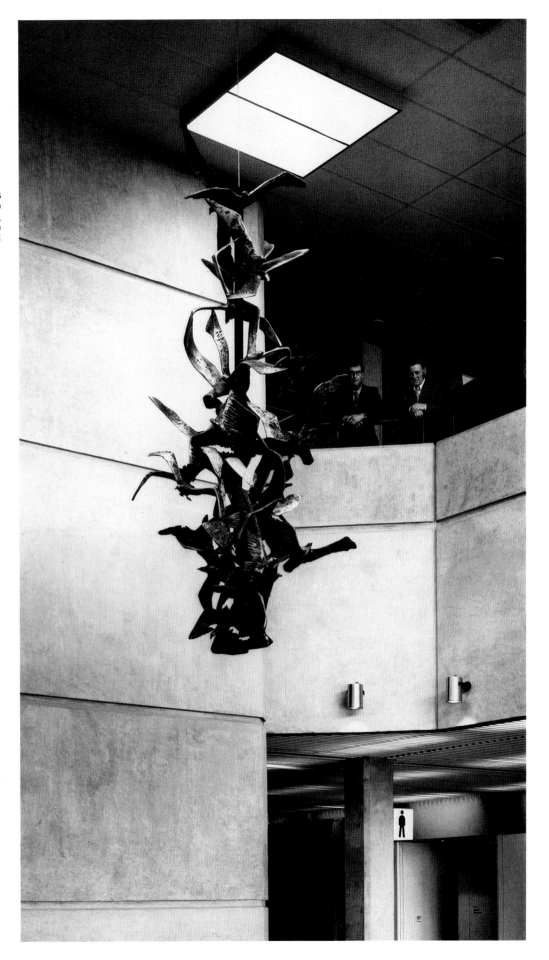

PETER NICHOLAS
Flight 4 **1970**
Cardiff Wales Airport,
Rhoose, Glamorgan
COUNTY OF GLAMORGAN ARCHITECT'S OFFICE

VICTOR PASMORE
Painting on glass 1961
Rates Hall, Civic Centre,
Newcastle-upon-Tyne
F.W. KENYON

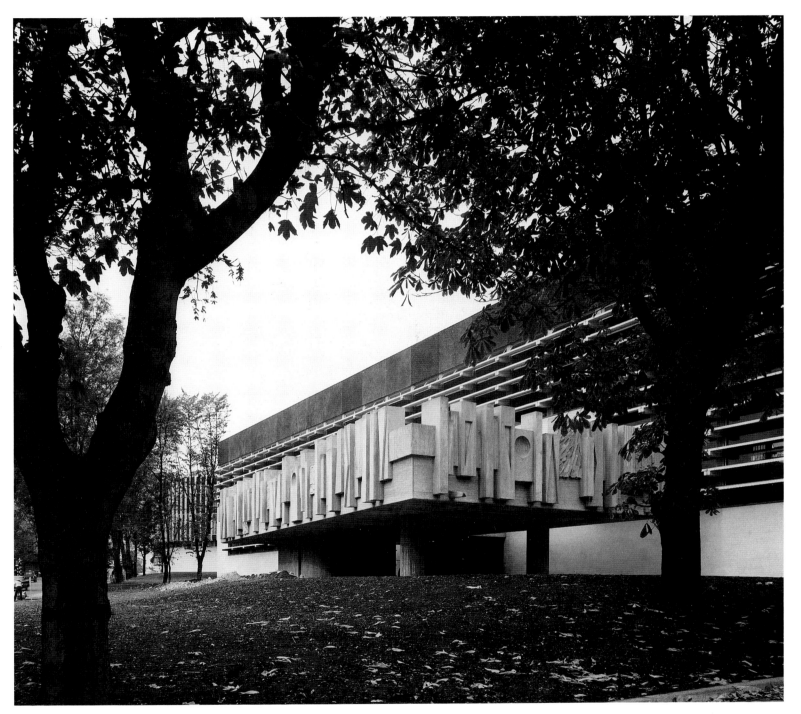

WILLIAM MITCHELL
Sculpted wall 1964
Hampstead Civic Centre
Swiss Cottage, London
SIR BASIL SPENCE BONNINGTON
& COLLINS

Opposite **KENNETH BARDEN**
Tiled mural 1955
Herts/Essex Water Board
Pump House, Sawbridgeworth
SCHERRER & HICKS

DAVID GENTLEMAN
Murals 1979
Charing Cross Underground Station,
London
LONDON UNDERGROUND LTD

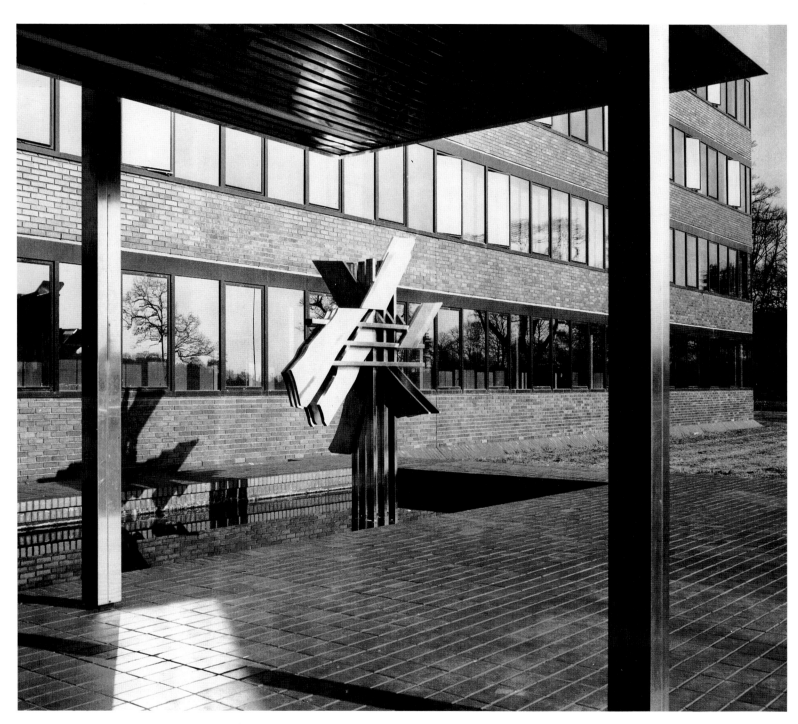

HUBERT DALWOOD
Sculpture 1972
Department of the Environment Business Statistics Office,
Newport, Gwent
PERCY THOMAS PARTNERSHIP

Opposite **JOHN HOSKIN**
Sculpture 1970
Darlington Town Hall,
Co. Durham
COUNTY ARCHITECT'S DEPARTMENT

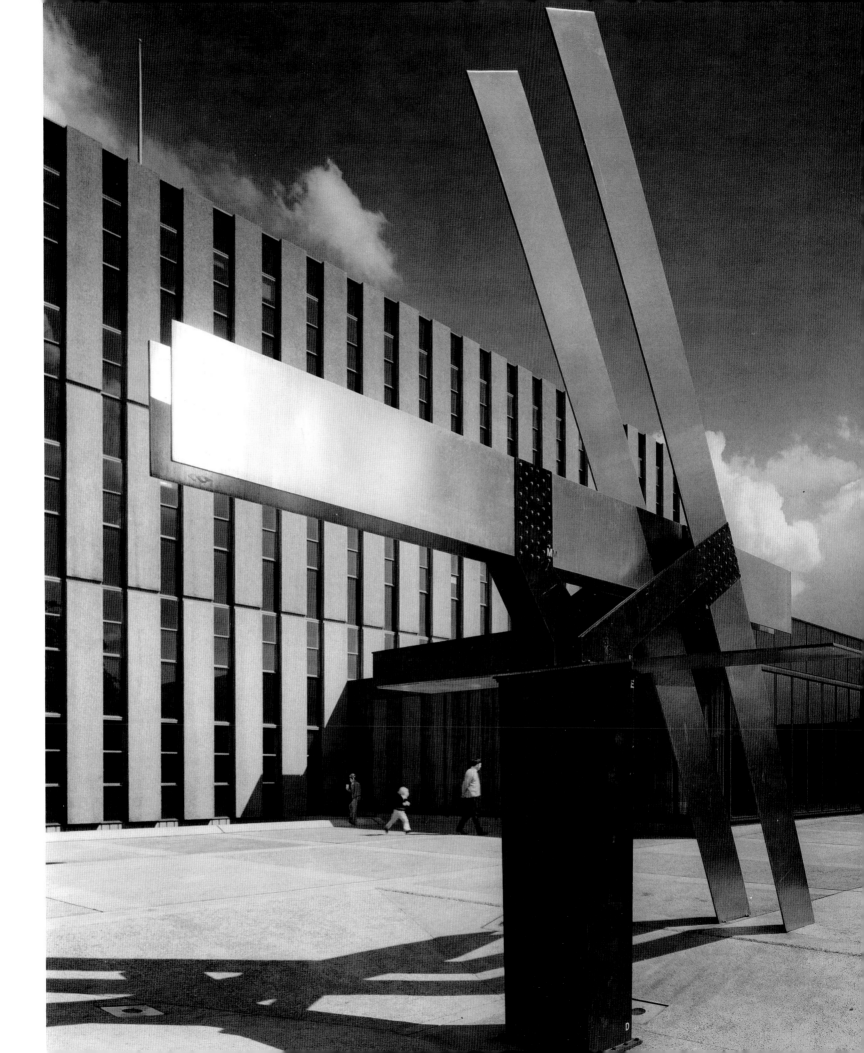

5 Hospitals

In eighteenth-century Britain an extraordinary abundance of ambitious art was produced for new hospitals, ranging from the baroque extravagance of Sir James Thornhill's great Painted Hall at Greenwich to Hogarth's robust work for St Bartholomew's and the Foundling Hospital. Although the tradition subsequently withered, it has been revived in the post-war period throughout the United Kingdom.

One of the earliest manifestations of this renewed interest occurred at Belfast, where Mary Martin was commissioned by the architect John Weeks to make a steel and plaster relief for the main entrance of Musgrave Park Hospital. With its D-shaped apertures breaking the predominant emphasis on rectangular order, this lucid relief presents a variety of aspects to viewers passing by on the entrance side or looking at it from the staircase leading to the first floor. The fact that it is also visible from the full length of the wards on either side testifies to the role played by the screen in the life of the hospital. It exemplifies, too, Martin's belief that 'the artist should ... have an understanding of, and a capacity to enter into, architecture, without destroying it, or dominating it, or distracting from it; an ability to crystallize it in an art which is a simple statement on the personal scale so that the work becomes a comprehensible symbol of the building itself, a part of the architecture but not architecture'.

Even greater prominence was accorded to works of art at the Altnagelvin Hospital in Derry, where Eugene Rosenberg commissioned F.E. McWilliam to make a commanding bronze of the mythical Princess Macha for an exterior space, and then invited William Scott to execute an immense wall-painting for the entrance hall. The outcome recovered some of the grandeur of the eighteenth-century commissions, and demonstrated a heartening determination to alleviate the impersonal, sterile severity of the modern hospital.

Realizing that art has a role to play in generating a sense of well-being among patients, Rosenberg went on to ensure that his new building for St Thomas' Hospital in London was filled with a cornucopia of images. Robyn Denny was commissioned to produce a sequence of abstract enamels for recessed positions in the entrance hall, and Kajt Kapolka produced a tiled mural for the hospital baths. But the most outstanding of all the works acquired for St Thomas' is, without doubt, the Naum Gabo *Revolving Torsion, Fountain* outside the building. When set in motion, the interplay between its tensile steel structure and the soft explosions of water is superbly orchestrated.

Most hospitals cannot afford to commission art with such expansiveness, especially in these relentlessly cost-cutting times. Another ambitious venture was, however, carried out in the late 1980s for St Mary's Hospital, Paddington. John Weeks invited Bridget Riley to produce an extensive mural sequence in the new Queen Elizabeth the Queen Mother Wing. Completed well before the building was opened, the paintings rely on the language of vibrantly coloured horizontal stripes deployed in many of Riley's recent easel paintings. Here, though, on both the seventh and eighth floors, the stripes have been integrated with the interiors they enliven. Instead of occupying a single site in each corridor, they are wrapped around the entire sequence of walls. With a warm mustard-orange dominant on one storey and a cool blue on the other, they lend an unexpected vivacity to spaces which might otherwise look clinical to a fault. Although abstract, they succeed in evoking the idea of swathing and, by extension, the curative impulse to which hospitals should above all be devoted.

NAUM GABO
Revolving Torsion, Fountain **1976**
St Thomas' Hospital,
London
YORKE ROSENBERG MARDALL

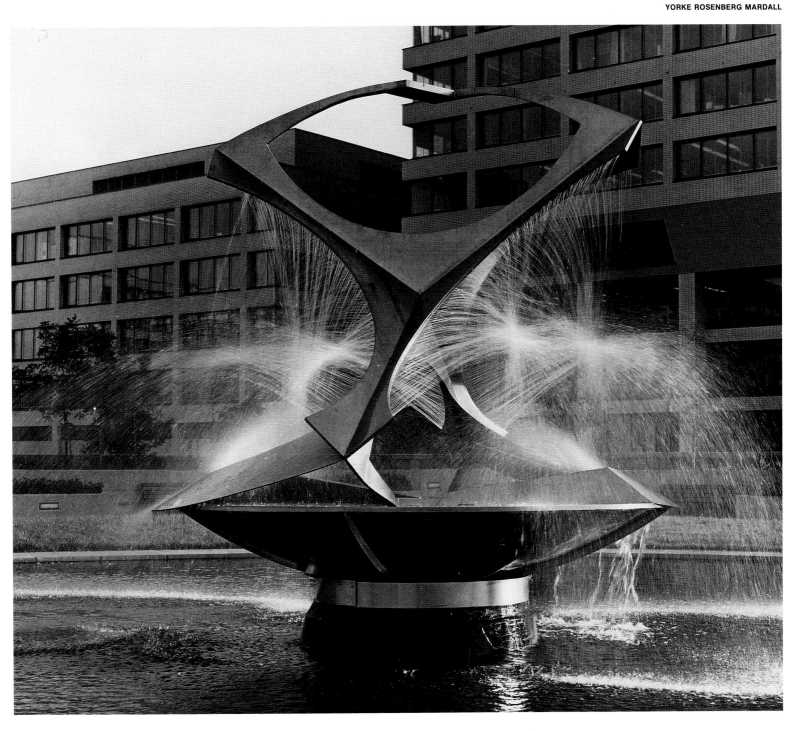

F.E. McWILLIAM
Princess Macha **1957**
Altnagelvin Hospital,
Londonderry
YORKE ROSENBERG MARDALL

Opposite **HENRY MOORE**
Reclining Figure **(working
model) 1963/5**
Charing Cross Hospital,
London
RALPH TUBBS

PAUL FEILER
Tiled mural 1957
Altnagelvin Hospital Hydrotherapy Pool,
Londonderry
YORKE ROSENBERG MARDALL

PETER RANDALL PAGE
Sculpture 1980
ANTHONY EYTON
The Beach 1974
Leicester Royal Infirmary
PICK EVERARD KEAY & GIMSON

JESSE WATKINS
Sculpture 1974
Royal Free Hospital,
Hampstead, London
WATKINS GRAY WOODGATE INTERNATIONAL

MARY MARTIN
Waterfall 1957
Musgrave Park Hospital,
Belfast
LLEWELYN-DAVIES WEEKS

EDUARDO PAOLOZZI
The Frog **1958**
Leicester Royal Infirmary
PICK EVERARD KEAY & GIMSON

ALBERT IRVIN
Celebration **1987**
Homerton Hospital,
London
YRM

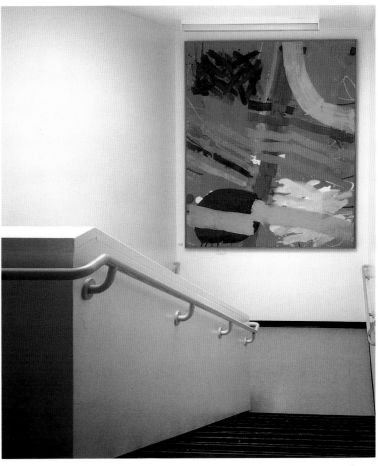

Below **WILLIAM SCOTT**
Four Seasons **1957**
Altnagelvin Hospital,
Londonderry
YORKE ROSENBERG MARDALL

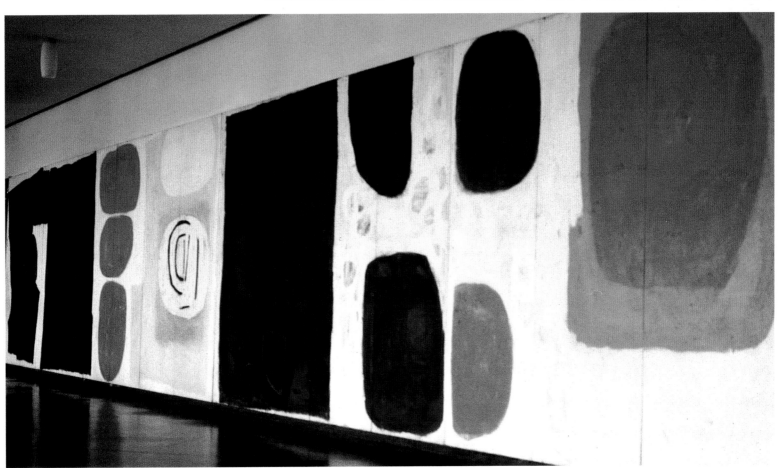

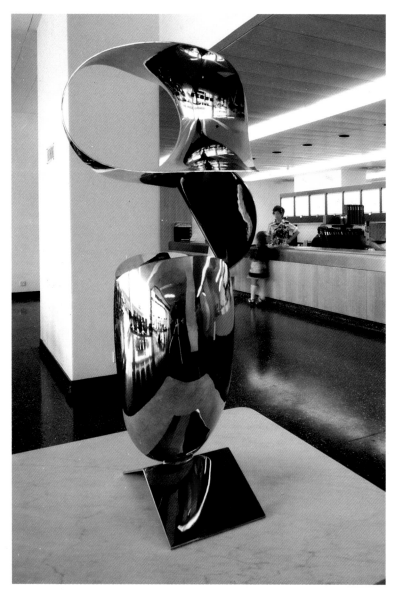

Above **ANTANAS BRAZDYS**
Bird **1975**
St Thomas' Hospital, Out Patients' Department,
London
YORKE ROSENBERG MARDALL

Right **KAJT KAPOLKA**
Tiled mural 1975
St Thomas' Hospital Hydrotherapy Pool,
London
YORKE ROSENBERG MARDALL

Opposite **BRIDGET RILEY**
Murals 1987
St Mary's Hospital,
Paddington, London
LLEWELYN-DAVIES WEEKS

ROBYN DENNY
St Thomas' Enamels **1975/6**
St Thomas' Hospital,
London
YORKE ROSENBERG MARDALL

6 Ecclesiastical Buildings

The decline of organized religion, combined with the rarity of new church architecture, has militated against the commissioning of ecclesiastical art in the post-war period. Henry Moore did, admittedly, produce one of his masterpieces when he was invited by the rector of St Matthew's, Northampton, to carve a *Madonna and Child* for the church's fiftieth anniversary in 1943. Three years later Graham Sutherland painted an impassioned *Crucifixion* for the same interior, and these two commissions suggested that a great deal might be expected of modern religious art.

The fact remains, however, that little work of consequence was subsequently produced for contemporary ecclesiastical buildings. St Matthew's is a Victorian church, and the nave of Llandaff Cathedral where Jacob Epstein installed his *Christ in Majesty* in 1955 is older still. It is difficult to avoid concluding, at Llandaff, that Epstein's aluminium figure on an organ loft designed by George Pace is an intrusive addition to the interior.

Coventry Cathedral, the most spectacular union of post-war religious art and architecture in Britain, provided Epstein with a more congenial setting. His bronze *St Michael Subduing the Devil* is given space to breathe on Basil Spence's sandstone facade, but it does not possess a wholly convincing relationship with the building. John Piper's stained glass in the Baptistery is more attuned to the architecture, and the bronze eagle produced by Elizabeth Frink for the lectern seems equally at home in its surroundings. As for Sutherland's colossal tapestry of *Christ in Majesty*, its defects cannot prevent this towering presence from presiding over the nave with an almost hallucinatory force. Spence's willingness to allow this image such an overpowering role marked him out from most members of his

profession, who would have been far more wary of allowing an artist to dominate a contemporary building.

At Liverpool, where the only other major cathedral of the period was erected after the abandonment of Lutyens's great pre-war design, Frederick Gibberd welcomed the use of relief carving and stained glass. But nothing here compares with the outsize audacity of Sutherland's *coup de théâtre* at Coventry. William Mitchell, who had at an earlier stage in his career worked for the London County Council's Housing Division under Oliver Cox, produced an abstract design and bronze doors for the Cathedral's entrance. His experience in London had convinced him of the need to integrate his work as closely as possible with the architecture, and the result could hardly be more opposed to the way Epstein's *St Michael* contrasts with the entrance facade at Coventry. Inside the Catholic cathedral at Liverpool, stained glass is likewise kept within the structural limits defined by the tent-like building. So are the tabernacle and reredos commissioned from Ceri Richards, who was not allowed to impose his vision of God on the interior as overwhelmingly as Sutherland.

Most contemporary church art is more discreet, and Ernest Pascoe's *Christ in Glory* at the Church Centre of St Augustine in Bristol seems almost subdued compared with the Coventry tapestry. Even Sutherland was obliged to scale down his ambitions when he painted a later *Crucifixion* for St Aidan's Church in west London. Although closely allied to his earlier version of the subject in St Matthew's, its image of the anguished Christ is here marooned with uncompromising severity in the starkness of a contemporary interior.

WILLIAM MITCHELL
Carving and bronze doors 1967
Metropolitan Cathedral
of Christ the King,
Liverpool
FREDERICK GIBBERD
& PARTNERS

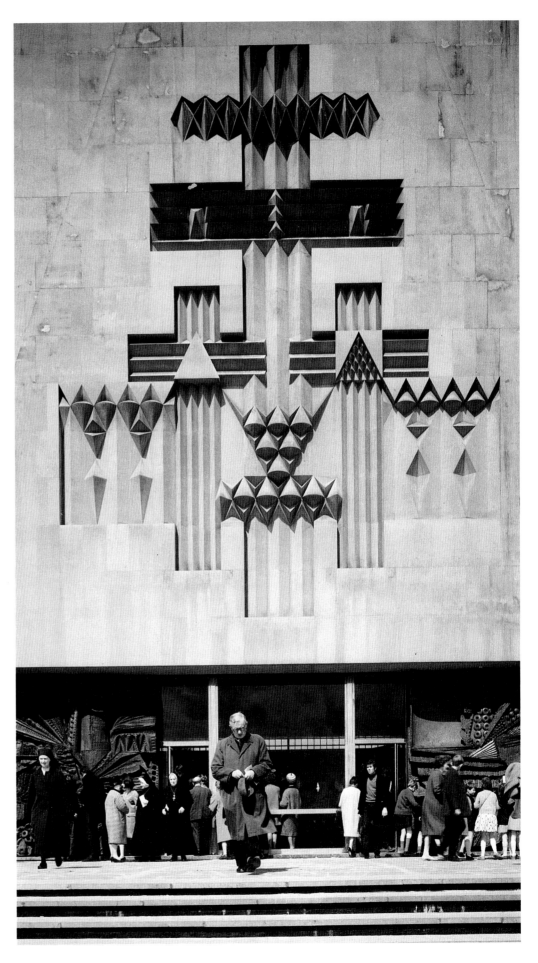

ELISABETH FRINK
Eagle Lectern 1958
Cathedral of St Michael,
Coventry
SIR BASIL SPENCE

JACOB EPSTEIN
St Michael Subduing the
Devil **1958**
Cathedral of St Michael,
Coventry
SIR BASIL SPENCE

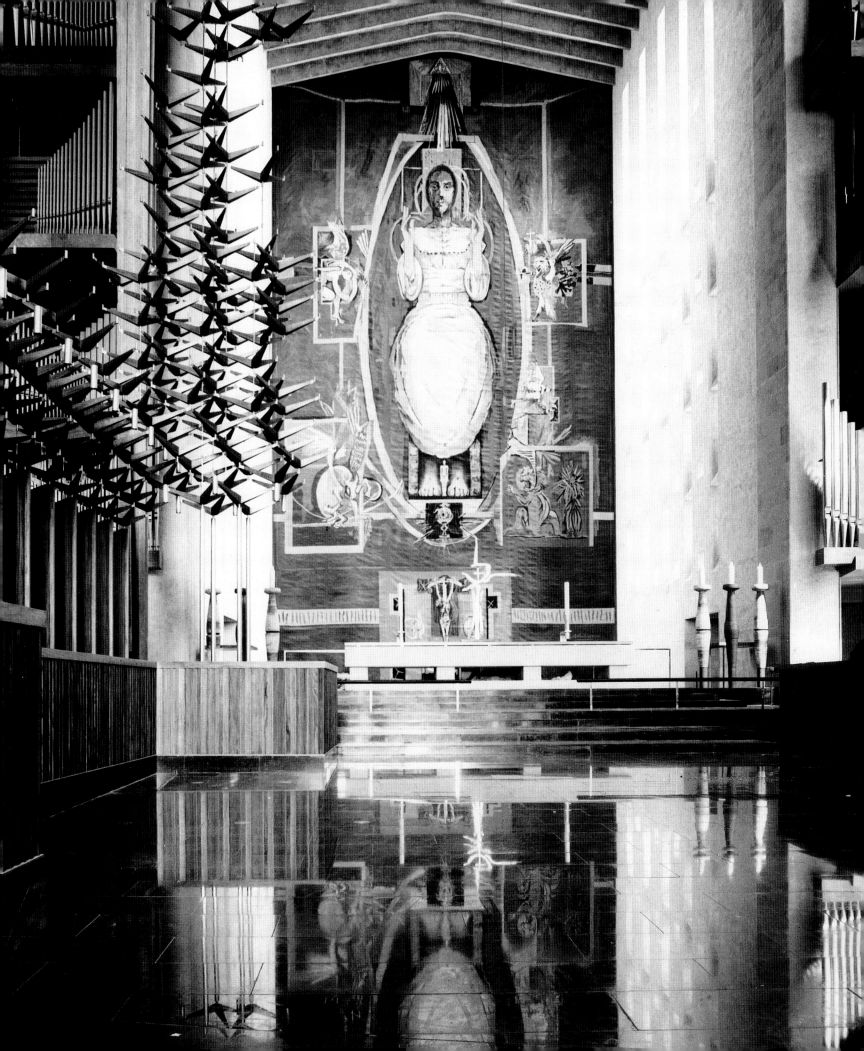

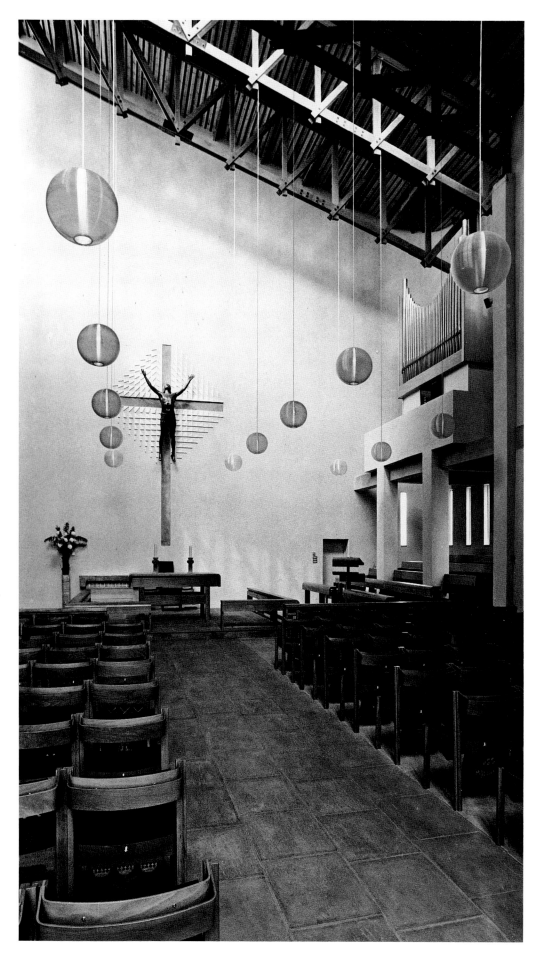

ERNEST PASCOE
Christ in Glory **1972**
St Augustine's,
Whitchurch, Bristol
MOXLEY JENNER & PARTNERS

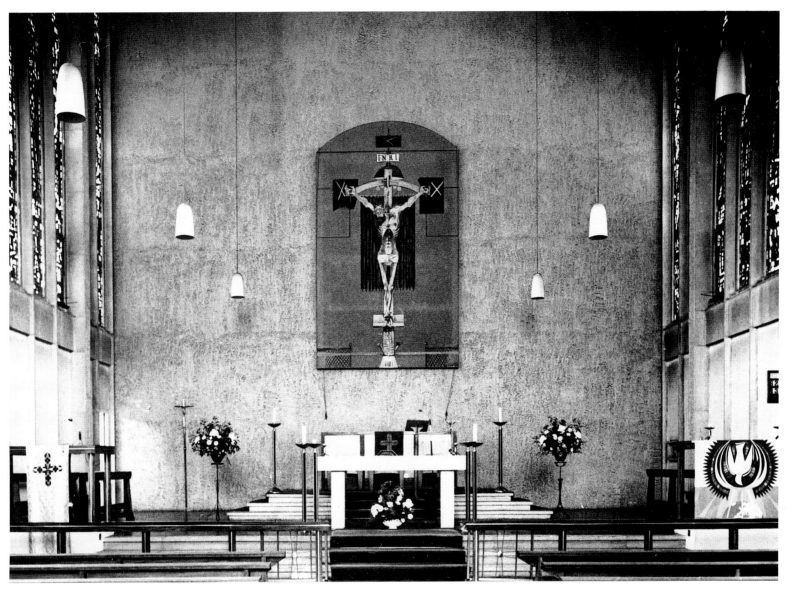

GRAHAM SUTHERLAND
Crucifixion 1963
St Aidan's Catholic Church,
East Acton, London
BURLES NEWTON & PARTNERS

IMOGEN STUART
Gargoyle 1976
HELEN MOLONEY
Ceramics 1976
Catholic Church,
Maghera, Co. Derry
LIAM McCORMICK

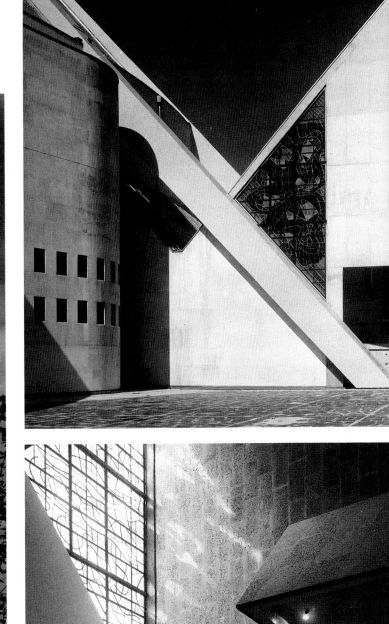

Right **CERI RICHARDS**
Above **Stained-glass window 1968**
Below **Tabernacle and reredos 1967**
Metropolitan Cathedral of
Christ the King,
Liverpool
FREDERICK GIBBERD &
PARTNERS

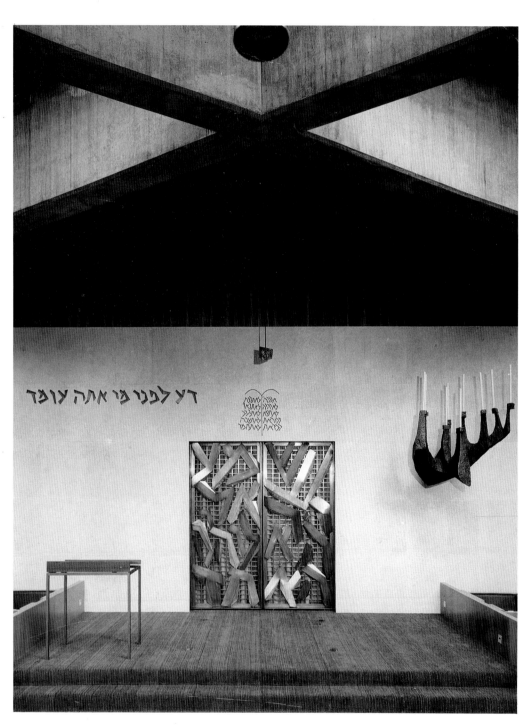

דע לפני מי אתה עומד

NECHEMIA AZAZ
Ark doors and candelabra 1964
Belfast Synagogue
YORKE ROSENBERG MARDALL

7 Art for Interiors

Some artists are wary about commissions for architectural interiors. When Henry Moore received an invitation from Berthold Lubetkin to make a carving for an alcove in High Point, his celebrated block of flats at Highgate, a small model was soon produced. It eventually flowered into one of Moore's finest carvings, the elmwood *Reclining Figure*, but Lubetkin's determination to place the sculpture eight feet above the ground meant that it was never installed at High Point. Moore preferred his work to be viewed at eye level, and explained later that 'when an architect simply wants to fill a space he thinks is too empty, the sculpture becomes a decorative thing. I think you've got to have the sense of meeting a sculpture face to face.'

The patron responsible for commissioning must therefore be alive to the particular needs of the artist, allowing the work to transcend the level of foyer images so anodyne that they are rarely even noticed. The timber mural relief and paintings on glass produced by Victor Pasmore for Pilkingtons in 1962 are grand and powerful enough to rise above the usual standard of office decoration. Pasmore's feeling for architecture ensures that his lyrical yet forthright disposition of form chimes very sympathetically with Maxwell Fry's building.

Although these works are as ample in size as they are in pictorial assurance, the monumentality of their surroundings keeps them subordinate to the architecture. In this respect they adhere to conventional ideas about the role art is supposed to play within an interior, whereas Patrick Caulfield was allowed an astonishing amount of space when he executed his still-life composition for the entrance hall of the London Life Assurance Headquarters in Bristol. Instead of remaining content with an irreproachably tasteful ornament, innocuous enough to offer no one a challenge, Caulfield made the most of his opportunity. His outsize painting is inescapable, and confronts everybody entering the building with its rigorously organized authority. Defined with crisp, deadpan certitude, and animated by colours of heraldic power, this mesmeric image transforms the building it inhabits.

For all its overwhelming dimensions, Caulfield's canvas is still restricted to a single, finite part of the interior. Bruce McLean's contribution to the bar at the Arnolfini Gallery, by contrast, is far less easy to pin down. Working in evident sympathy with the architect David Chipperfield, he conducted a series of deft, witty raids on the room at his disposal. Preliminary watercolour studies show how McLean envisaged an interior alive with unpredictable activity, and the speckled bar counter is only the most visible of the places he has energized here. Enigmatic steelwork faces gaze out from shielding hands underneath the bar and elsewhere, their tangled linear vitality reflecting the incessant animation of a rendezvous where sociability flourishes.

When Howard Hodgkin was commissioned to produce a mosaic of epic proportions for the pool in the Broadgate Club, he likewise took his cue from the activity within the space. But it could hardly be more opposed to the frenetic, cabaret-like mood of the Arnolfini bar. Hodgkin's design is governed by the motion of the water within the pool. Although figures cannot be discerned in the mosaic, the undulations caused by their swimming inspired its gently surging rhythm. It is as appropriate to the setting as Sol LeWitt's sonorously coloured drawings in the entrance hall of the Bankers Trust Company nearby. Admirably at one with the stillness of their location, the unforced grandeur of these tall panels testifies to LeWitt's long experience of responding to a diverse range of architectural spaces.

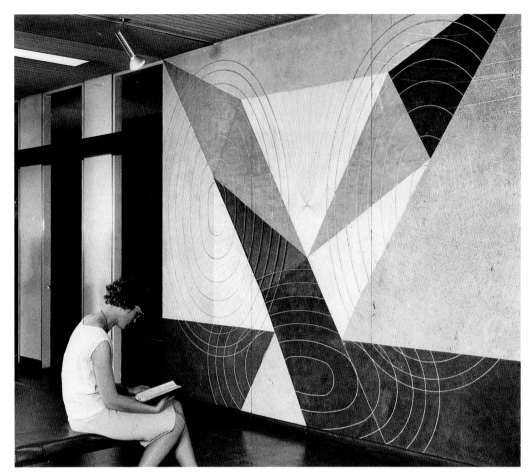

EDWARD BAWDEN
Murals 1964
University of Hull,
Physics Building
ARCHITECT'S CO-PARTNERSHIP

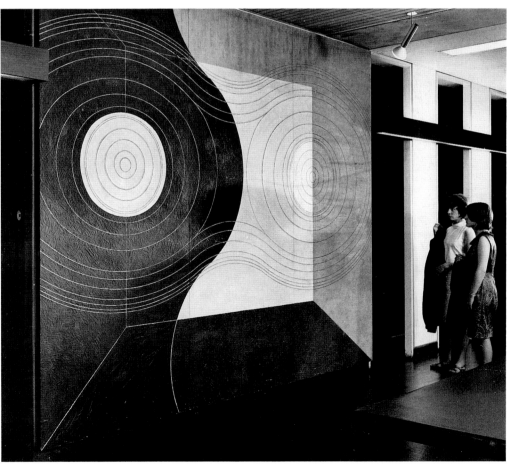

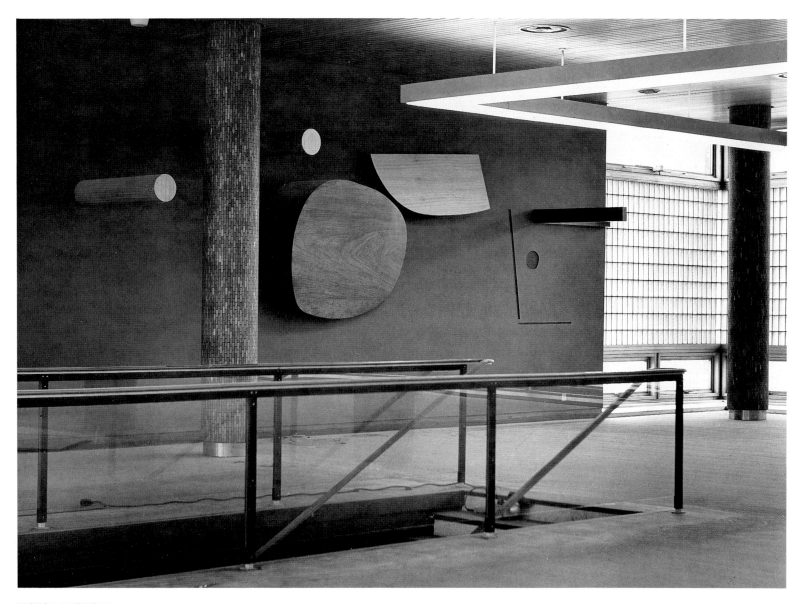

VICTOR PASMORE
Above **Timber mural relief 1962**
Opposite **Paintings on glass 1962**
Pilkingtons Staff Centre,
St Helens, Lancashire
MAXWELL FRY & PARTNERS

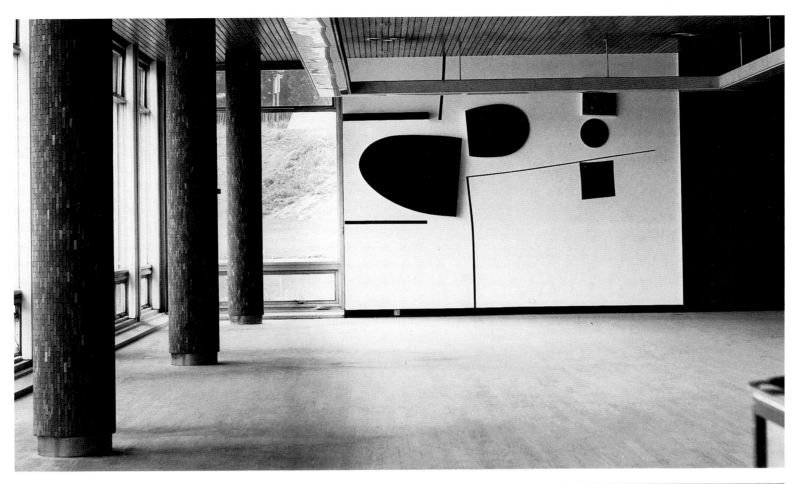

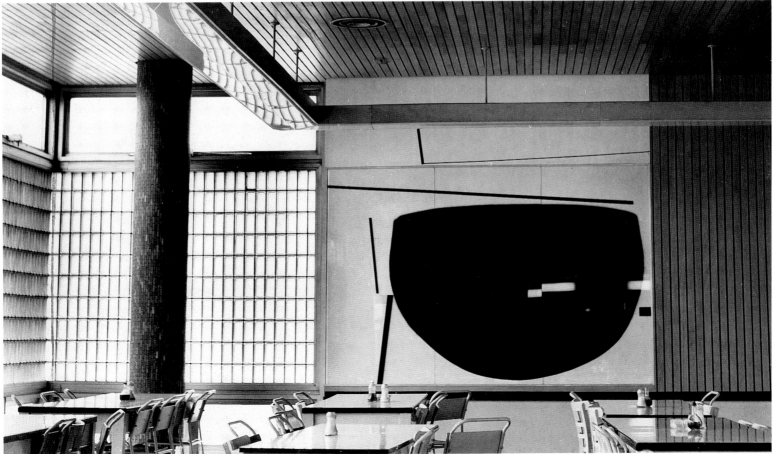

BRUCE McLEAN
A Place for a Lean 1987
The Arnolfini Gallery Bar,
Bristol
DAVID CHIPPERFIELD

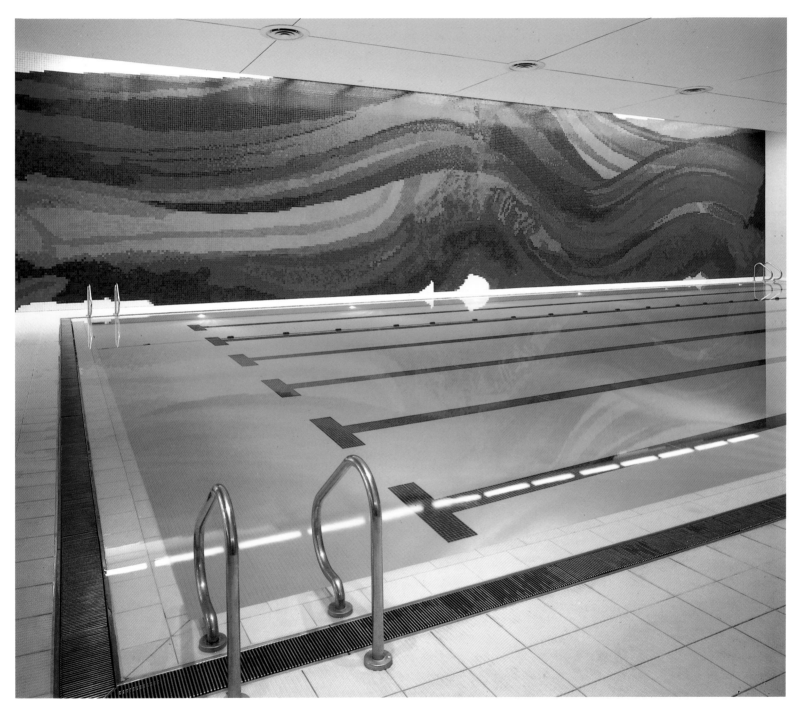

HOWARD HODGKIN
Wave mosaic **1988/9**
Broadgate Club Swimming Pool,
City of London
SKIDMORE OWINGS MERRILL

SOL LeWITT
Wall drawings 1988
Bankers Trust Company
Dashwood House,
City of London
SKIDMORE OWINGS MERRILL

PATRICK CAULFIELD
Painting 1983
London Life Assurance Headquarters,
Bristol
WELLS THORPE SUPPEL

139

JOE TILSON
Geometry **1972**
Heathrow Airport
**FREDERICK GIBBERD
& PARTNERS**

Below **RICHARD SMITH**
Leaps and Bounds **1982**
**IBM UK Headquarters
North Harbour, Portsmouth
ARUP ASSOCIATES**

JOE TILSON
Mural in timber 1973
Brunel University Library
RICHARD SHEPPARD ROBSON
& PARTNERS

PATRICK HUGHES
Pile of Rainbows **screenprint 1973**
W.D. & H.O. Wills Offices
Hartcliffe, Bristol
SKIDMORE OWINGS MERRILL
YORKE ROSENBERG MARDALL

Below **JUSTIN KNOWLES**
Blacks with Yellow & Greens **1967**
University of Warwick,
Science Building
YORKE ROSENBERG MARDALL

RON NIXON
Wall hanging 1976
Henry Boot Construction Company,
Dronfield, Sheffield
MAX CLENDINNING

BEN NICHOLSON
Carnac Red and Brown **1965**
W.D. and H.O. Wills Offices
Hartcliffe, Bristol
SKIDMORE OWINGS MERRILL
YORKE ROSENBERG MARDALL

ROBERT WALLACE
Tapestry 1975
King's Cross House,
Islington, London
CHAPMAN TAYLOR PARTNERS

GEOFFREY CLARKE
Extraction and Refining of Oil **1959**
Castrol House,
London
GOLLINS MELVIN WARD & PARTNERS

Opposite **JOHN WALKER**
Juggernaut 4 **1974**
Price Waterhouse Offices,
Southwark Towers, London
T.P. BENNETT & SON

Below **GERALD HOLTOM**
Appliqué curtains 1962
Pilgrim School,
Bedford
COUNTY ARCHITECT'S DEPARTMENT

Opposite **GILLIAN WISE**
Stainless-steel panels 1974
University Hospital & Medical School,
Nottingham
BUILDING DESIGN PARTNERSHIP

ALAN BOYSON
Ceiling 1974
Halifax Building Society
Headquarters Restaurant,
Halifax
BUILDING DESIGN PARTNERSHIP

MAX BILL
Striving Forces of a Sphere 1966/7
Commercial Union Assurance,
Leadenhall Street, City of London
GOLLINS MELVIN WARD & PARTNERS

Opposite **KEITH NEW**
Stained-glass window 1964
Royal College of Physicians,
London
DENYS LASDUN & PARTNERS

8 Public Sculpture

Post-war history proves that considerable hostility can be generated by work in exposed locations. The full extent of potential public anger was disclosed when the Peter Stuyvesant Foundation organized a well-meaning 'City Sculpture Project' in 1972. A number of prominent artists were commissioned to make works for specific spaces in Birmingham, Cambridge, Cardiff, Liverpool, Newcastle, Plymouth, Sheffield and Southampton. Each sculpture was supposed to be installed for a minimum of six months, so that the public would become acclimatized to it. A series of documentary exhibitions provided information about the scheme, its historical precedents and the chosen artists, who included Barry Flanagan, Bryan Kneale, Liliane Lijn, Kenneth Martin, Nicholas Munro, William Tucker and William Turnbull.

A considerable amount of debate was generated by the scheme, and Munro's colossal *King Kong* became notorious immediately it was installed in Manzoni Gardens, Birmingham. None of the works succeeded in winning over the city for which it was made, however. One wry commentator in Birmingham wondered if *King Kong*, which had after all been modelled on an animal responsible for 'a lot of destruction' in New York, was Munro's 'way of saying that part of Birmingham perhaps needs to come down and start all over again'. Many of the works were widely seen as onslaughts on the environments they occupied, and public disaffection reached its height at Cambridge where Flanagan installed a five-part sculpture. Following waves of attacks involving dirty washing, lavatory seats and attempts to burn the totemic fibreglass forms, the Stuyvesant Foundation requested its removal less than a month after the sculpture had been erected.

Athough the Stuyvesant initiative proved a disillusioning experience for many of the artists involved, other attempts to instal public sculpture in prominent sites have met with considerable approbation. Franta Belsky's corkscrew fountain outside the forbidding bulk of the Shell Centre on the South Bank has a whirling energy which counters the building's oppressiveness. The sculpture gains much of its appeal from Belsky's spirited determination to subvert the implacable stolidity of the architecture, whereas Bernard Meadows achieved an equally notable result by working in harmony with a building he could respect. His sculpture appears to grow out of the Eastern Counties Newspapers office in Norwich with a satisfying sense of inevitability. Playing off his architectonic stone segments against the gleaming bronze forms embedded within them, he arrives at a subtle combination of structural austerity and organic richness.

Even when artists find themselves in sympathy with the surrounding architecture, they should not allow their work's identity to be swallowed up in the building. Kenneth Martin's poised *Screw Mobile* hanging in the atrium of Victoria Plaza, London, might have lost itself in the intricacies of the roof. But the forcefulness of Martin's chaste formal rigour preserves its independence in the end, and Richard Serra's *Fulcrum* achieves an even greater sense of tough-minded autonomy at the entrance to the Broadgate development adjoining Liverpool Street Station. While honouring the arena-like character of the space, and vying with the vertical thrust of the tall buildings encircling it, *Fulcrum* retains its own stripped and defiant integrity. Although the starkness of Serra's soaring steel plates gives the lie to the fussiness of the nearby architecture, they

lend an aspirational quality to a development which might otherwise have remained a monument to Mammon and British Rail alone.

BERNARD SCHOTTLANDER
South of the River **1976**
Becket House, Lambeth,
London
YORKE ROSENBERG MARDALL

BARBARA HEPWORTH
Above ***Winged Figure*** **1962**
John Lewis Department Store,
London
SLATER UREN

Right ***Meridian*** **1958/9**
State House,
High Holborn, London
TREHEARNE NORMAN PRESTON
& PARTNERS

Opposite **STEPHEN GILBERT**
Sculpture 1972
British Steel Corporation,
London
C.H. ELSOM PACK & ROBERTS
DESIGN RESEARCH UNIT

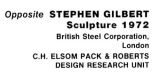

155

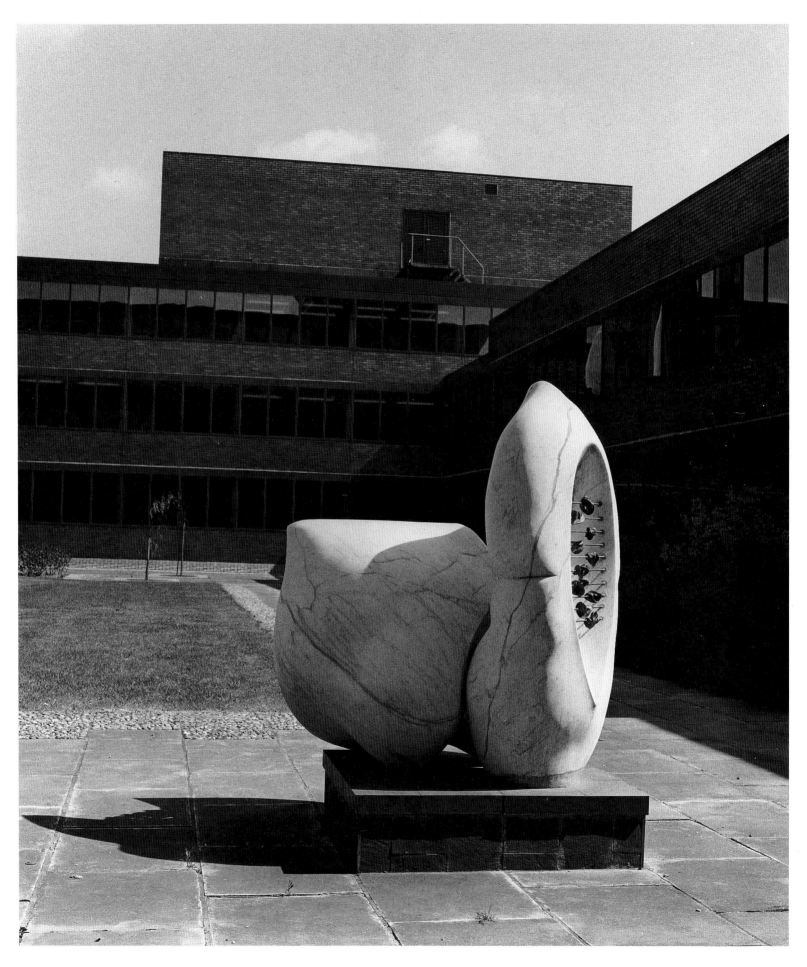

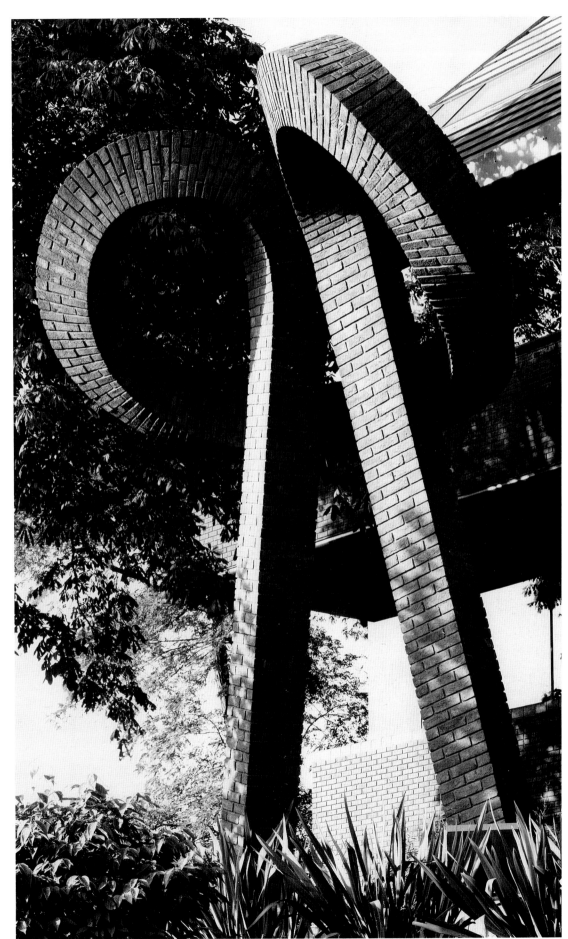

Right **WENDY TAYLOR**
Sentinel **1980/1**
Redland House,
Reigate, Surrey
FREDERICK GIBBERD
& PARTNERS

Opposite **PETER W. NICHOLAS**
Abacus **1974**
Department of the Environment
Business Statistics Office,
Newport, Gwent
PERCY THOMAS PARTNERSHIP

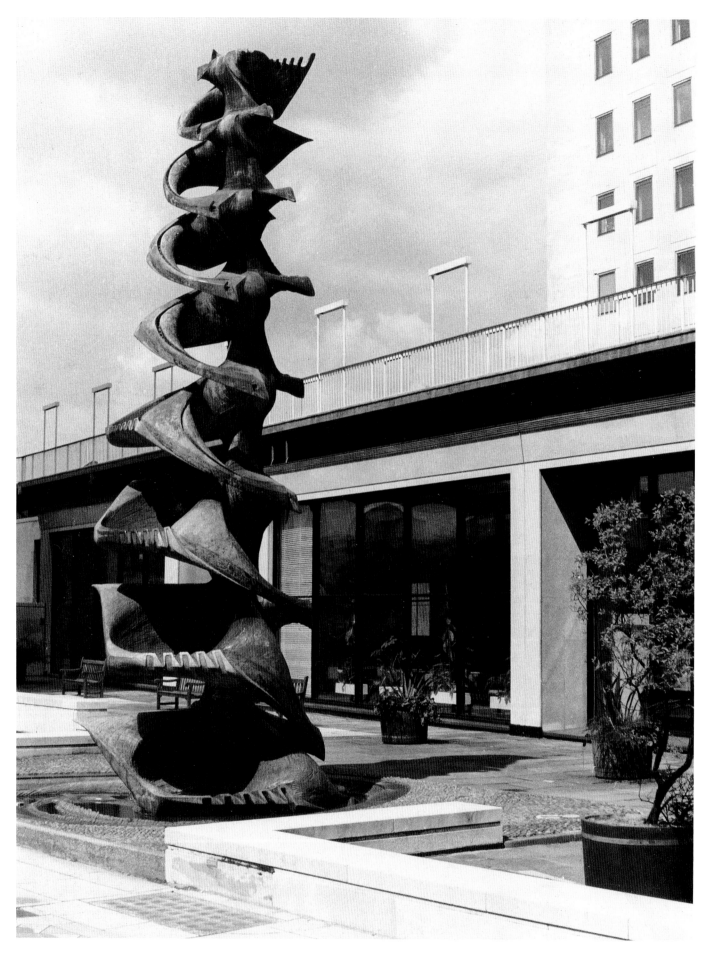

FRANTA BELSKY
Opposite **Fountain 1961**
Shell Centre,
South Bank, London
EASTON & ROBERTSON

Right **Totem 1977/8**
Arndale Shopping Centre,
Manchester
WILSON & WOMERSLEY

BERNARD MEADOWS
Sculpture 1969/74
Eastern Counties Newspapers,
Norwich
YATES COOK & DERBYSHIRE

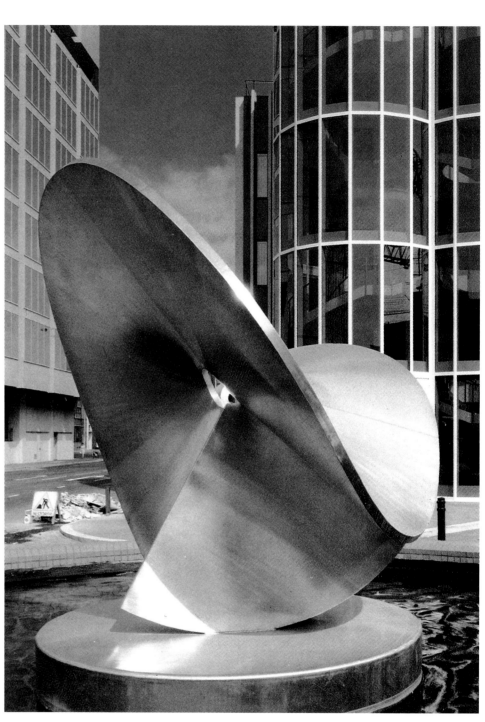

Above **ROBERT ADAMS**
Phoenix **1972**
Fire Services Technical College,
Moreton in Marsh, Gloucestershire
DEPARTMENT OF THE ENVIRONMENT
PROPERTY SERVICES AGENCY

KEITH McCARTER
Judex **1983**
Goodman's Yard,
The Minories, City of London
FITZROY ROBINSON & PARTNERS

WILLIAM PYE
Zemran **1971**
Queen Elizabeth Hall,
South Bank, London
GLC ARCHITECT'S DEPARTMENT

PETER FINK
Castle Cross 1981
Castle Street,
Banbury, Oxfordshire
SIR FREDERICK GIBBERD & PARTNERS

Opposite
KENNETH MARTIN
Screw Mobile **1983**
Victoria Plaza,
London
EPR

RICHARD SERRA
Fulcrum **1987**
Broadgate Development,
City of London
ARUP ASSOCIATES

WILLIAM PYE
Sculpture 1974
King's Cross House,
Islington, London
CHAPMAN TAYLOR PARTNERS

Opposite **JOHN HOSKIN**
Sculpture 1970
Provincial Insurance Building,
Kendal, Cumbria
BASIL WARD PARTNERSHIP

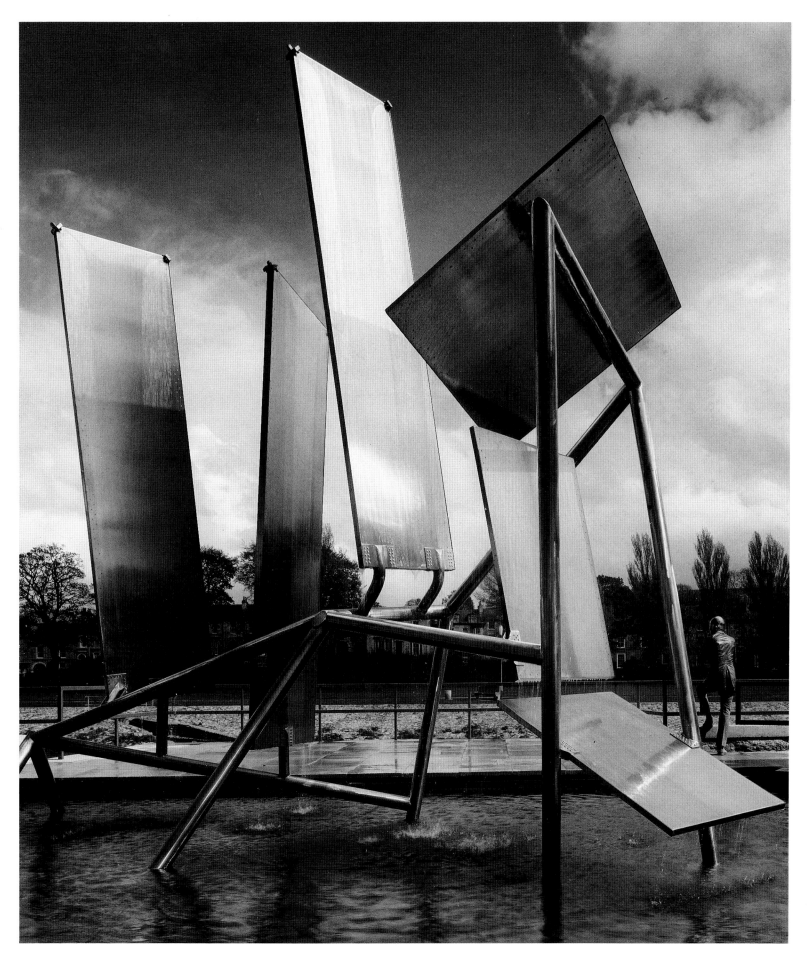

Notes on the Text

1 Charles Holden, memoir, 5 March 1958, Adams, Holden and Pearson archives, London. See Richard Cork, *Art Beyond The Gallery In Early 20th-Century England* (New Haven and London, 1985) for a comprehensive account of the Strand statues and their destruction.

2 Jacob Epstein, *Let There Be Sculpture. The Autobiography of Jacob Epstein* (London, 1942 edn.) p.41.

3 Henry Moore, interview with the author, 26 May 1981. Only at the end of his life, when he was very ill, did Moore consent to a retrospective exhibition at the Royal Academy, held posthumously in 1988.

4 Henry Moore, 'Sculpture in the open air. A talk by Henry Moore on his sculpture and its placing in the open air', British Council 1955, *Henry Moore on Sculpture*, ed. Philip James (London, 1968, revised edn.) p.99.

5 Wadsworth's design for the mural was executed on the wall by the American painter Charles Howard.

6 J.L. Martin, Ben Nicholson and Naum Gabo (eds.), *Circle. International Survey of Constructive Art* (London, 1937, new edn. 1971) p.v.

7 Ibid., pp.v–vi.

8 Henry Moore, 'Sculpture in the open air', op. cit., p.99.

9 Ibid.

10 Ibid.

11 Herbert Read, *Henry Moore Sculpture and Drawings* (London, 1944) p.xxxvi.

12 In 'Sculpture in the open air', op. cit., Moore recalled that 'we stood it as far away from the wall as possible, but one can only see it from a limited number of views, one cannot get those sudden revelations that occur when one comes upon a sculpture from an unexpected angle'.

13 The Hertfordshire Schools scheme and the Barclay School are discussed in detail in the *Architectural Review*, February 1947 and September 1949.

14 Herbert Read, *Henry Moore Sculpture and Drawings*, op. cit., p.xxxvi.

15 Gerald Barry, speech at a Symposium on 'Painting, Sculpture & the Architect', organized by the ICA and the MARS Group at the RIBA, 2 September 1949, published in *The Architect and Building News*, 16 September 1949.

16 Ibid.

17 Huw Wheldon, quoted by Hugh Casson, 'Period Piece', *A Tonic to the Nation. The Festival of Britain 1951* (London, 1976), p.81.

18 Misha Black, 'Architecture, Art and Design in Unison', ibid., p.83.

19 Hugh Casson, *Image 7*, Spring 1952.

20 In 'Sculpture in the open air', op. cit., Moore recalled that 'I made the figure, then found the best position I could.'

21 Victor Pasmore, 'A Jazz Mural', *A Tonic to the Nation*, op. cit., p.102.

22 Ibid.

23 Ibid.

24 Ibid.

25 H.F. Clark, 'New Architecture and Abstract Art. The Regatta Restaurant', *Broadsheet No.1*, 1951.

26 Giacometti's *The Palace at 4am* is in the Museum of Modern Art, New York.

27 Jane Drew, 'The Riverside Restaurant', *A Tonic to the Nation*, op. cit., p.103.

28 Jane Drew, conversation with the author, 18 November 1990.

29 Recorded by Mary Banham, 'Introduction', *A Tonic to the Nation*, op. cit., p.72.

30 Misha Black, 'Architecture, Art and Design in Unison', ibid., p.84.

31 Reg Butler, quoted by Richard Calvocoressi, 'Reg Butler: the Man and the Work', *Reg Butler* (London, Tate Gallery, 1983) p.24.

32 Lawrence Alloway, 'The Siting of Sculpture', *The Listener*, 17 June 1954.

33 Reg Butler, quoted by Richard Calvocoressi, op. cit., p.24.

34 A photograph of *The Oracle*, showing the entrance hall in its entirety, is reproduced by Paul Damaz, *Art in European Architecture* (New York, 1956) p.110. Both *The Oracle* and Hepworth's carvings *in situ* are reproduced in the *Architectural Review*, February 1953. *The Oracle* has since been moved to the interior of the new C.P. Snow Computer Centre.

35 Louis Osman, 'Cavendish Square – Past and Present', *The Journal of the London Society*, 20 February 1957.

36 See Timothy Lingard, 'Michael Rosenauer. Architect (1884–1971). A Biographical Sketch', *Henry Moore and Michael Rosenauer* (London, Fine Art Society, 1988) n.p.

37 Henry Moore to Michael Rosenauer, 10 March 1952, published by Peyton Skipwith, 'Abstract Sculpture and Modern Architecture', *Henry Moore and Michael Rosenauer*, op. cit., n.p.

38 *Trades Union Congress Memorial Building Sculpture Competition. General Conditions and Instructions*, 1954, items 21–22, Congress House, London.

39 The marble subsequently deteriorated, and has now been replaced by a different material.

40 For a full account of the exhibition's genesis, see *The Independent Group: Postwar Britain and the Aesthetics of Plenty*, ed. David Robbins (Cambridge, Mass., and London, 1990) p.135.

41 Colin St John Wilson, 'A Note About *This Is Tomorrow*', unpublished, quoted in *The Independent Group*, op. cit., p.135.

42 Statement by Group 8, *This Is Tomorrow* (London, Whitechapel Art Gallery, 1956) n.p.

43 Peter Smithson, statement requested by Leonie Cohn for the BBC Talks department, July 1956, quoted ibid., p.141.

44 *The Times*, 9 August 1956.

45 In conversation with the author, Eugene Rosenberg recalled that his plans to incorporate art in building projects were often frustrated by cost-cutting edicts imposed from above.

46 Colin St John Wilson, 'Reflections on the Relation of Painting and Architecture', *London Magazine*, April/May 1979.

47 James Stirling, *This Is Tomorrow*, op. cit., n.p.

48 John Weeks to Eugene Rosenberg, dated only '31 October', Rosenberg archive, London.

49 Ibid.

50 Mary Martin, 'The Waterfall', 1957, *Mary Martin* (London, Tate Gallery, 1984) p.27.

51 Ibid.

52 According to *Gillian Ayres* (London, Serpentine Gallery, 1983), she had already 'seen the Hans Namuth photograph of Pollock working on the floor' (p.25). Her panels were subsequently dismantled, wall-papered over, restored and then reassembled in a different sequence in another part of the school.

53 Catherine Martineau, interview with Richard Cork, 18 February 1991. Information relating to the conception of the paintings is also taken from this interview.

54 Quoted by John Rothenstein, *Stanley Spencer The Man: Correspondence and Reminiscences* (London, 1979) p.131.

55 Henry Moore, 'Preface', *Sculpture in Harlow* (Harlow, 1973) n.p.

56 Sir Frederick Gibberd, 'Introduction', ibid.

57 Victor Pasmore, interview with Peter Fuller, *Modern Painters*, Winter 1988/9.

58 Ibid.

59 In his introduction to *Victor Pasmore* (London, Arts Council, 1980), Alastair Grieve points out the similarity between Pasmore's 'clusters of dynamically balanced positive and negative spaces aligned on a diagonal grid' and 'a *Counter Composition* by Van Doesberg' (p.12).

60 Victor Pasmore, interview, op. cit.

61 Ibid.

62 Ibid.

63 Victor Pasmore to Eugene Rosenberg, 9 May 1977, Rosenberg archives, London.

64　Ibid.

65　Ibid. In the same letter Pasmore noted: 'I wanted to call the big sculpture the "Apollo Pavilion" to celebrate the landing on the moon which more or less coincided with its completion but unfortunately the Corporation wouldn't have it.'

66　Reported in the *Sunday Telegraph*, 22 April 1962.

67　During the recent reconstruction of Thorn House (now Orion House), the *Spirit of Electricity* was taken down, restored and then re-erected on the tower overlooking West Street.

68　See Roger Berthoud, *The Life of Henry Moore*, op. cit., pp.245–6.

69　Basil Spence, *Phoenix at Coventry* (London 1962) p. 68.

70　Graham Sutherland to Andrew Révai, quoted by Ronald Alley, *Graham Sutherland* (London, Tate Gallery, 1982) p.134.

71　The house at New Malden is illustrated in Mel Gooding, *F.E. McWilliam Sculpture 1932–1989* (London, Tate Gallery, 1989) p.17.

72　From a memoir, 1990, by W.G. Lucas, the architect in charge of the Altnagelvin Hospital, Rosenberg archive, London.

73　William Scott, quoted in *William Scott Paintings, Drawings and Gouaches 1938–71* (London, Tate Gallery, 1972) p.77.

74　Ibid.

75　According to a letter Denys Lasdun wrote to Eugene Rosenberg (18 November 1975), Keith New 'rearranged some old stained glass from the original College building and worked it in with a design using new stained glass'. Rosenberg archive, London.

76　Herbert Read, *Henry Moore* (London, 1965) p.199.

77　Richard Calvocoressi, 'Public Sculpture in the 1950s', *British Sculpture in the Twentieth Century*, ed. Sandy Nairne and Nicholas Serota (London, 1981) p.135.

78　Jimmy Forsyth, *Scotswood Road*, ed. Derek Smith (Newcastle upon Tyne, 1986) p.120.

79　Jeremy Rees, 'Public sculpture', *Studio International*, July/August 1972.

80　Herbert Read, *Education Through Art* (revised edn. London, 1961) p.298.

81　Phillip King, quoted in *Growing up with Art. The Leicestershire Collection for Schools and Colleges* (London, Arts Council, 1980) p.21.

82　John Watts, ibid.

83　Herbert Read, *Education Through Art*, op. cit., pp.256–64.

84　Richard Cork, 'Editorial', *Studio International*, September/October 1975.

85　See Graham Cooper and Doug Sargent, *Painting the Town* (Oxford, 1979) for a concise survey.

86　For a discussion of the work at Laycock School, see 'Outside The Art System: Collaborative Work in Schools', *Studio International*, 2/1977.

87　For a detailed account of the project's progress, see 'Naum Gabo talks to David Thompson', *Art Monthly*, February 1977.

88　Naum Gabo to Lewis Mumford, 29 October 1976, Gabo papers, Beinecke Library, Yale University.

89　Naum Gabo and Antoine Pevsner, *Realistic Manifesto*, first published in Moscow, August 1920. An English translation of the complete text is included in *Naum Gabo: The Constructive Idea* (London, South Bank Centre, 1988) pp.52–4.

90　Eduardo Paolozzi, 'Going Underground', *Eduardo Paolozzi Underground*, ed. Richard Cork (London, 1986), p.8.

91　Charles Jencks, 'A Modest Proposal: on the collaboration between artist and architect', *Art Within Reach*, ed. Peter Townsend (London 1984) p.19.

92　The conference was held at the ICA over the weekend of 27 and 28 February 1982.

93　The Arts Council exhibition, *Four Rooms*, was held at Liberty's, London, February–March 1984.

94　Anthony Caro, statement on the *Child's Tower Room* in the *Four Rooms* catalogue, op. cit.

95　Anthony Caro, quoted by Richard Rogers in his introduction to *Aspects of Anthony Caro. Recent Sculpture 1981–89* (London, Knoedler Gallery and Annely Juda Fine Art, 1989) p.5.

96　Richard Rogers, ibid., p.4.

97　Kevin Atherton, *Art Within Reach*, op. cit., p.36.

98　The public art consultant for Eastern Arts was Isabel Vasseur.

99　For a detailed discussion of the significance of Hephaestus in Paolozzi's sculpture, see Robin Spencer, 'Paolozzi as a portrait sculptor', *Paolozzi Portraits* (London, National Portrait Gallery, 1988) pp.10–11.

100　McLean's exhibition, *The Floor, The Fence, The Fireplace*, was held at the Anthony d'Offay Gallery in March 1987.

101　William Waldegrave and Richard Luce, 'Foreword', *Art for Architecture, A handbook on commissioning*, compiled and ed. Deanna Petherbridge (London, 1987) n.p.

102　Deanna Petherbridge, 'Introduction', ibid., p.2.

103　Ibid., p.5.

104　Michael Sandle, interview with Paul Bonaventura in the exhibition guide for the *Michael Sandle* retrospective at the Whitechapel Art Gallery, May–June 1988, n.p.

105　*St George and the Dragon* was commissioned by Stockley, Barclays Property Investments, Unilever and British Land with assistance from Stanhope Properties. It is owned by the Mountleigh Group.

106　Stuart Lipton, quoted in *Art Within Reach*, op. cit., p.27.

107　The other members of the Steering Group were Conrad Atkinson, Robert Breen, Lesley Greene, Ernest Hall, Denys Hodson, Christopher Martin, Jane Priestman, Ann Sutton and, from the Arts Council, Sandy Nairne and Rory Coonan.

108　*Percent for Art* (London, Arts Council 1990) 13.2, n.p.

109　Ibid.

110　The architects were delighted with the outcome, declaring that 'it was immensely gratifying that such an artist responded so positively to the spaces, the light and the atmosphere of the centre. The paintings belong to their sites in a specific and complementary way: the way in which they live with the building and are part of what goes on in it' (from a statement by Edward Cullinan Architects, 2 August 1988).

111　Tom Phillips, quoted by Callum Murray, 'Art Attack', *AJ*, 28 October 1987.

112　*Percent for Art*, op. cit., 2.5.

113　Ibid., 3.1.

114　See fn. 101.

115　See *Art For The New British Library* (London, 1990) for a discussion of Colin St John Wilson's plans.

116　*Percent for Art*, op. cit., 10.7.

117　Ibid., 4.7, 4.6.

118　John Willett, *Art in a City* (London, 1967).

119　John Willett, 'Back to the Dream City: the current interest in public art', *Art Within Reach*, op. cit., p.11.

120　Charles Jencks, 'A Modest Proposal', op. cit., p.15.

121　See Eugene Rosenberg's Preface (p. 6).

122　Colin St John Wilson, 'Reflections on the Relation of Painting to Architecture', op. cit.

Acknowledgments

Help received from the following is gratefully acknowledged:

Arts Council of Great Britain; Camden Local History Library; Greater London Record Office; Lee Valley Water Board; London Underground Ltd, Architects' Division; Royal Institute of British Architects; Universities Funding Council; Leicestershire County Council; Glenrothes Development Corporation; Harlow Development Corporation; Skelmersdale Development Corporation; the late Stewart Mason; W.G. Lucas, RIBA; John Partridge CBE, FRIBA; John Weeks CBE, AADipl, FRIBA; Archivist, Cathedral of St Michael, Coventry; Archivist, Cathedral of Christ the King, Liverpool; Curator, Barbara Hepworth Museum; Curator, Art Collections, University of Liverpool; Curator, Art Collections, University of Stirling; Curator, Mead Gallery, University of Coventry; Art Historian, St Thomas' Hospital; Photographic Librarian, YRM Partnership Ltd.

and all who so readily contributed photographs and information.

Special thanks are due to:

Richard Cork for his collaboration;
Thames and Hudson for advice and guidance;
Sir Norman Reid for his longstanding support and encouragement for the project;
and to Patricia Mowbray, without whose involvement from the outset this book could not have been completed.

Illustration Acknowledgments:
Annely Juda Fine Art p. 27 (below left); Anthony d'Offay Gallery, London p. 30; Robert Adams p. 162 (photo: Sam Lambert); Aldenham School p. 19 (top and bottom); Arnolfini Gallery p. 136; Arts Council pp. 27 (top), 35, 36–7, 38, 39, 40, 41, 97; ARUP Associates pp. 88–9 (photo: Colin Westwood); Bedfordshire County Architect p. 146 (bottom); Franta Belsky p. 159 (photo: Paul Francis); Crispin Boyle p. 165; Ivor Braka p. 19 (centre); British Airports Authority p. 140 (photo: Henk Snoek); British Gas Corporation p. 98 (top); British Steel Corporation p. 87 (photo: Louanne Richards), 154; Building Design Partnership pp. 148, 149 (photo: John Mills); Cardiff University College pp. 94–5; Chapman Taylor Partners p. 145 (photo: Brecht-Einzig); Charing Cross Hospital p. 111; Colin St John Wilson & Partners p. 32; Coventry Cathedral p. 22 (top); Michael Craig-Martin p. 29; Richard Deacon pp. 29, 33, 78–9; Denys Lasdun & Partners p. 151 (photo: John Donat); Easton & Robertson p. 158; J.L.W. Ellacombe p. 109; Mrs Marjorie Evans pp. 46–7; Exhall Grange School p. 45; Farmer and Dark pp. 44–5 (photo: Brecht-Einzig); Peter Fink p. 164; Ian Hamilton Finlay p. 93; Frederick Gibberd & Partners p. 129 (photo: Henk Snoek); GLC (copyright Greater London Record Office) pp. 8, 11, 12, 13, 48, 53, 64, 65, 67; Glenrothes Development Corporation pp. 64 (right), 67 (right), 70, 71, 72–3; Gollins Melvin Ward & Partners pp. 42, 43, 146 (photos: Henk Snoek); Antony Gormley p. 29; Richard Hamilton p. 16 (top right); Harlow Development Corporation pp. 62 (bottom), 63; Alfred Harris p. 131; Ron Haselden p. 25; Herbert Art Gallery, Coventry p. 22 (bottom); David Hoffmann p. 27 (right); John Hoskin pp. 84, 107 (photo: Keith Gibson, Keighley), 169; Hull University p. 133; IBM UK p. 140; Albert Irvin p. 117 (photo: John Riddy); Tess Jaray p. 31; John Lewis Partnership p. 155; Liliane Lijn p. 60 (photo: Stephen Weiss); Lisson Gallery pp. 29, 78–9; Liverpool University p. 90; Llewelyn-Davies Weeks p. 115 (photo: Architectural Review); London Transport Museum p. 99; London Underground Ltd pp. 9, 105; Keith McCarter p. 162 (photo: David Leach); Liam McCormick p. 128; John Maine pp. 76–7; Manchester University p. 80; Mayor Rowan Gallery pp. 25, 26, 120; Bernard Meadows pp. 160–1; Andrew Mylius pp. 58–9; Peter Nicholas pp. 101, 156 (photo: Hylton Warner & Co. Ltd, Cardiff); Ron Nixon p. 143; Eduardo Paolozzi pp. 12, 29 (photo: Frank Thurston), 99, 116, published with kind permission of the artist; Ernest Pascoe p. 126 (photo: Derek Balmer, Bristol); Victor Pasmore pp. 56–7, 102 (photo: Turners Photography Ltd, Newcastle-Upon-Tyne), 134–5; Percy Thomas Partnership p. 106 (photo: Hylton Warner & Co. Ltd, Cardiff); Pick Everard Keay & Gimson pp. 113 & 116 (photo: Martin Charles); Price Waterhouse p. 147 (photo: Photographic Techniques); Public Art Development Trust p. 30 (photo: Susan Ormerod); William Pye pp. 100 (photo: Edward Woodman), 168; Richard Sheppard Robson & Partners pp. 82–3, 141; Rosehaugh Stanhope Development Corporation pp. 31 (photo: Ian Clook), 137, 138 (photo: Hansen-Brown), 166–7; Eugene Rosenberg pp. 14, 15, 16, 54, 55, 75, 91, 92, 93, 98, 110, 112, 117, 127, 150, 163; Michael Rothenstein pp. 50 (top), 51; Scherrer & Hicks p. 104; Heini Schneebeli p. 139 and cover; Bernard Schottlander pp. 61 (photo: John Donat), 153; Henk Snoek pp. 62, 66, 81, 86, 90, 103, 114, 123, 124, 125, 130; Skelmersdale Development Corporation pp. 68, 69 (photo: John Mills, Liverpool); Stirling University pp. 84–5; Strathclyde University p. 86 (photo: Scottish Arts Council); Sun Life Assurance Society plc. p. 28; Tate Gallery: Frontispiece; Wendy Taylor p. 58 (top left, photo: John Donat; bottom left, photo: Roy Davis), 157; Frank Thurston p. 29; Tothill Press Ltd p. 18; Warwick University pp. 33 (photo: Alan Watson), 142 (photo: Henk Snoek); John Weeks p. 16 (photo: Sam Lambert); Colin Westwood p. 155; YRM pp. 49 80 (photo: Direct Colour Ltd), 118 & 121 (photo: John Roaf), 119, 142 & 144 (photo: Brecht-Einzing); Photographs of works by Henry Moore are reproduced by kind permission of the Henry Moore Foundation.

Index

Page numbers in italic refer to illustrations.